W9-BZM-914

Graffiti

Graffiti
Two Thousand Years of Wall Writing

Robert Reisner

COWLES BOOK COMPANY, INC.
NEW YORK

Contents

To

Dr. Allen Walker Read, whose early investigations in the field led the way.
Max Gartenberg, my literary agent, who said, "I know you can find some Ice Age graffiti that didn't melt."
Julia Weissman, whose assistance on the manuscript was invaluable.

My Life In Graffiti

AN AUTOBIOGRAPHICAL NOTE

Some years ago, in the course of writing a book entitled *Show Me The Good Parts,* I was doing some esoteric research in the rare book room of the New York Public Library. This tome, on which I spent a good number of years, was an annotated bibliography on the salacious sections of novels. The idea was to circumvent eye strain and save time for those people who were interested largely in the sexy parts of books. Why, I reasoned, should a person of that persuasion have to read 360 pages in order to find the three where the master seduces the maid?

The book had only a moderate sale. I had dallied too long in the library stacks and, in that interim, the D. H. Lawrence and Henry Miller cases regarding the difference between literature and pornography had been won. Censorship had relaxed and purchasing my book to find the hot parts of other books was unnecessary. All the sex you wanted to read about was as close as your nearest drugstore paperback stand.

The foregoing has a direct bearing on my interest in graffiti. One of the titles that intrigued me in the catalogue drawer at the rare book room was *Lexical Evidence From Folk Epigraphy In The English Vocabulary,* by Allen Walker Read. I asked the librarian for it, and the item was so incendiary that it was handed to me with tongs. The book contained, verbatim, the messages found in a good many Western and Canadian privies. Not much humor appears in Dr. Read's findings, but this may be because the boldness of the vocabulary is descatol-

ogized (so to speak) by the purity of the scientific data presented, like the place and date of the finding, and some philological history. Here is an example:

> Derivative: ass hole. A glossary of about 1400 (MS Harl. 1002) has the entry "podex, arce-hoole," as printed in Thomas Wright, *A volume of Vocabularies* (1857), p. 183.
>
> **Don't judge a girl by her looks**
> **For her eyes may be black as charcoal**
> **For her beauty lies between her thighs**
> **Two inches from her ass hole.**
>
> *Yosemite National Park, California, July 11, 1928.*
>
> Collation—This sense missing in *Webster*, arse, "obs. or vulgar"; "low." The Oxford English Dictionary gives "vulgar and dial. sp. and pronunciation of arse" with one quot. of 1860 about a block or pulley. Manchon, p. 54, gives numerous derivatives of arse, such as arse up, arseways, slap-arse, splitarse, arse-coller etc. Partridge . . . says of arse: Frederic Manning was considered extremely audacious (January 1930) to use the word in his supreme war novel *Her Privates We.*

Dr. Read's book, the first in the semantic analysis of toilet wall writing, was begun in 1927 and printed privately in Paris in 1933. Just a few copies (for the information of the highly specialized collector) are now extant. Dr. Read, at present a professor at Columbia University, was only a youth when he made his trip to the Far West and Canada. I do feel he showed a precocious aptitude for his field, philology, in realizing that the lavatories of the West were gold mines of epigraphical nuggets worthy of scientific observation, and I concur with his statement concerning the peculiar province of his work: "A sociologist does not refuse to study certain criminals on the ground that they are too dastardly; surely, a student of language is even less warranted in refusing to study certain four-letter words because they are too 'nasty' or too 'dirty.'"

That statement was something of an inspiration for me. I had always read with detached amusement the writing on the variety of walls but now I saw them in a new light. I noticed one bit of dialogue

in a men's room: "I am 10½" long and 3" wide." Someone wrote underneath: "Interested. How big is your prick?"

Inherent in this serendipitous literature, I realized was a wonderful fount of folk humor. My first move in exploiting the newfound interest was to visit Dr. Read and write an article telling of his pioneer work. In the article, I included samples of graffiti I had started to collect. Then a friend enthusiastically recommended I go to an Italian restaurant he knew, not to eat, but to look at the men's room. He had been there to lunch and noticed some striking wall comments.

After that, I bought a large map of the city and determined to visit public bathrooms every day, section by section, day and night, going from the dingiest subway toilets to the posh places where you had to be lucky to get a quick read before the attendants cleaned the scribbled offal off. I abandoned most of my ordinary activities so that I could dedicate the major part of my time collecting what I felt were significant statements by the anonymous.

My eyesight had begun to give me much trouble, but I carried on. I bought a powerful flashlight for the night sojourns, and I became more maniacal in my pursuits, washing my hands countless times a day. When I had a date, the woman was forced to go with me from place to place, not to eat or drink or converse but to check on the ladies' room. I had to pursue several women at a time, for many would drop away after a few toilet safaris. When I had no women to take, I would stand in front of a ladies' room, wait until someone emerged, and ask her if there was anyone in there. If there was not, I would ask her to please play sentry and guard the door while I scanned the walls. If ladies so accosted seemed a little skeptical or wary of my intentions, I swept away their doubts by telling them I was working on a doctorate in scatology or that I was doing a thesis on feces. I feel safe in boasting that, outside of the cleaning and janitorial personnel who enter ladies' rooms at safe hours, I have invaded this no-man's land more than anyone else in history. My emotions were as Keats wrote in his poem, "On First Looking Into Chapman's Homer":

> Then I felt like some watcher of the skies
> When a new planet swims into his ken;
> Or like stout Cortez when with eagle eyes
> He star'd at the Pacific. . . .

When I had amassed enough inscriptions for a paperback book, I went to a publisher, a firm called Parallax, which means "an apparent change in . . . an object resulting from the change in direction or position from which it is viewed." To me, it sounded like the brand name of a laxative. Very fitting, I thought, for a book on toilet wall writing.

Even before publication of this book, I was acquiring the (perhaps dubious) reputation of being an expert on toilet wall writing. For one thing, I had placed several notices in the papers asking for suggestions of places to visit to find interesting graffiti. Then, Jake Brackman enlisted my aid for an article on wall writing he wrote for *The New York Times Magazine Section*. My name was not even mentioned in the article through no fault of Mr. Brackman's, who, I thought, wrote a very fine piece. Anyway, the article helped considerably in acquainting the public with the word graffiti and that didn't hurt my book, which was published a few months later.

I rather regret that some very clever fellow over in England beat me to the presses with a hardcover work entitled *Graffiti,* a strange potpourri of literary essays, poems, and various excerpts bearing obliquely or directly on the theme of wall writing. I am forever indebted to Richard Freeman, its author, for locating some jolly good stuff, especially the classic I love to quote: "You're never alone with schizophrenia."

My little paperback book *Graffiti, Selected Scrawls From Bathroom Walls,* published in 1967, won for me and my subject one of our country's highest accolades, an invitation to appear on the *Johnny Carson Show.* I confess I said very little about the serious nature of my studies. I felt I should play it for laughs. I was even guilty of being a traitor to my own cause, because when I was asked about ancient graffiti, I made some up on the spot: "Spartacus was a sissy," "Athena is a great necker," and, especially for the band, "Nero couldn't read music. He faked it." True graffiti can't be artificially manufactured. After a few more shows: Merv Griffin, David Susskind, Al Capp, and such people began to say to me in the street, "Read any good walls lately?"

My second paperback book was much easier to compile because the subject had so caught on that people were inundating me by letter

and telephone with things they had seen on walls. I was by now in communication with students and professionals doing articles and papers on graffiti, and the *Reader's Digest* included the word on their monthly vocabulary list. This second book was entitled *Great Wall Writing and Button Graffiti.*

Well, I may not have been the first to publish a book on graffiti, but I am the first ever to teach a college course about it, in the Department of Anthropology at the New School for Social Research in New York. My first class had only a modest ten students, nine young women and a Catholic priest. I figured the plurality of ladies was due to their curiosity about the writings in men's johns—men probably figured they had seen it all. The priest took the larger view that graffiti expressed current problems. He hoped the course would help him understand his parish better. I hope it did.

Each student had a project for the term, such as the examination of desk graffiti in schools, the comparison of the types of inscriptions produced by two diverse socioeconomic neighborhoods, graffiti produced in the hot spots of protest during times of conflict, etc. Our field trips took us to the fallow fields of the rest rooms in coffee houses and nightclubs. I owe much to my students in this and future classes, which were double in number. Their enthusiasm, as well as their critical attacks, have spurred me on to do this study.

Graffiti

Scratching Below The Surface

The writing of graffiti, perhaps because its practitioners are so elusive, is one human activity not given serious consideration or study by behavioral scientists—the historians, philosophers, sociologists, psychologists, psychiatrists, columnists. I consider this a grave oversight. Graffiti, too, are revelatory of developments, trends, and attitudes in man's history. Man is a natural communicator. A thought occurs to someone suddenly, or something is experienced during the day, and there is a compulsion to express it, if not to another person, then to whatever is close at hand: paper, wall, rock, tree, door. Graffiti, then, are little insights, little peepholes into the minds of individuals who are spokesmen not only for themselves but for others like them.

As such, some effort to analyze them is long overdue. Only in the past few years have any scholarly papers appeared. There have been a dozen or so magazine articles, and these have been mostly small collections of humorous examples of wall gleanings. Admittedly, millions of inscriptions have been obliterated by time and Tide. That's a pity. Very likely many were highly evocative and might have contributed much to our learning of what life was and is like for the common man. Most of recorded history is written, on the whole, from the standpoint of the ruling classes, be they nobles of former times who controlled their paid scribes, or the present-day Establishment which does the same thing in subtler fashion.

Writings on walls that have survived and come down to us may give us pause, when, dissatisfied with our world, we wish, like Miniver Cheevy, to go back in time. The prehistoric cave drawings in France disclose that the unpolluted atmosphere had other hazards way back then. France was not so sunny, harsh arctic winds blew over the land, and primitive and early man had to struggle unremittingly against an environment of hostile weather and beasts. (But poison air and hostile people, is that any better?) Early Roman times weren't entirely an improvement. One of their graffiti states: THE PHILOSOPHER AMNAEUS SENECA IS THE ONLY ROMAN WRITER TO CONDEMN THE BLOODY GAMES. (Pompeii, A.D. 79) (The exhibition fights of ancient Rome were not games in the fun sense. The loser almost always lost not only the game but his life. His dead body was dragged off with hooks to clear the arena for the next brutal act.)

The Middle Ages may have been romantic, what with knights in armor and all that, and early intellectualism may have bourgeoned in the arts and in literature. But graffiti as well as manuscript accounts indicate that neither man's physical condition nor his housing were very solid. A storm could wipe away a whole town, an epidemic wipe out a huge segment of population:

> The beginning of the plague was in 1350 minus one . . . wretched, fierce, violent. The dregs of the population live to tell the tale [the inscription goes on to note a terrible storm on St. Maurus's Day on January 5, 1361.] At the end of the [pestilence] a mighty wind. This year Maurus thunders in the heaven.
>
> Translated from the Latin. On a wall of Ashwell Church, Hertfordshire, England

Time marched on and with it the intercourse of nations and civilizations. By the eighteenth century wall inscriptions were bemoaning the fact that the price paid for sex too often included the cost of doctor bills to treat venereal disease:

> W——s, lay at the Angel in Marlborough Town,
> And an Angel lay with him all night:
> He tipp'd her an Angel before she lay down,
> Which you know was but decent and right.

But an Angel of Darkness she prov'd to be sure:
For scarce twenty Angels would pay for his cure.

> *From a window at the Angel (inn) in Marlborough, eighteenth century*

Bright is my Silvia, when she's drest;
 When naked, cloath'd with wond'rous Charms;
Her Main has oft my Heart opprest;
Her nakedness I have possest;
And by the last I am distrest,
 By the embraces of her Arms.
What can we Mortals say of Love?
Why? 'Tis the Pleasure of the Gods above:
But then if Cl-ps proceed from Love,
How hot are all the Gods and Goddesses above!
A fine Reward for Love for Love!
UNDERNEATH
Avoid the Thunder-Cl-ps, and After-Cl-ps, says Jove.

> *On a window at Oxon, Merton-College, eighteenth century*

Here did I lay my Celia down;
I got the pox and she got half a crown.

> *From a window in Chancery-Lane, 1719*

The intercourse of ideas seems to produce its own form of disease, too. At the turn of the century, in central Europe and especially in Germany, there were many wall messages with themes of racial prejudice, with Catholics and Jews as the frequent targets of vile and bitter abuse. To the astute observer of history in the making, these were harbingers of the future:

> *Die Juden sind die grossten Saue, drum schlagt sie tot nur ohne Reue.*
> Jews are the biggest pigs, therefore kill them without remorse.
> *Breslau, 1909*

> *Wo ein Pfaffenarsch tat blasen, riecht es gut katholischen Nasen.*
> Where the ass of a priest blows, there smell good Catholic noses.
> *Breslau, 1909*

Could we judge ourselves by our own era's inscriptions? Perhaps

not definitively. The majority of contemporary wall inscriptions are, I am forced to admit, quite banal. This may be a reflection of the banality of our lives, our education, and our ideas, our thoughts. Or it may demonstrate a lack of courage to say, or write, even in unwatched places, what we really feel or think. Physical surroundings, though, and location of available writing space are definite factors in the content of a graffito. As the graffiti writer gets more into the open areas where his chances of being seen are greater, there is a tendency for his message to be of a generalized nature, without too much pornographic emphasis. Inscriptions on advertisements and subway and outdoor walls are usually fairly topical, or if subjective, are declarations of love, although the latter may deviate from the old-fashioned concepts to declare that "Silas loves Cyrus" or "Jane digs Joan." In lavatories, or in any place where there is complete privacy, however, the messages, although still often banal, are much more visceral. And in subway stations, the extreme ends of the platform harbor the more virulent messages; the ferocity tapers off as one gets nearer the center or more populated car areas.

Despite the prevalence of the fruits of their efforts, writers of graffiti are seldom seen at their labors. So, if we ask what type of individual writes graffiti, the answer lies in the nature of the message, the place where it is written, and the spirit of the times.

I have sought possible explanations from psychiatry and psychoanalysis, because so many graffiti are sexual in nature. Several psychiatric authorities view the raw sexual message and obscene drawing as a kind of psychic masturbation which is sometimes followed by physical masturbation. They see it as a form of exhibitionism. The "ordinary" run-of-the-mill exhibitionist is driven by some unrelenting anxiety to expose his own sexual organs in public in order to relieve that anxiety. The sexually hung-up graffitist is a once-removed exhibitionist who may draw or describe genitals, possibly his own, usually in an exaggerated manner. Some of the sexual messages, it has been surmised, may be the work of men who are afraid to have sex and have severe problems in this area. Sex messages in ladies' rooms have been found, in some cases, to have been done by janitors or custodians. This could be considered, I imagine, a kind of fantasy rape.

A large group of wall writers would appear to be iconoclasts, doubting Thomases, and very untrusting. Their general bitterness is reflected in the nature of their humor as scribbled or scratched on the wall. In early England, we find among the graffiti preserved for us, much indication of a constant disillusionment with women. They all turn out to be whores, they are untrustworthy in marriage, etc. As we examine modern graffiti, of which so much more is available to us, we will note that cynicism is evinced in more and broader areas. *All* people are no damn good, is the general feeling, horse races are fixed, politicians are crooks, motherhood is a dirty word, cops are corrupt, machines cannot replace human stupidity, and nostalgia isn't what it used to be.

For all that what wall writers write is often very funny, very few of their inscriptions accentuate the positive or eliminate the negative. After many years of collecting and studying their expressions, I must say I have found that wall writers are rarely cheerful cherubs. Life for this group of cynics seems to be a shedding of various beliefs without taking on any new credos to replace those discarded. "We hate all people, regardless of race, creed, or color" sums it up.

Freud has written a great deal about wit and humor, and some of his observations offer a glimmer into the other *raisons d'être* for wall writing. He has stated that humor is the most mature way man offsets pain. As such, it is allied with the refusal to be frustrated by stress or tough situations. Rightside up, a situation can be sad; turned upside down, it can be laughed at, as did the scribblers of the following:

Reality is a crutch.

**It's not the work that gets me down,
it's the coffee breaks.**

Freud theorized that hostile wit is correlated with the turning outward of aggression. The person who feels helpless against or frustrated by such powers as his government, his boss, his wife (or in the case of a woman, her husband—I bear no malice toward Women's Lib), or an oppressive moral code, and considers himself (or herself) in no position or condition to tilt against these windmills

for fear of being crushed, rather than bottle the aggression and get an ulcer, turns to wall writing instead of open attack:

> **The difference between this firm and a cactus plant is that the plant has pricks on the outside.**

Another of Freud's observations is that the ability to produce and appreciate wit is highly related. This certainly applies to the bright type of wall writer who appreciates witty graffiti enough to add his own quick comeback:

> **Shakespeare eats Bacon.**
> REPLY IN ANOTHER HANDWRITING
> **It can't be Donne.**

> **The family that lays together stays together.**
> SOMEONE ELSE'S CONTRIBUTION
> **The family that shoots together loots together.**
> A THIRD VOICE HEARD FROM
> **The family that kicks together, sticks together.**

Very likely, one of the major reasons for writing on a wall may be nothing more grandiose than just sheer boredom, particularly in a privy. Sitting there, with nothing to read, the occupant may find in the bare wall a challenge to create busy work for the eyes. It may also be that these blank surroundings offer so little sensory stimulation they make the person more aware of his internal conflicts and more conscious of sensual feelings in rectal and urinary tracts, and he writes thereof or of something more or less related.

It isn't necessary to look for esoteric reasons why inmates write on sanitorium walls or prison concrete. Their graffiti may be symbolic ways of getting out. On the opposite side of the coin is an interesting story of one graffitist who felt he belonged behind those restraining walls and was in fact trying to climb back inside them. There is a documented account of how the writer of one persistent message scrawled in almost every West Side subway station in New York, on stairway risers, the walls, and steel columns, was tracked down. SUPPORT MENTAL HEALTH, his graffito exhorted over and over again.

He turned out to be a man who had been institutionalized for schizophrenia and released as cured. But, pathetically, he felt himself slipping, and riding the subways and scrawling through the night was his way of crying for help.

Subsequent scrawlers of waggish turn of mind took off from his plea and wrote: SUPPORT MENTAL HEALTH OR I'LL KILL YOU.

The wall wags had some macabre fun with another well-publicized graffito some years back. In 1946 the country was shocked by a series of three particularly brutal slayings. The victims were all female. The confessed murderer turned out to be a pleasant-looking young man named William Heirens. Although he felt himself to be someone else while committing these atrocities, he was aware of what he was doing. Unable to check his demented compulsions, he wanted to get caught and die for his crimes, and he made this clear by scrawling in bright red lipstick on the bedroom wall of one of his victims:

For heaven's sake, catch me
before I kill more
I cannot control myself.

He was given ninety-nine years. Long after the case, one could see echoes of it in wall writings such as STOP ME BEFORE I FUCK MORE or I AM A FUCKER, I CANNOT HELP MYSELF.

Just as it is probably not possible to definitively categorize or make specific statements about who writes or draws what graffiti, so would it be equally difficult to make any in-depth study of just how much attention is paid to bold inscriptions by the various classes of people who are exposed to them. There are, I am sure, a good number who consciously avert their glances—one may assume that theirs is a narrow, well-mannered existence and their genteel pretensions are ruffled by a starkly calligraphic WILHEMINA (or WILLIAM) SUCKS. To others, those who sometimes question the circumstances and responsibilities that have made their lives a dull routine, the crudities that their eye falls upon may give something of a lift. They are reminders that the daily grind of competitions in life are not really all that serious. It pulls them back to life's fundamentals—and

there is hardly anything as fundamental as what is implied in the above quotations.

One could presume that graffitists can, in spite of their faceless-ness, be slotted into type categories. I tend not to feel that way. There is one type, however, that does seem to prevail, and it may be that it isn't a type at all, but an activity that most of us indulge in at one time or another. That is gossip. The gossip columnists of the world of wall writing are scrawlers who can get pretty vicious and try to wield their anonymous power by saying something slanderous about people in high positions. To wit:

Mayor Wagner is a lesbian. [Note: Written by those who thought him weak in office.]

Lindsay is a closet queen.
> *Property Clerk Storage Pier, New York City*

J. Edgar Hoover sleeps with a night light.
> *Horn and Hardart Automat, New York City. Also a button message*

Strom Thurman [sic] **sniffs drainpipes.**
> *Men's room, Rutgers University, Newark Campus, New Jersey, 1969*

Oddly enough, the victims of wall gossips are frequently not real people but are instead beloved cartoon characters, mythological heroes, or famous fairy tale folk. Such graffiti can be pretty amusing, really, when they try to shatter our illusions about Cinderella (she married for money) or Mickey Mouse (he's a homosexual and never cared for Minnie). (The counterpart of this reverence-shattering attitude in the publishing world was the "little hot book," a 3″ by 5″ book of pornographic cartoons showing Popeye, Winnie Winkle, or Dick Tracy enjoying the wildest sexual adventures. This was a part of their lives our standard daily newspapers gave us no hint of!)

Curiously, the enormously appealing Charlie Brown and Snoopy have been exempt from wall gossip. The graffitists seem to prefer to snitch about the vintage cartoon characters. Could be that Charlie

and Snoopy, because of their succinctness of style in both drawing and blurb, are already too close to graffiti in their terse insightfulness. Or maybe it takes a really down-deep mean graffitist to attack these two lovable underdogs.

This very large category, and the bulk of graffiti is wall gossip, contains a lot of the so-and-so loves so-and-so messages. Those presented here are not the sweet, simple and utterly boring ones that so often deface perfectly nice trees, rocks, benches, telephone poles, kiosks, etc.; they are ones I have preserved for their wry intellectualism or historic interest.

Batman loves Robin.

Homosexual bar in San Francisco and on a button

Little Orphan Annie puts out, but she's a lousy lay.

Zeus loves Ganymede.

Lion's Head, New York City

Leda loves swans.

Electra loves daddy.

Ladies' room, Ninth Circle Restaurant, New York City

Ludicrous, preposterous, and irreverent as wall gossip mongers are, the reader, as he laughs, will still feel some shock at the malicious fantasies about these paper figures from his childhood, for at one time we really believed that Porky Pig and Little Jack Horner existed and we loved the innocence and purity of their absurd antics.

Although none of these graffiti are factually true, of course, there is in many of them shrewd psychological perception, demonstrated by a strain of black humor. Sometimes a single griffito examined in light of where it was found will reveal, on second thought and some analysis, more than a single layer of meaning. That is graffiti almost at its very best: a scratching below the surface of things. My favorite of these is PINOCCHIO IS A SWINGER, which I found in a discotheque. This tells us that the swingers are mere puppets.

They go through the jerky movements of the dance (of life), wooden dummies, unfeeling, manipulated by a society that proscribes genuine individualism.

The writing of graffiti is gaining more recognition as a legitimate means of communication than it ever has before. Sweden has set up an official wall in Stockholm, and a man is paid to paint it every day to ready it for the day's passing commentators—which may not be such a good thing after all because who knows what beautiful sentiments or worthy observations may be obliterated? These were noted before they were painted over: KOSYGIN GO HOME; GIVE ELEVEN YEAR OLD GIRLS THE PILL. Many universities, in an attempt to drain off student hostilities and, at the same time, show a measure of leniency toward those animosities, have put blackboards and chalk in the bathrooms, and in quite a few instances have provided public wall space for student comment.

Such recognition is, however, a minority trend. Management is, in the main, often quite mean in its attitude toward wall writing. One can understand a severe stance when it comes to the elevator gouger or to the property damager, but it does seem unduly harsh to post notices prohibiting writing on temporary walls such as construction fences and lose the likes of: ON THIS SITE A BLOCK-LONG ERECTION WILL ARISE. They are coming down, anyway, so why the fuss? Some are so ugly, almost anything would enhance them, and others so blank, they just cry out for embellishment, however limited the life span.

The battle waged between writer and management in the lavatories of many commercial establishments is fascinating. Where there are ink-resisting tile walls, messages are written on the receptive cement filler between the tiles. Other places paint their walls black. But underneath is white plaster, exposable by the graphic power of a knife point. Some have tried a drip paint effect. The same knife works there.

Some coffee houses, restaurants, and bars, however, know the publicity and promotional value of interesting walls, and the reputations of these places are enhanced by underground tip-offs (deliberate, maybe?) that there are amusing comments in the rest rooms.

Some owners have been known to go so far as to write their own graffiti. The in-between approach is where the establishment provides its own pictures or murals to amuse and deflect the patron from contributing any ideas of his own. Such pictorial efforts, however, often invite graphic comment in the form of "improvement" by the graffitist who will not be daunted.

There have been several instances where subway poster ads actually have deliberately been designed to accommodate the graffitist, and the public has been invited to write right on the advertisement. At least one beer company and one pen manufacturer must have made some special arrangement with the New York City Transit Authority for this, because it is usually a misdemeanor to write on subway cards or ads.

On occasion, the real humor is not in the inscription but in the bizarrely magnified Pyrrhic conflict engendered. I like to recall one such story in particular:

A daring miscreant was repeatedly covering the walls of the men's room on the ninth floor of the American Telephone and Telegraph building at 32 Avenue of the Americas in New York with all kinds of messages and drawings. The company posted guards but they failed to nab the fellow, so a camera was secretly installed in the air-conditioning duct. The camera clicked every seven seconds, yet a run of its strips revealed that it had recorded just the usual variety of eliminations and cigarette goof-offs.

The clicking, however, caught the attention of several employees, and one of them snipped the camera wires. The union representing the employees stepped in and protested what it considered an "invasion of privacy" and a "lack of ethics." *The New York Times* of September 25 and 26, 1963, carried the headlines:

UNION PROTESTS HIDDEN CAMERA
CLUE TO WASHROOM VANDAL SOUGHT BY AT&T
PHONE STRIKE VOTED IF CAMERA RETURNS
TO MEN'S WASHROOM.

The company's position was that the scrawl was likely the work

of a perverted mind and they had hoped to catch the culprit by means of the camera. They were sure he was going to return to finish a huge drawing he apparently had not had time to complete. After one day of negotiation, it was deemed wiser to let the vandal escape detection rather than have an employee walkout.

To me, the serious aspect of this incident is that the walls of that bathroom were washed. Who knows what striking flights of that persistent fancy of tedium-dispelling, graphic messages to bored workers have been lost to the social researcher!

I am not the first collector to regret such vandalism masquerading as cleanliness. Positive thinking in the realm of graffiti was expressed early in the eighteenth century. A man with the jolly name of Hurlo Thrumbo requested that people gather the fugitive writings on glasses, toilets, windows, signs, etc., and send them to him. He put them together in a four-part collection entitled, *The Merry Thought.*

In his introduction, Mr. Thrumbo refers to the dangers that befall wall writings: "Consider only, Gentlemen and Ladies, how many accidents might rob us of these sparkling pieces, if the industrious care of the collector had not taken this way of preserving them to posterity . . . some careless drawer breaks the drinking glasses inscribed to the beauties of our age; a furious mob at election breaks the windows of a contrary party; and a cleanly landlord must have, forsooth, his rooms new painted . . . every now and then."

He goes on to thank his contributors for inscriptions gathered before the Christmas holiday. He considers that a particularly hazardous time because "who know, but many . . . pieces might have been lost, by the effects of wine, punch, and strong beer . . . sticking the windows with holly and ivy . . . we run . . . [the hazard of] having many curious pieces destroyed and buried in oblivion. And then the cleaning of the windows against the holidays might have endangered the loss of many of these brittle leaves of wit and learning."

The positive attitude toward wall writing in our time is proclaimed on my own favorite button, PRESERVE GRAFFITI. But the great majority opinion is one of contempt. And it is that contempt that makes the producers of industrial wall cleaners rich.

Although graffiti are generally highly localized in exhibition, and, as indicated, victims of temporaneity, a few have so caught on in form and concept as to have become internationally known and seen. The most famous and ubiquitous of these was Kilroy. His leering eyes, big paper clip of a nose, and impish boast KILROY WAS HERE materialized during World War II and he lived on for many years after. It has been conjectured that Kilroy was really a sore-footed infantry sergeant who got tired of hearing the Air Force brag of its prowess with the impossible. He was especially p.o.'d about the Air Transport Command. When the A.T.C. hastened to some farflung, hazardous part of the globe to set up a new base, they found the bold announcement that Kilroy had got there first. On Kwajalein Atoll in the Marshall Islands, some pilots tried to beat him to the punch, but they failed. The pilots put up a sign which read:

NO GRASS ATOLL, NO TREES ATOLL, NO WATER ATOLL.
NO WOMEN ATOLL, NO LIQUOR ATOLL, NO FUN ATOLL,

and they capped it off by adding at the end:

AND NO KILROY ATOLL.

The paint was scarcely dry when they looked again—and there, just below the last statement, they read:

I JUST DIDN'T PAUSE ATOLL: KILROY

It was not so much what this graffito said, it was where it turned up that made it so outrageous. An atomic bomb was to be tested on a Bikini atoll. The battleship *New Yorker* was towed into the target area, checked by the crew, and then abandoned. The next day, the bomb was dropped. After a few days, when Admiral Blandy and his men, encased in safety clothes and armed with Geiger counters and safety devices, approached to examine the ship, they found in bold letters on the port side that KILROY WAS HERE.

The message turned up in some very weird places—on the very

top of the torch of the Statue of Liberty, on the bullet-scarred base of the Marco Polo Bridge in China, under the Arc de Triomphe, and workmen even found it on the topmost part of the George Washington Bridge. Its later appearance was not always of GI origin. Soldiers reported seeing small Polynesian and Melanesian children spelling it out with coral beads. It was scrawled across a picture of a pregnant woman, appeared in chalk on the back of a coat on a totally unaware woman strolling down Michigan Boulevard in Chicago, and was written on the packing cases of three wild elephants sent to the United States by the Belgian Government.

I myself am very impressed by what I consider to be one of Kilroy's most daring appearances, which occurred during the meeting of the Big Three in Potsdam, Germany, in July, 1945. As may or may not be fitting, the higher the rank, the more opulent the bathroom and, for VIPs Attlee, Truman, and Stalin there was a sumptuous marble showplace, available for them exclusively. On the second day, Generalissimo Stalin emerged in a state of excitement and spluttered something in Russian to one of his aides. It was overheard by a translator, who later revealed that Stalin had asked, "Who is Kilroy?"

And he might also have asked why this particular message, and at this particular time. I offer you the hypothesis presented by Richard Sterma in *American Imago*, vol. 5, 1948:

> . . . cut the name in two and it is he . . . who killed the king (killroi) . . . we find ourselves in . . . psychoanalytic territory . . . king and father are identical, and . . . Kilroy is a recent edition of the hero of our oldest legends . . . the revival of the most daring member of the brother hordes who killed the original father . . . idealized . . . as the great hero of all times. . . . And with surprise we become aware of the intensity of . . . archaic patricidal strivings in ourselves . . . expressed . . . in . . . a legend so powerful that it sweeps the whole nation and its extensions over the entire globe . . . symbols . . . make the legend clear in its emotional significance. . . . The Kilroy legend started during the war, under emotional conditions . . . well known to us from other war myths. . . . [I]n the unconscious the enemy in war is identical with the father . . . as the little boy experiences him emotionally in the Oedipus phase of his libido developments. The country or . . . territory . . . in the enemy's

legends copied onto walls. When the button madness was full upon us in 1966–68, it was impossible to determine which inspired which, button wall or wall button.

The equivalent of wearing your heart on your sleeve is to wear a button in your lapel. It tells the world where you're at, what your opinions are, and what an uninhibited individual you are—*i.e.*, GO NAKED or REPEAL INHIBITION. It is not uncommon to see very meek-looking young men wearing buttons that exhort free love, drug-taking, perversion, and prostitution. Someone may sport one saying LET'S FUG. This is not a misspelling but refers to admiration for a singing group. If worn by an older person, it may refer to fornication, once called a fug.

The anonymous writers of graffiti are, it seems to me, generally repressed people; their inscriptions are, *ipso facto*, wish fulfillment and fantasy. The button buyers bring these wishes into the open by publicly displaying them, but they too may be repressed. Actually, button buyers fall into many categories. Some may be strong-minded extroverts, some may flash the button only occasionally and only in sympathetic company, or buy the buttons only to hide them in drawers. Some stick them on the office bulletin board. Others mail them to friends in lieu of greeting cards.

People have worn buttons for generations, but until recently such buttons were, in the main, limited to political signia proclaiming one's party affiliation or support. Few were of such deviant persuasion that it required any particularly radical pretensions, subconscious or otherwise, to flaunt them. From time to time, as in the early thirties, a daring sharpie might sport one to match his glow-in-the-dark tie and the button may have said: I COULD JAZZ ALL NIGHT, or, I'M LOOKING FOR A THRILL, or, TEASE MY BILLY AND I'LL TEASE YOUR NANNY, or, CHICKEN INSPECTOR.

Today, there are quite a few new politically pregnant, if not actually party-affiliated, categories thematized on buttons—narcotics, atheism, abortion, and prostitution (LEGALIZE POT, PILLS PLEASE, BAN THE BIBLE). As with wall writings, buttons favoring liberal sentiments in any given category, outnumber the conservatives by a wide margin. Both sides are manufactured, but not in equal proportion. The Vietnam conflict produced many antiwar messages, but just a

posession is . . . the mother, whom the little boy wants to . . . possess . . . after having done away with the father-enemy. The Kilroy legend confirms the symbolic significance of the (possessing) enemy as the Oedipal father. . . . Kilroy's inscription is found on the most inaccessible place, e.g., the top of the mountain . . . the jungle . . . desert . . . on walls in a village which . . . withstood capture. It is this inaccessibility of a place which gives it mother significance . . . in the emotionally frustrating situation of the little boy in the Oedipal phase. Kilroy's presence in all inaccessible places is the expression of a grandiose fulfillment of our Oedipal wishes.

I don't pass judgment on this interpretation. You can take it or just let it hang there.

There was a Canadian counterpart to Kilroy, a mythical Clem. His name was inscribed in every unlikely place in the army camps. At one command post, it drove the officer in charge to a point of extreme irritation. One morning he called out every single man in the camp to assemble, averred in strong language that the inscription must cease, dismissed them, and returned to his office—to find "Wot! No Clem?" inscribed on his desk.

A pre-Kilroy incident is told by Walter Sullivan in his book *Quest For a Continent*. When Commander Richard E. Byrd and his company went to explore Antarctica for the second time in 1933, they found in one of the camp buildings the inscription of the name of one of the young newcomers to their group. It was Finn Ronne, and it had been inscribed there by his father, Martin, the Norwegian sailmaker who had accompanied Amundsen and Byrd to the Bay of Whales.

Researchers, Harvey Lomas and Gershon Weltman of *Newsweek,* scoured the Los Angeles area two years ago and found the legendary Kilroy reincarnated in a mysterious character named Overby. Usually, Overby graffiti announce little more than OVERBY LIVES or OVERBY RULES, or as a sign off the Pacific Coast Highway put it, OVERBY HAS A HESKINNY IN HIS FREBUS. At times, however, Overby seems to be the biter of the unknown hand that picks young grafficionados for the Army. In Los Angeles, one road sign reads, DOWN WITH THE DRAFT— OVERBY STRIKES EVERY 7 HOURS.

Kilroy, incidentally, may be the only graffito to whom a poem was dedicated, tracing in verse the Freudian history suggested by Sterma.

KILROY*

By Peter Viereck

1.

Also Ulysses once—that other war.
(Is it because we find his scrawl
Today on every privy door
That we forget his ancient role?)
Also was there—he did it for wages—
When a Cathay-drunk Genoese set sail.
Whenever "longen folk to goon on pilgrimages,"
Kilroy is there;
 he tells The Miller's Tale.

2.

At times he seems a paranoic king
Who stamps his crest on walls and says, "My own!"
But in the end he fades like a lost tune,
Tossed here and there, whom all the breezes sing.
"Kilroy was here"; these words sound wanly gay,
 Haughty yet tired with long marching.
He is Orestes—guilty of what crime?—
 For whom the Furies still are searching;
 When they arrive, they find their prey
(Leaving his name to mock them) went away.
Sometimes he does not flee from them in time:
"Kilroy was—"
 (with his blood a dying man
 Wrote half the phrase out in Bataan.)

* *Terror and Decorum,* 1948. Reprinted in *New and Selected Poems,* Bobbs-Merrill, 1967.

3.

Kilroy, beware. "HOME" is the final trap
That lurks for you in many a wily shape:
In pipe-and-slippers plus a Loyal Hound
 Or fooling around, just fooling around.
Kind to the old (their warm Penelope)
But fierce to boys,
 thus "home" becomes that sea,
Horribly disguised, where you were always drowned—
 (How could suburban Crete condone
The yarns you would have V-mailed from the sun?)—
And folksy fishes sip Icarian tea.
One stab of hopeless wings imprinted your
 Exultant Kilroy-signature
Upon sheer sky for all the world to stare:
 "I was there! I was there! I was there!"

4.

God is like Kilroy; He, too, sees it all;
That's how He knows of every sparrow's fall;
That's why we prayed each time the tightrope cracked
On which our loveliest clowns contrived their act.
The G.I. Faustus who was
 everywhere
Strolled home again. "What was it like outside?"
Asked Can't, with his good neighbors Ought and But
And pale Perhaps and grave-eyed Better Not;
For "Kilroy" means: the world is very wide.
 He was there, he was there, he was there!
And in the suburbs Can't sat down and cried.

Any overview of the why, what, and who of graffiti must include comment on a commercial but nonetheless, I feel, honest extension of the graffiti concept as it is conceived today. And that's the button. Buttons, those dollar-sized, plastic-protected stickpin legends, have become so universal that one can almost say "Button, button, just who doesn't have a button?" I refer to them as "walking graffiti."

Most of the sayings inscribed on buttons in recent years were originally from walls, but I frequently found, after a while, button

few of the BOMB HANOI and BOMB SAIGON variety. This may be a testament to the bravery of radicals rather than their preponderance. The silent majority doesn't appear to be given to much overt demonstration and seems satisfied—or perhaps so sure as to feel the need for nothing more—with the discreet lapel display of a tiny American flag done in enamel, or a modest decal stuck on its car windows.

Even though there is extant one button bravely proclaiming ALIENATION CAN BE FUN to ward off those who support encounter movements, most buttons can and often do serve as come-hither signals. They invite comment and debate and, as such, are a means of getting acquainted. I, for one, feel you have the right to stop anyone wearing a button and ask about it. He or she will almost always respond in a friendly way, since a basic purpose of the button is to draw attention to the wearer as well as to his point of view. Many times, the legend is quite obscure, almost deliberately so, and naturally you have to ask what it means. For example, TAO CHU KWANG. Intriguing, isn't it? He's the soldier who killed John Birch. If you don't know, make a new friend today by asking the button wearer.

I asked one young lady what GIVE THE GRASS A CHANCE on her button meant. She said she was not sure but that it probably meant not to cut the grass or that we should have more green areas. I loved her naïveté, but felt I should inform her, ever so gently, that since grass is a slang term for marijuana, it more likely was offering the suggestion to try pot. She was shocked, for truly she knew not what she wore. But we remain friends to this day.

Quite a few buttons, such as the one just mentioned, do have double interpretations—the literal one to disarm the naïve, and the secondary which is a figure of speech or colloquialism whose totally different meaning is quite clear to the cognoscente. HAPPINESS IS A WARM PUSSY is a fine example. Who doesn't like kittens and other pleasantly furry things?

A great deal of button-wearing is not necessarily for espousal of a cause but merely because it is the "in" thing. We are a nation willing to buy anything that we are told is "hip"—hula hoops, mini skirts, maxi coats, pop posters, sick greeting cards, nonfunny nonbooks, sex novels that would bore the Marquis de Sade into celibacy.

Every man wants to be a comic, and when a person buys a funny

button, it's as if *he* had made up the saying. It's his discovery, despite the fact that the item is selling in the tens of thousands.

There is no doubt that motives are often mixed when buttons on certain subjects are worn. The pro-drug culture, despite warnings of their lethal dangers, seems well represented on buttons such as HEAD POWER and VIVA SATIVA, but this may be youthful defiance rather than true belief.

Sex, of course, is as much a subject for the buttons as it is for wall writings, and the campaign for more and freer love and/or sex has produced some titillating buttons: LEGALIZE NECROPHILIA, SEX BEFORE FINALS. Buttons not only advocate free love but the pay-as-you-come variety: SUPPORT FREE ENTERPRISE—LEGALIZE PROSTITUTION. To be really eye-catchingly effective, the buttons must concern themselves with nonconformist causes, and there aren't too many of those any more in the realm of sex. Still, MORE DEVIATION LESS POPULATION, EQUALITY FOR HOMOSEXUALS does open up new possibilities of ecological advantages not hitherto seen in this area.

If most of the buttons are anti-establishment (LET THE STATE DISINTEGRATE), then it naturally follows that the guardians of that structure must be attacked: WARNING:—YOUR LOCAL POLICE ARE ARMED AND DANGEROUS. The cynicism toward religion is neatly encapsulated: KILL A COMMIE FOR CHRIST. And to assuage any feelings of neglect suffered by psychiatrists, there are buttons that proclaim: PSYCHIATRY, THE NEW INQUISITION.

(The obvious offshoots of the button are bumper stickers for your car, proclaiming similar statements, but their usage is not really so extensive as to warrant discussion.)

I must point out that while the button itself, whether humorous, vicious, or daring, falls roughly into one of the three major subject categories—politics, sex, and drugs—the button wearer falls really only into one, the person who wants to draw attention to himself.

Such need for attention in certain individuals is tragically demonstrated by the macabre story in June of 1970 of the Zodiac killer who claimed to have killed ten people. He sent notes to the newspapers threatening to blow up a school bus unless a bizarre demand of his was acceded to. He wrote:

If you don't want me to have this blast, you must do two things. Tell everyone about the bus bomb with all the details. I would like to see some nice zodiac buttons wandering about town. Everyone else has these buttons like [and he drew a peace symbol] black power, melvin eats bluber. Well, it would cheer me up considerably if I saw a lot of people wearing my button. Please, no nasty one like melvin's. . . . Thank you.

As a suggestion, perhaps, for the design for his button he affixed his own signature symbol, a cross and a circle. The "melvin eats bluber" bit seems to indicate the confusion in his mind. There is a button MELVILLE EATS BLUBBER. The killer was probably thinking of attorney Melvin Belli to whom he had sent a Christmas card pleading, "Please help me. I cannot remain in control much longer."

Before turning away from this general spectrum of what graffiti is today, I would like to mention one more category of graffiti, and that is false graffiti.

There should be a button which reads KEEP AMERICA BEAUTIFUL—STAMP OUT PSEUDO-GRAFFITI, because there is a great deal of writing on walls which should not be there, and cannot be called graffiti in the pure sense of the word. These inscriptions are, ordinarily, one-line gags or jokes of low-level stuff of dubious origin. In recent years, graffiti have found their way into television, paperbacks, newspaper magazines, Ajax ads, a restaurant name, and a perfume name, and now all the frustrated comedians of the world keep rewriting the lines they have heard or seen in these sources. In fact, many of the scrawls one sees these days are merely traditional jests whose origins are from the vocal currency—radio, TV, living room or cocktail party exchange. Consider: DO MOUNTAIN MEN KEEP MOUNTIN' WOMEN? and IS GRAPE-NUTS A VENEREAL DISEASE?

After you have seen a great deal of graffiti, you almost instinctively know which are genuine and which are phonies and, therefore, mere defacings of a good surface. The true graffito has style, a surrealistic, imaginative quality, a spontaneity you can feel even though

the topic itself may now be stale. You can almost sense the feelings of the writer, even though you may not agree with his sentiment. The production of low-level graffiti can be reduced to a simple formula. Take a famous individual, determine his most well-known characteristic, and then attribute the opposite to him. Example: HERCULES WAS A WEAKLING.

Poor punning is another ingredient of the childish, immature graffiti one sees around. Puns in the hands of the skilled, I would be the first to admit, can be a very high form of wit and some of the very best graffiti are made up of the sudden twist of meaning or contradiction in terms. The difference in quality lies, of course, in its imaginativeness. Their authors need not be ashamed of ABSINTHE MAKES THE HEART GROW FONDER and HOW ARE YOU GOING TO KEEP THEM DOWN ON THE FARM AFTER THEY'VE SEEN PARITY?

In this category should be included too, I think, what is on the whole the massive bulk of graffiti—names, often just first names, scratched or gouged around there and there. Even though this kind of thing is a minor striving for individuality, a tiny record to show that this person is not as anonymous as the crowds around make him feel, it is not often that the ego is strong enough to include the last name. Sometimes, in fact, the ego is so self-effacing that the writer merely states, "I was here."

The following are examples of the kind of thing I protest. They contain a trifling of humor but I am almost certain they are not the work of an original graffitist's talents:

> The difference between "stick-up" and "hold-up" is age.
>
> Some guys like tall girls, but I go for little lasses.
>
> Thanks, I enjoyed every inch of it.
> *Attributed to Mae West*
>
> I believe in capital punishment, but I don't think women should be hung like men.

Now to the genesis and history of graffiti.

The Galaxy Before Gutenberg

"What is graffiti?" I asked one of my students. "Anonymous Lenny Bruce with a balls-point pen" was his elegant answer. The more usual reply, "Dirty words on clean walls."

If I suggest that graffiti has a history as ancient and honorable as, and inseparable from, that of writing and art I may be accused of over-drawing history. But the antiquity of graffiti, however vulgar its subsequent commonality, cannot be denied. It began almost when man did, when he was the Paleolithic *Homo sapiens*, living in a cave. My theory is it had its start when some inarticulate, hairy-pawed early man picked up a rough rock to crack a nut resting on a larger rock; maybe he missed his target, and the force of his blow produced a big scratch, or several scratches. This intrigued him and appealed, I like to think, to his artistic sensibilities, and he banged away happily for a few minutes, producing random designs pleasing to him.

My fantasy is probably not too far-fetched at all. There is plenty of indication that man has been trying to put it, if not in writing, then certainly in drawing since prehistoric days. To judge by available evidence, he was almost from his very beginnings a doodler and, therefore, a graffitist. (Which may also indicate how hoary is his un-conscious, how old his need to express the inchoate musings of his evolving intelligence.)

It would not be germane, for the purposes of this book, to go into any detailed summary of the Paleolithic age, when *Homo sapiens* appeared. The Stone Age lasted 980,000 years, which is a lot of pre-

historical territory. Suffice it to say that it is because there are graffiti dating that far back that we know that there was purposeful speech and rudimentary social living.

These early graffiti, ranging in form and style all the way from simplistic scratchings and trailings of wet clay to beautiful impressionistic and realistic drawings, are to be found on the walls of Paleolithic-age caves scattered throughout Europe. The graphic arts probably began with doodling. The first such doodles were made by the Aurignancians, the bone and stone toolmakers who decorated their caves in the Pyrenees of southern France by dipping their hands into the wet clay around them, much as if it were finger paint, and smearing it in wavery trails across the rough walls. Others, in other caves, added embellishments and decorative touches to such "macaronis."

They also made hand prints, which they emphasized by outlining the fingers with colors made from elementary materials right at hand (so to speak)—red ochre and white chalk, manganese ore mixed with charcoal (for a strong black), and blood and albumen (for the fixative strength that has insured their survival until now). (I was saddened to read recently that many of these caves are now closed to all but the most serious of scholars. The pollution given off by human breath is too lethal. Their durability seems to have been due more to their isolation from human curiosity than the permanency of their paints.) I take these hand prints as primeval evidence of man's drive to leave his impress upon the universe, which continues in the contemporary conceit of movie stars' leaving their hand prints in the cement in front of Grauman's Chinese Theatre in Hollywood.

One of the most recently discovered as well as most famous of these caves is the Lascaux cave in France, found by two boys in search of their dog who had disappeared down a hole. On its time-protected walls are amazing depictions of bison and deer and even a unicorn. Equally famous is the cave of Altmira, Spain, whose beautiful and widely reproduced drawings indicate how far back they were fighting (if not throwing—forgive me) the bull. There are other famous caves—Les Combarelles, Font de Gaume, Niaux, Les Trois Frères, Gargas, etc., scattered throughout Europe in the Dordogne

region of France, the Pyrenees, and southern Italy, whose naturalistic often impressionistic drawings are viable just as works of art. But they also help us discern through the back reaches of time darkly something of what life was like twenty thousand years ago.

There are several theories as to why primitive man drew all those beautiful pictures in such hidden, not easily reached recesses as these caves. Well, early man was a serious fellow, it seems, and these paintings were not fun and games or occupational therapy. They were, it is the opinion of many scholars and students, a form of hunting magic. The closer man could come to making his drawings duplicates of the real thing, the more powerful his control over them, and the more successful he would be in his hunting. He sought to catch the woolly mammoth, the antlered reindeer, and the rugged small horse in paint so that he might more easily catch them in the flesh. (There may be some element of such wishful thinking *au fond* the exaggerated depictions of the body's prime sexual parts on the walls of secluded privies.)

I do wonder, though. Might he not also have chosen the walls of caves to protect those pictures because he was, at heart, a graffitist with the needs of the graffitist to immortalize himself? And that, as such, he also wanted to communicate, to tell his story? That he was determined to tell what had happened or what he wished would happen to him during the day?

It turns out that we can't escape the possibility that even those ancient eons ago, sex was on the scene, if not as explicitly as it is today, then implicitly. Bruno Bettelheim, in his book *Symbolic Wounds*, theorizes of the cave man:

> They painted in long, deep recesses, narrow, slippery corridors. All this suggests to me what an effort was made to reproduce the setting in which procreation takes place. If so, the crawling through narrow, wet channels might have represented, on entering, the process of birth . . . symbolically reenacted. Their paintings, therefore, were executed at places where animals come into existence. It is possible . . . early man created . . . the painted animal in a place which represented the womb, so that the real animal might be induced to do likewise.

We shall, at this point, have to reduce all this speculation to fit on the head of a tack and say that the simple graffiti of earliest cave men matured into near realism. In the later art of Neolithic man, such graffiti became more abstract, a shorthand method of drawing, using symbolic and spiritual essence rather than realism or naturalistic detail. Man is now taking the first steps toward writing. By cutting out detail, schematizing figures, he creates a shorthand. Using a few lines, he has created symbols that are, in a sense, an alphabet of animals, men, and objects.

The conventionalized symbols are called, generically, pictographs; when painted or drawn on rocks, they get the more specialized cognomen petroglyphs (a shade too imposing a word, however, to be applied to the kind of thing one finds on rock substitutes these days). These story-telling pictures, descended to us in that delightful childhood game, the rebus, were the basis of the written language of many succeeding and varied civilizations. Thus, with his graffiti on the rocks, man begat the word we today call media. Shall we not accord to him some of the responsibility McLuhan has put upon poor Gutenberg?

The development of man in the two million years before he made his first graffito was slower than a snail's waltz compared to the speed with which he progressed once he grasped the potential power compressed into those at first minimally meaningful scratches and linear daubs. The Paleolithic age evolved leisurely into the Neolithic age, which began, if so specific a word can be used to describe transition periods of history, with the melting away of the last Ice Age (a mere thirteen thousand to fifteen thousand years ago), and lasted some ten thousand years before evolving into the Bronze Age, three thousand years ago.

The Neolithic age is not really a chronological phase in man's development and history, but a way of life distinguished by marvelous skill in the use of remarkably perfected stone tools. They now were able to hunt better, and fish better, so they ate better. And the climate was better. All this added up to a rapid increase in population, and, with it, a spread of trade contacts. One more thing: They began to create villages of sorts. They had to, because they discovered farming and animal husbandry, thereby increasing and stabilizing

their food supplies but, at the same time, shackling many of them to one locale. How well we know that feeling! To think from this came paper money and telephones that don't work.

These Neolithic "centers" were not so much urban centers, at first, as they were sites. Curiously, what is left to mark their where-abouts are not remnants of where those people lived, but monuments to where they died, the crude but mighty megaliths, enormous an-cestors of our own polished marble slabs (whose graven statistics can be considered a kind of graffiti, I feel) that commemorate the most permanent of life's conditions, its end. There are the amazing, gigantic structures made of huge, single stones standing upright, some as high as twenty-two feet with capstones fifteen feet across, at Stonehenge in the British Isles; others equally impressive in Scandi-navia, France, Germany, parts of Asia, North Africa, and Polynesia. How they were ever put up at all is an unsolved mystery. They are of interest to our study because they are incised with what might be called cult graffiti—depictions of symbols and objects having to do with the worship of the dead and their gods.

I think it quite interesting that the first graffiti, made when staying alive was a pretty iffy proposition, were positive in their con-cern with the mysticism of nature and life. There was a here and now quality to them. In time, man recognized death and put up a kick. He expended tremendous energy inventing and insuring for himself a life beyond the limits put upon him by time, accident, disease, or a fatal blow. He invented a religion to provide him with a code of be-havior to please some gods he invented to reward himself with that hoped-for life after death or punish him by denying it to him. He put up staggering monuments to prove his worth to those gods, and gouged magic symbols into the stones to make permanent the sin-cerity of his worship.

There were, in all this fury of action, elements of the same kind of wishful thinking that produced the cave drawings. By carving or painting a pictographic life after death such a hope, like the animals, might become real and available.

I don't think it is necessary to go into any detailed description of the megalithic monuments, save to note that almost all of the ones at Stonehenge have inscriptions which, so far, are undecipherable. One

graffito, however, depicts a Mycenaean dagger, which gives some indication of how far from home people were traveling, even in those days. Was this graffito to prove that, like Kilroy, the Mycenaeans had been there?

The Englishman, Richard Freeman, in his book *Graffiti*, sees a relatedness in the temporally separated ancient devotional graffiti and the modern scrawls found in London loos, or for that matter, any privy. "Tombs," he says, "lavatories and prison cells have a strong physical resemblance . . . the atmosphere is secret, confining, sub-terranean, and conspiratorial. They affect the human emotions in roughly the same way.

"In circumstances like these, a man is likely to assert himself graphically, a silent means of expression. If an unoccupied house stands empty for a long time, it becomes haunted. Hollow trees, wishing wells, and rooms with locked doors are treated with cautious suspicion. We believe that, if they are empty, something must inhabit them. . . . Then graffitist responds to this presence." (By, I presume, supplying a presence in the form of an inscription.)

And now, with that Mycenaean dagger, we have plunged into the Bronze Age. Pictography is nearly universal in practice but naturally by no means identical in style or meaning. Although pic-tography is considered the primitive forerunner of writing, it was sometimes an attempt at purely aesthetic expression, casual (our graffitist doodler) or intended (the budding artist), so it hasn't been easy to translate the ancient varieties and give them meanings. This is particularly true in regard to drawn or painted pictographs.

Pictography has persisted as a medium of communication even today among simpler peoples in the ever-lessening remote areas of this earth. Once the human being grasped the idea that lines could be connected, curved, undulated, etc., he realized he could say as much with his finger (or an extension of it in the form of a tool or paint brush) as he could with his voice, and further he didn't have to stick around and wait for his audience reaction. The nice thing about pictographs is that you don't always have to know the language to get the message. It is for this reason that we have been able to get some idea of what life was like those thousands of years ago. Many American Indian tribes, speaking totally different languages, con-

veyed all kinds of pertinent news to each other through pictographs.

Pictography is not exactly the speediest way to get a story across. Even though it can be done almost any old way on almost any old kind of surface (Eskimos carved on whale tusks, Australian aborigines carved on trees, Bushmen painted on rocks, Africans painted on skins, Melanesians on bark) it is time consuming. As civilizations accelerated in development, people had a lot more to talk about and needed to say it in a quicker way and use a lot less space so that the message could be portable. We can't go into the complexities of why man must do everything in a hurry, but he must, and so handwriting emerged from the chrysalis of pictography.

We might note some of the early forms of pictographic writing perfected by and reflective of mighty and well-known ancient civilizations.

One of my favorites, if one can say that one has a favorite old civilization, is Phrygia, now known as Central Turkey. Dating back to about 1200 B.C., it seems to have been a pretty lively society to have produced striking buildings, good art, and a written language which was, as far as can be told, something like early Greek script. It is assumed, therefore, that the Phrygians had a literature. But what really has more than anything else given clues as to what their life was like, and this is why I like Phrygia, are their doodles, their graffiti, little pictures scratched on the soft limestone walls of many of their buildings, done, as indicated, by Rodney S. Young in the October, 1969, issue of *Archeology*, by the same kind of person who writes on walls today. Young explains: "These drawings are the products, not of specialists, but of the common citizens of the town; they reflect the contemporary scene, the things which the common man saw about him as he circulated every day through the town. Thus, they are important primary sources for the life of the time-contemporary illustrations from a world long forgotten and little documented in later literature."

For me, such a statement justifies all the many hours I have put into my on-site research in this subject.

The Egyptian hieroglyphics are well known and we need do no more than remark that they are not pure pictographs, but rather a cross between pictograph and writing, containing phonograms (a

symbol used to represent a word, syllable, or phoneme). It is the phonograms, actually, that become the basis of an alphabet.

The Egyptian hieroglyphics can't have been easy to learn, yet, when the tombs were opened, it was evident that a lot of people know how to read and write. Almost everything that could be written on was. There were inscriptions on walls of temples and burial chambers, sides of paintings, mummy cases, statues, papyrus, and clay pottery. Although such writing was done primarily by scribes and priests, illiteracy was not as general as one might think. Even the poor workmen had a school where they were taught to write, for samples of their homework, including corrections, have been found along with more erudite limnings. One thing for sure, those dead people were going to have plenty of reading to while away the long hours of eternity.

The other well-known civilization in the near East to use hieroglyphics was that of the Hittites. Oddly, they had had a cuneiform writing, which was used for their everyday business, but around 1500 B.C. they created a form of hieroglyphics because the kings felt that their decorative, ornamental quality—the Hittites were a very artistic people—made them suitable for the outsides of buildings. Is this not a little like the Japanese, who felt that the grace of their calligraphy was as important as the message it conveyed? The Hittites must have protected their buildings pretty well. There doesn't seem to be much evidence of graffiti talent left on *their* walls. This may be because much of the hieroglyphic carving was done in relief rather than incised. What graffitist could afford the time or tools that takes?

There were hieroglyphisists on the other side of the Atlantic who are also well known—the Mayans, the Aztecs, and the Incas of Mexico, Central and South America. These hieroglyphics are often very stylized and complex, and the literacy required to produce them seems to have been exclusively limited to priests. If there was any grumbling among the hard-driven workers who had to haul all those rocks that went into the building of the altars for their ritual murders and luxuriously appointed tombs for the dead aristocrats, there are virtually no graffiti that record it. Well, rock is hard, and they may not have had the energy left for it.

I must mention one exception. There were graffitists among the

Mayans, and there do exist in plethora on the walls of many Mayan temples in Tikal, Guatemala, graffiti dating from about 100 B.C. to A.D. 700. These inscriptions, like those of the Phrygians', do give something of an intimate view of the peoples who lived there. There is no organization of design, and they are, it would therefore seem, random, individual comments about events, customs, beliefs, and superstitions of their time. There has been found nothing that could be interpreted as pornographic. A clean-minded people, for sure.

(You would think scholars would regard such findings as sacrosanct, but some have been known to have added their own graffiti to those antique ones they were studying. In Tikal, the German-born Teobert Maler put himself down for posterity by inscribing his name and "1895-1904" on the door jamb of the palace he researched. Others have done likewise, including many either unthinking or envious tourists seeking immortality.)

When writing was invented, it lifted the floodgates on man's imperative to communicate. From then on, talk poured out in ever-increasing volume until now there is almost no escape from it.

Pompeii is a good example of how writing served to loosen the mental tongue of many a person whose jaws, figuratively speaking, may have been broken by the complexities of pictographic expression. When Mt. Vesuvios erupted in A.D. 79, the enormous abundance of ash and cinders it belched forth sifted down (cooling as it fell) in such profusion that it covered everything—buildings, theaters, houses, stelae, people, animals, and even bugs. This protected everything from incineration and preserved a number of things almost intact, including a literally incredible number of graffiti.

It would seem, almost, that the walls were for the Pompeiians their newspapers, posters, and handbills. Helen Tanzer notes in her book *The Common People of Pompeii:* "There are lost-and-found articles, real estate, announcements of gladiatorial shows, personal and public notices, local news." Of course, much of the larger body of the Pompeiian graffiti is, as with any graffiti from any time or area, trite and uninspired, for she adds: "Others are mere scribblings resulting from *cacoethes scribendi* which seems to have inflicted the infantile mind at all times and in all places since the beginnings of writing . . . little nothings of sentiment and opinion."

Back in 1899 another scholar, August Mau, wrote with regret in his study *Pompeii, Its Life and Art,* that the information gleaned from this abundance of graffiti concerned the common people rather than the well-to-do and those of refinement. He states: "The cultivated men and women of the ancient city were not accustomed to scratch their names upon stucco or to confide their reflections and experiences to the surface of a wall. Some graffiti, to judge from the height at which we find them above the floor, were undoubtedly made by the hands of boys and girls. For the rest, we may assume the writers were as little representative of the best elements of society as are the tourists who scratch or carve their names upon ancient monuments today. Nevertheless [he concedes], we gain from these scribblings a lively idea of individual tastes, passions, and experiences."

There were inscriptions about and from all the trades and tradesmen: bakers, inn keepers, ball players, peddlers, carpenters, and politicians. Common people they may have been, but their language seems, compared to our own mode of speaking, rather elegant. If that was how the common people spoke, how astrally elegant was the verbiage of the upper crust? For example, compare this piece of political campaigning done with the sharp stylus upon the stucco to the terse stickers we see today:

> *M. Holoconium Priscum Iivirun iure dicundo Pompari universi cum Helvio Vestali faciatis rogant.*
> The united fruitmen with Helvius Vestalis urge you to make Marcus Holconius Presicum duumvir with judiciary powers.

Or the one by a lover who felt a woman's resistance could be worn down by his tears:

> *Quid pote tam durum saxo aut quid molius unda? Dura tamen molli saxsa cavatur agua.*
> What's harder than stone and gentler than water flowing? Yet the stone is hollowed by flowing water.

(Obviously he had a lot of time on his hands—not only for his wooing but to scratch all of that on a wall.)

Quite a few graffitists who may have suffered from a paucity

of originality were, nonetheless, sufficiently well educated to write quotations from Virgil, Ovid, Lucretius, Propertius, and Tibullus, sometimes even going so far as to credit the source. They seem to have been a lively bunch, intellectually speaking, those Pompeiians, interested in plays and music and having favorite thespians, as indicated by this plaudit to C. Ummidium Actius Anicetus, the Laurence Olivier of his time.

Acti, amor populi, cito redi.
Actius, darling of the people, come back quickly.

Or this graffito, with its implications of a plot suitable for a musical of the early 1940s. It tells of a young lady who is bitter about more than just her defeat in a musical competition:

I deny all gods, all of 'em. He wins. He wins in the All-Out Musical Contest, Tal, the lute player does. He plays like Apollo. I'm only a flute player, so of course I lost. But [a wistful note here] he's a camelopard. [A giraffe. I presume she means he had a long neck.]

She then added, still wistful in her anger, something about his being an Achilles of renown and finally:

But me, I'm in a passion. Well, Vulcan is the medicine.

That little lady was perhaps unusually prolix, for shorter (and pettier) expressions of rancor are quite frequent. At the baths someone wrote, MAY YOU BE NAILED TO THE CROSS, and someone else, CHIUS, I HOPE YOUR PILES ARE CHAFED ONCE MORE THAT THEY MAY BURN WORSE THAN THEY'VE BURNT BEFORE. (How old the common ailments of man!) The curse may have worked, for another graffito reads: PYRRHUS TO HIS CHUM CHIUS: I'M SORRY TO HEAR THAT YOU ARE DEAD; AND SO, GOODBY.

And then there were the moralists:

Moran si quaeres, sparge milium et collige.
If you want to waste your time, scatter millet and pick it up again.

And this fine example of a pot calling the kettle black:

Admiror, paries, te non cecidisse ruinis, quo tot scriptorum, taedia sustineas.
Truly, 'tis wonderful, Wall, that you have not fallen in ruins, forced without murmur to bear the taint of so many hands.

If the pictograph graffitist was shy about sex and/or love, the Pompeiian certainly was not, for the themes were abundant, replete with the same kind of gossip, scandal, and braggadoccio:

Romula hic cum Staphylo moratur.
Romula tarried here with Staphylus.

Festus hic fuituit cum Sodalibus.
Here Festus made it with Sodalibus.

Hic ego puellas multas futui.
Here I have found many girls who make love.

Daddy Colepius kisses the ladies where he shouldn't.

One thing we have not heretofore noted—and to mention it in this context is not to imply that the Pompeiians were the first to show signs of it—and that is, the appearance of humor. It is not particularly recognizable in pictography, but it is in writing, although much of it may get lost in translation. (In A.D. 79 Pompeiians probably roared at HELLO. WE'RE WINESKINS.) Or else, if any raunchier expressions of it have been found, prurient scholars have chosen to turn their heads and eyes and excise it by omission.

Be that as it may, scholars do admit that whereas the writers, historians, and record keepers of various eras have provided panoramic stylization of a civilization, it is the graffiti that attest to the continuity of the common man, and the continued commonness of many of his problems. It was true of Pompeii, and is certainly true of ancient Rome, where the mania for writing on public and private buildings was intense. There was hardly an edifice that didn't bear the scars of a schoolboy's pocket-knife (or whatever little Roman boys carried for such purposes—I don't think togas had pockets) or

some idle passerby's nail. One must admire the patience of the scholars who had to sift through this welter of names, profanity, alphabets, emblems, caricatures, and sentences in search of the ordinary Roman. Many graffiti show that deeply entrenched in time and history are some of life's daily vexations, such as those of youngsters who expressed the usual pleasure when school was over, or misery when the work was tough. One drawing found was that of a donkey turning a mill with a caption, WORK, WORK LITTLE DONKEY, AS I HAVE WORKED MYSELF, AND THOU SHALT BE REWARDED FOR IT.

No matter how lofty a civilization in art and ideology, it still has to cope with the midden heaps that the mechanics of staying alive discharge to all civilizations—sewage, waste, garbage, and pollution. Rome, in all its glory, was no exception and it, too, had to find a place for the daily refuse, rubbish, carcasses and corpses. There were public signs warning dumpers off various areas. One such decree had a hand-painted addendum: DO CARRY THE DIRT A LITTLE FARTHER, OTHERWISE YOU WILL BE FINED. That graffitist must have lived to the windward of a dumping ground.

There has been preserved, in the Kircherian Museum in Rome, an interesting graffito which may in its own day have typified fairly accurately the attitude many had toward conversion to Christianity. It is a caricature, with Jesus represented as having the head of a donkey, tied to a cross, but with his feet resting on a horizontal piece of board. A Christian youth has his arms raised in adoration of this figure, and underneath is the explanatory legend: ALEXAMENOS WORSHIPS [HIS] GOD.

As far as ancient graffiti are concerned, aside from the Ten Commandments, the most famous graffito ever is the one recorded in the Old Testament and from whence comes the expression "the handwriting on the wall," grim in its implication of tragic finality. The graffito is, of course, the famous MENE, MENE, TECKEL, UPHARSIN, written by a detached hand which appeared at a party being given by King Belshazzar. Daniel (of the lion's den fame) was called in to translate what this moving finger had left upon the plaster. His translation was accurate enough, a nicety which may have meant little to Belshazzar, since the words were not a warning but a fore-

telling of the imminent demise of both himself and his kingdom. Children of the Western world who have transliterated those famous words into the graffito "Meany, meany, tickle a person" know not what they are saying.

Real or not, Belshazzar's graffito falls into the category of religious epigraphy of which there are two quite important forms—the Pagan runes and Christian epigraphy. Epigraphy is a term applied to inscriptions written on hard materials. The Christian epigraphy, usually in Latin or Greek, was rife between the second and seventh centuries A.D. The runes, which were written in a peculiar and ancient Germanic alphabet, date from around the first to the third century A.D. Both are included in the study of graffiti because of where and how they appeared. Scholars often refer to them, in fact, as graffiti.

The Christian epigraphic graffiti are rather limited in subject matter, dealing with funeral inscriptions, pious invocations, scripture quotation, cult of saints, and remarks of faithful pilgrims. They do, nonetheless, give some insight into the daily life and activities of the ordinary people of Christian communities, and the cult of martyrs. They also are historical evidence of the spread of primitive Christian thought and practice because they appear in Palestine, Egypt, Rome, Gaul, southern France, and Spain. Many of them, too, indicate the Judeo-Christian character of many of these early pilgrims.

The runes were not so open to interpretation as was the Christian epigraphy, nor was this a form of writing taught to the ordinary person. Its practice seems to have been the exclusive province of priest and sorcerers, and it was used more as a kind of graffiti incantation rather than a method of conveying a message. It was not used to perpetuate legends, or stories of events, as have other forms of epigraphy, but was instead an epigraphic way to protect a person from bad or evil spirits. The primitive superstition or heathen religious form they embodied seems to have been carried through Denmark, Norway, Iceland, Germany, and the British Isles, all countries of Germanic and Anglo-Saxon heritage. Although there was a trickle of runic inscription that persisted up until the seventeenth century, this strange, fascinating magic writing disappeared as Christianity extended its control across the European continent.

We shall not go into any examination of the origins of the runic alphabet and its form but shall turn instead to the more understandable inscriptions that were the delectation of a large audience which could read as well as write them.

England:
Medieval, Merrie, And Otherwise

Christianity when it came to medieval England either brought with it an unusual purity of mind and attitude or else successfully repressed in the graffitists of the time their usual tendency to be profane or earthy, even grouse a little bit, as was the wont of the pagan of Rome and Pompeii. Of course, the pagan gods were, when you come right down to it, a pretty earthy lot themselves, which may account for the lack of spirituality in the graffiti of their worshippers. We, then, must cleanse our definition of graffiti of its present-day taint of salacious worldliness when we study the graffiti of Olde England, and think of it in the purer art concept of *sgraffito*.

I will do this, but with a certain amount of caveat. I find it hard to believe that those early Englishmen confined their bawdy verbiage to the pages of Chaucer, for all that Olde Englishe appears to have been just as hard to write as it is to read.

But just remember, the cities—and that means temples, public buildings, businesses, inns, and homes of the rich—of Egypt, Greece, Rome, and Pompeii were built of stone and plaster. They were old. As a civilization gets richer and older, its institutions lithify (in more ways than one). Just look what has happened to New York in a scant three hundred years!

Medieval England was young. Its cities, even the major ones, were built of wood, except for the churches, which were half crypts, and the castles, which were half dungeons. These bastions to defend

the kingdoms of God and private power were built of rock, stone, slate, and some marble. Who knows what lusty morsels of folksy lore have disappeared in the dry rot and ashes of lesser edifices?

One of the reasons Christianity had such appeal is that it promised everybody, regardless of caste or color, a very pleasant heaven to make up for some of the drearier aspects of earthly existence. The price of the fare to man's first satellite, so desirably described if not seen, even through the most powerful of telescopes, was virtuous behavior and pious thought. Its threats of retribution to the sinner particularly when so vividly corporealized by some of its post-apostolic methods of conversion, such as the Inquisition, were fairly effective. That kind of indoctrination went a long way toward insuring the inviolability of holiness and holy places. Only the most cynical of blasphemers would have dared desecrate church walls or risked being haunted by an irritated spirit guarding a tomb.

This narrowed the scope but did not particularly reduce the output of the medieval graffitist. Between the twelfth and the sixteenth centuries, there were drawings and writings a-plenty incised on the walls, pillars, and even floors of churches and monasteries and dungeons, some done with a stylus and some with fine chisel. Of these ancient buildings still standing today in England, there is hardly one that doesn't have troves of graffiti. But their subject matter bespoke not of the vulgar (in its original meaning) life. They dealt instead with knighthood and objects pertinent to it, such as badges, crests, shields, weapons, and the knights themselves in armor. It was all right to put these on church walls because, after they had been blessed and seen service in the crusades, they were looked upon as religious items and, therefore, suitable for ecclesiastic masonry.

Whatever these graffiti may have lacked in humor, I have to concede they make up twenty-fold in charm. Their fame and form have been spread by scholar, artist, and art-hip tourists who have transferred them to paper by pencil or wax rubbing. For those whose interest in graffiti may be in the area of its expression as an art form, I would recommend a visit to the Cloisters in New York or perusal of the book *English Medieval Graffiti*, a most comprehensive and scholarly work by Mrs. V. Pritchard, published by Cambridge University Press. My readers so inclined will see in the graffiti repro-

duced in her work their similarity to the manuscript art of the era. Christmas card designers have found them a great source of inspiration.

There are, too, innumerable inscriptions in Latin, the contexts of which indicate why one of the other oft-repeated drawings was that of the scythe bearer. The Cambridge Antiquarian Society records this lugubrious Latin inscription, written in large letters:

> *Mors comparatur umbre que semper sequitur corpus.*
> **Death is like a shadow which always follows the body.**

And on a pillar in a church in Cambridgeshire:

> *His est sedes margaratae Vit. a.d. (Vitae anno decimo)*
> **This is the resting place of Margarite in the tenth year of her life.**

In Flamstead, Hertfordshire, on one of the pillars of St. Leonardo's church is a rhyming graffito which reads:

> **Within this piere where bricks are laide**
> **There buried lieth a virgin mayde**
> **Ffrauncys Cordall was her name**
> **She lived and died in godly fame**
> **Anno 1597 June vij.**

(There may have been more than one reason to have felt sorry for this poor girl.)

And one wonders whether the author of the following elegiac couplet at St. Margaret Church, Cowlinge, Suffolk, carved it with premortem intention that he should have postmortem influence in keeping God alive:

> *A(uu)m p(er) me transis, vir vel mulier uer an sis,*
> *Pretereau (n)do caue ne taceat (ur) Aue.*
> **Whensoever you go by me**
> **Whether man, woman or boy you be,**
> **Bear in mind you do not fail**
> **To say in passing, "Mary Hail."**

The language of the Church was Latin, and so most of the inscriptions are, too. Mrs. Pritchard did find one verse, however, in Ridgewell Church, Essex, written in Middle English. I don't particularly get it, but it amuses me to recite it to myself from time to time. I am rather unsure of the pronunciation:

A yong rewler wytles
A pore man spendar haveles
A ryche man bif nedeles
A old man leche (r lwue) les
A woman rebolde sameless.

One of the most famous (and indeed at times infamous in its fame) ancient repositories of English graffiti dates in its construction back to the eleventh century A.D. Known by the single name of the Tower of London, thickly encrusted with English history, dour and menacing in aspect, it is a complex of buildings in the heart of London covering thirteen acres on the banks of the Thames. Designed as a fortress, it served as a residence of detention—in cold fact, a prison—for a long list of notables. Back around 1483, Richard III put his two young nephews, Edward V and Richard, Duke of York, there. They were to live on in history and Shakespeare, but they never emerged from the Tower alive. One of Queen Elizabeth's favorites, Robert Dudley, Earl of Leicester, whom she even thought of marrying, languished there when his charm failed to offset his political mistakes. Sir Walter Raleigh, as it turned out, muddied his cloak in a vainglorious gesture. He did a thirteen-year stretch in the Tower. The last detainee, by contemporary definition a criminal rather than a political prisoner, was the Nazi leader Rudolf Hess, who spent a few days in the Tower in 1941.

Actually, there are several towers in the Tower. There is Wakefield Tower, where the Royal Jewels and all those fancy crowns are held. Then there are Traitors' Gate and the Bloody Tower, whose names are related to the action that went on there. It is Beauchamp Tower, however, which interests us most because it is where the prisoners left a record of their experiences by writing on the walls.

There are ninety-one graffiti on the walls of Beauchamp. Most

are merely names, but quite a few are longer and, by their content, we can see that there were only two types of prisoners kept in the Tower: political and religious. Whether it was because literacy was low among the earlier nobles or because its use was sporadic, to judge from those graffiti that are signed and/or dated, most of the heavy action in the Tower seems to have gone on in the 1500s and 1600s. Many of the graffiti are, of course, not dated but the time they were inscribed can be determined if the author has signed his work, as in the case of T. Fane. He would have been in the Tower in 1553, for he was party to the unsuccessful rebellion led by Sir Thomas Wyatt against Mary I, the Bloody Queen, when she announced her plan to marry Philip II of Spain. Wyatt was hanged in 1544. Fane wrote upon the prison walls, whether to console himself or Wyatt is not definitely known:

Be thou faithful until death and I will give thee a crown of life.

I suppose there is some implication here that the gates of the Tower opened onto the stairway to heaven. To my way of thinking, a death knell is a death knell, but perhaps these prayers made the bang of iron gates sound like the clang of church bells.

Queen Elizabeth seems to have sent a rather talky lot to the Tower during her reign. One of them was a certain Charles Bailly, a native of Flanders employed by friends of the then imprisoned Mary, Queen of Scots, to transport correspondence in cypher to fellow conspirators. Since his crime concerned royalty, he was sent to the Tower. His prolixity and its quality on the hard walls bespeak the possibility that he may have been stronger in fist than in foresight. At any rate, he must have been given plenty of time to reflect because he wrote a lot and seems, in his reflections, to have been the Charlie Chan of his day. The following are illustrative:

Wise men ought circumspectly to see what they do—to examine before they speake—to prove before they take in hand—to beware whose company they use, and above all things, to whom they truste.

> The fear of the Lord is the beginning of wisdome.
>
> Be frend to one—Be ennermye to none.
>
> The most unhapy man in the world is he that is no pacient in adversities; For men are not killed with the adversities they have, but with ye pacience which they suffer.

Two other losers in this altogether chancy business of trying to defy Elizabeth by serving Mary were the brothers Poole, Edmund and Arthur, whose participation in that political struggle cost them their lives. It is a little difficult to decide whether the intensity and sincerity of their religious faith made them victims or sustained them, or both:

Edmund wrote, on the walls of Beauchamp Tower in 1562:

> *Qui seminent in lacrimis in exultationemetent.*
> They who sow in tears shall reap in joy.

while Arthur left the following message in 1564:

> To serve God, to endure penance, to obey the fates is to reign.

Another for whom the towers proved to be portals to heaven was Philip Howard, first Earl of Arundel, who at least got through the pearly gates with head intact. And his faith, too, for that matter. Arundel, who had been a wild young man at court and never successful in getting in good favor with Elizabeth, became an ardent Catholic, a combination of circumstances that made it easy for his enemies to have him put into the Tower. Falsely accused of praying in secret mass for the success of the Spanish Armada, at that time moving against England, he was slated for execution but died of food poisoning, which some said was not accidental. Just before he died, he inscribed the following:

> *Quanto plus afflictionis pro Christo*
> *in hos saeculo*
> *tanto plus gloriae cum Christo in futuro*
> *Gloria et horore eum cornasti Domine in memoria*
> *aeterna erit justus.*

As much suffering for Christ in this world
So much the greater glory with Christ
 in the world to come
Thou has crowned him Lord, with glory and honor;
The just man shall be forever.

One must give credit to Elizabeth's tower guests for doing their best to keep up their morale, even if their philosophizing is tainted with a touch of gloom. Thomas Clarke is a case in point. He, too, had plenty of time to think things out. He was committed to the Tower in 1578 and his two entries are dated 1586:

> It is the poynt of the wyse man to try and then triste, for happy is he who findeth one that is just. T.C.

> I live in hope and I give credit to my friends in time did stande me most in hande; so would I never againe excepte I had him in bonde and to all men wish I so, unless ye sustaine the like love as I do. Unhappie is the man who actes doth procure the miseri of his house in prison to endure. 1586 Thomas Clarke

Or take the brief remarks made by George Gyfford, reputed to be a spy:

> Grief is overcome by patience. Geo. Gyfford, August 8, 1586.

> An evil conscience makes men fear even security. G. Gyfford.

Not all the graffiti in Beauchamps Tower were written by prisoners. There is one, rather obscure in meaning to me, by a Hugh Longworths who was a prison keeper in the Tower. On the north wall arch of the Tower he scratched a graffito which reads:

> I hope in the end to deserve that I would have men.

Nonpolitical though he may have been, his death was, alas, something of an execution in its own way. He was killed by one of his charges, Peter Bourchet, a madman who struck him over the head with a poker.

Quite obviously, many of Beauchamps graffitists in residence felt that there would be but one way to get out of there, and that was by

the scythe, whether wielded by the executioner or by Father Time, and many were as resigned as was James Typpinge:

> Typping stand and bare they cross for thou art catholyke but no worce and for that cause this 3 year space thou has conteanewed in great disgrace or be wel content swet Good.

Although the majority of the graffiti of the Tower of London are scarred into the walls of Beauchamps Tower, there are graffiti in some of the other towers, too. E. A. Humphrey Fenn, in his article, "The Writing on the Wall," in the English magazine *History Today*, tells of graffiti "undated and nameless" by a prisoner who had been tortured in "Little Ease" in Bell Tower. ("Little Ease" was a cell in which a prisoner could neither lie down or stand upright.) Also in Bell Tower is an inscription by Thomas Mehoe (Mick O'More from Ireland), imprisoned in 1581. It gives more than an inkling of the intensity of belief which gives such strength of endurance to those who pursue what they consider a just cause:

> bi—tertvre—strange—my—troulh—was—tryed—yet—of—
> my—libertie—denied—there—for—reason—hath—me—per-
> suaded—that—paysans—must—be—ymbraced—though—hard
> —fortune—chassyth—me—with—smart—yet—paysans—
> shall—prevayl.

Mehoe obviously had his moments of despair as well, for he also wrote:

> Lord whoe art of heavn, King, grant gras and lyfe everlasting to Miagh thy servant in prison alone. Thomas Miagh.

Elizabeth died in 1603, but Catholics were still subject to incarceration, as attested by the 1612 date of this inscription by Father Robert Fisher, who used a nail to pen it on the wall of White Tower:

> *Sacris vestibus indictus dum sacra mysteria servans, captus, et in hic augusto carcere inclusis R. Fisher.*
> While robed in the sacred vestments and administering the sacred mysteries, I was taken and held in this narrow cell. R. Fisher.

The English graffiti from the Middle Ages through the early seventeenth century, though scribed by the educated and upper class, don't have a patch on the literary quality of those that have been recorded from the next era. The eighteenth century was the golden age of English graffiti. In fact, at no time and in no place is graffiti as consciously literary. All its practitioners, although often persons of lesser quality, seem to have been deep in the sway of the literary giants of that day and of the previous century. Shakespeare, Lovelace, Ben Jonson, Donne, Robert Herrick, Milton, Dryden, Pope, Goldsmith, Gray, Blake, and Bobby Burns were so well known that their verses were not only read in drawing rooms but were the talk of the coffee houses and filtered down to the common people engaged in the ordinary levels of commerce of the city streets. Graffitists of the eighteenth century were much taken with the "conceit" (a fanciful image, especially an elaborate analogy). Take, for example, this little gem "written at the request of a lady who, on her wedding day, entreated an old love to write something upon her window":

> This glittering diamond and this worthless glass,
> Celia, display thy virtue and thy face
> Bright as the brilliant while thy beauty shows
> Ever less itself's less brittle than thy vows.

And note the similar use of the literary device in this excerpt from William Shakespeare's sonnet Number 130:

> My mistress' eyes are rather like the sun
> Coral is far more lips' red
> If snow be white,
> Why then her breasts are dun;
> If hairs be wires
> Then black wires grow on her head.

While fine literature may have influenced the style of the graffiti of the eighteenth century, the stuff of much wall poetry was inspired by subject matters somewhat less than worthy of elegiac talent. Impure water and not my fair lady's alabaster skin indirectly prompted much of it. Plain water was unsafe, and since tea and coffee were not universally available to every home, the English imbibed their neces-

sary intake of liquids in the form of ale, and, as Hogarth so well depicted, they drank gin. The inn as well as the coffee house, with its rows of generous tankards, became an integral part of the Englishman's life, and it was in these places that many of those inscriptions that have been preserved were composed.

Not unnaturally, under the circumstances, drunkenness was a national problem. The religious groups of the day, in their diatribes, broadcast in the form of tracts, dwelt on grisly possibilities such as getting killed, falling off one's horse, or being beset by agonizing seizures of one kind or another and, of course, the absolute certainty of winding up in hell. The perils of alcohol elegized in the graffiti, however, were more concerned with the gloomy likelihood of sexual failure than with morality. More than moral rectitude failed to remain upright, and this saddened numerous graffitists:

> I'll never get drunk again,
> For my head's full of pain,
> And it grieves me to think
> That by dint of good drink
> I should lie with my Phillis in vain.
>> *Star of Coventry (inn), on a window, 1712*

Or,

> Drunk at Comb-Abbey, horrid drunk;
> Hither I came, and met my fav'rite punk.
> But she as well might have embrac'd a log,
> All night I snor'd and grunted like a hog,
> Then was not I a sad confounded dog?
>> *Star of Coventry (inn), on a window*

There are no statistics on just how many were saved from alcohol by such warnings, but it is known that gin killed off a large part of the population between 1720 and 1750. At the peak of gin consumption, between 1740 and 1742, burials in the City of London were twice the baptisms. Meanwhile, ale was doing a good job of undermining health out in the villages where the population was very vulnerable to smallpox, the scourge of the early eighteenth century.

There is graffiti evidence, however, that people feared the doctor who came to cure them almost as much as they did the disease—at least, up until vaccination was developed by Edward Jenner in 1796. Consider this example:

> The doctor more than illness we should fear;
> Sickness precedes, and Death attends his coach,
> Agues to fevers rise, if he appear,
> And fevers grow to plagues at his approach.

> *Written in the chamber window of a lady who, on a slight indisposition, sent for S.J.S., early eighteenth century*

Even so, there were some who had reason to be grateful to their doctor for the successful treatment of another sort of communicable disease:

> Jenny has got a clap
> Which was my mishap;
> But Doctor R—— set me right,
> And I'm now in good plight.

> *Bridge, at the Crown, Jan. 30, 1720*

> I have had a clap
> By a sad mishap;
> But the doctor has cur'd it,
> And I've endured it.
> The bitch that gave it to me,
> She is gone over sea,
> God damn her arse,
> That fir'd my tarse.

> *Pancras-Wells, eighteenth century*

The graffiti of this era are of particular interest in their seesaw from flights of hyperbole on the charms of so and so to deep disillusionment when the lover-graffitist discovers he has contracted syphilis. Observe the following illustrations:

> Sitting on yon bank of grass,
> With a blooming buxom lass;

Warm with love, and with the day,
We to cool us went to play.
Soon the amorous fever fled,
But left a worse fire in its stead.
Alas! that love should cause such ills!
As doom to diet, drink and pills.

*In the window of a green house
near Tunbridge, England, eigh-
teenth century*

My maidenhead sold for a guinea,
A lac'd head with the money I bought;
In which I looked so bonny.
The heart of a gamester I caught:
A while he was fond, and brought gold to my box,
But at last he robbed me, and left me the pox.
UNDERNEATH
When you balance accounts, it sure may be said,
You at a bad market sold your maidenhead.

*On a panel at the Faulcon'in St.
Neot's Huntingdonshire, En-
gland, eighteenth century*

Frequently what appears to have been an almost intuitive evalua-
tion at one time may, at a very much later time, turn out to be upon
analysis, a valid judgment. Take the case of tobacco. Tobacco, as a
product and a habit, came to England around 1597. Smoking tobacco
as well as the taking of snuff was quite popular. (It is interesting to
note that taking snuff was the fad during Queen Anne's time, 1702 to
1714, simply because the English captured some Spanish ships that
were loaded with it.) Tobacco was "in" until 1773 when Dr. Johnson
wrote, "Smoking has gone out." Eschewed by the upper classes, it
stayed out for eighty years. It took an education campaign, of course,
to reduce its usage, and there were warnings of hazards not mentioned
in the current drive against cigarettes. Perhaps our scientists have not
yet done studies to verify the admonition cut into a vaultway in Trinity
Church:

Tobacco, that outlandish weed,
It dries the brain, and spoils the seed
It dulls the spirit, it dims the sight,
It robs a woman of her right.

Most likely written by a woman. Would less tobacco usage lower the output of sex manuals?

All in all, England appears to have been, during the eighteenth century, a verie merrie place, with its conceits, its literature, and open recognition of the existence of sex, at least in graffiti. The nineteenth century, however, was Queen Victoria's day, and we all know what kind of influence *she* had. It was a remarkable era, the era of the industrial revolution, of a population explosion of the poor, of Charles Dickens and all the makings of marvelous novels that became epic movies in our time, of nannies, scullery maids and butlers, stiff upper lips and all that. It was the era during which the British developed their famous cool.

But Victoria ran a tight ship, and if any graffiti sullied it, those scullery maids must have scrubbed them away. Hard to believe, but the legacy of the Victorian era does not include any record of any graffiti, literary or banal, sly or sexual, protest of the poor or aberrations of the rich. (My researches have not even turned up any information on public privies in connection with the development of rail travel. Of course, England *is* small, the distances between places are short, and the British talent for restraint is well known.)

But over on the Continent, things were a little different.

Middle European Wall Writing

However effective Queen Victoria's personal and royal rectitude may have been in keeping British walls clean, things in Middle Europe were very different, indeed. The profusion and vibrancy of graffiti there aroused the investigative interests of several scholars as early as 1907, and their findings and opinions were published in a German scientific journal, *Anthropophyteia*. They collected examples, for the most part in the area of toilet wall writing, from widely separated cities, most of them of Germanic character: Leipzig, Vienna, Copenhagen, Berlin, and Zurich.

These scholars were struck by two characteristics of the graffiti they encountered: an unusual number were in rhyme and they were quite raunchy. The latter trait is, of course, common enough, but the first is, on the whole, rare in graffiti practice currently. This surprising aspect of the graffiti led the scholars, as is the custom of researchers, to propound some interesting theories. Credit must be given to these pioneers for their interest in the entire subject of graffiti and even more specifically in the area of toilet graffiti, but it must be conceded that their hypotheses are often quite naïve and even snobbish. This attitude may have been due to a flowering of intellectualism and early stirrings of Aryanism.

Hugo E. Luedecke was the spokesman for the 1907 study, and, after sifting through a number of possible reasons for the elegance of form and coarseness of content, he came to the conclusion that there

were basically two types of toilet graffiti—those penned (if that is the word to use) by the educated folk and those written by commoners. The purely physiological comments were without a doubt from the common people, and the witty remarks were unquestionably the product of the educated minds.

> *Wie auf den Stuhl der Gotter*
> *setz du dich auf dieses Geschirr,*
> *und lass den Sturm, das Donnerwetter*
> *laut krachen unter dir.*
> As on the throne of the gods
> you sit yourself on this gadget
> and let the storm, the thunder
> crash loudly under you.
>
> *Men's room, Germany, 1907*

> *Wer nie mit Schweiss im Angesicht*
> *dem Abtritt zugekeucht,*
> *der kennt das Wonngefuhl noch nicht*
> *wenn man ihn hat erreicht.*
> He who never with sweaty face
> gasped toward the can, he knows
> not the feeling of voluptuous relief
> when you reach it.
>
> *Elberfeld, 1905 Offenbar*
> *schwebten dunkle Erinnerungen*
> *an Goethe's* Wer nie sein Erot.
> *vor (Inspired by Goethe's* Wer
> sein Erot.)

> *Wenn die Haare werden grau,*
> *Und des Piephahns Spitz blau,*
> *Und du kannst nicht mehr in Bogen seechen*
> *Ach das sind drei bose Zeechen.*
> When the hair turns grey,
> and the cock turns blue,
> and you can no longer piss in arcs,
> these for sure are three bad marks.
>
> *Men's toilet, Leipzig, 1882*

It was Dr. Luedecke's considered opinion (and I do think he was serious) that the learned individual wrote for two reasons, boredom and the drive to imitate. (Just who was being imitated is not clear; Goethe, perhaps? Heine, Schiller, Nietsche?) When there

are no newspapers around and the walls are blank, the intellect must have something to engage it and so it is an open invitation to write. Herr Luedecke puts it very nicely: "Lo and behold, you get a spiritual excrement. In the spiritual excrements religious, national, social, and confessional contrasts can be seen."

Consider the following:

Wer zum Pfarrer geht als Magd, bald um verlorene Unschuld klagt.
Whoever goes to the priest as a virgin, soon bemoans her lost innocence.

<div align="right">Breslau, 1909</div>

Wer Deutschlands Einheit sehen will, braucht gar nicht viel zu wandern, denn, wie man hier geschrieben sieht, scheisst einer auf den andern.
He who wants to see German unity needn't travel far, for as one sees it here, one shits on the other.

<div align="right">An Austrian, Oderberg, 1880</div>

Reiche Leute kussen sich
arme Leute bepissen sich.
Rich people kiss each other,
poor people piss on each other.

<div align="right">Berlin toilet, 1910</div>

Vikter von Stein
der macht's recht fein
und steckt ihn (Penem) auch suss hinein.
Victer von Stein
does it right fine
and puts it quite sweetly in mine.

<div align="right">Ladies' toilet, 1903 Halle a.S.
Klause St. Lukas</div>

This learned scholar felt that the lower classes must be affected by the air that is peculiar to toilets because, where ordinarily they would never write verse, here they are suddenly inspired. (I do confess to some slight feeling of insult on behalf of the common man.)

"There are two directions that the inspirations can take," he states. "That of excretory matters or that of sex. Without exaggerating, we can state that the common people are standing a step lower

than we [note the level at which he places himself] in the development scale. We have left the world of instinct and have become a brain. The common people live in instinct and are striving toward the brain. To admit this is easy [get this] for the discoverer of the substratum. The enjoyment in feces and excrement as it is manifested inspirationally in uncultured people in their graffiti is nothing more than a throwback to animalism. We have only to think back to the fact of what a true glory or excitation it is for dogs to sniff around the feces in the street [obviously, he was ignorant of dog or cat olfactory self-identification] and to intensively smell them in order to have a satisfactory explanation for the theory of the 'inspirational aspect of the air in the bathroom.' In all of us there is a little piece of the animal, a piece of our developmental past. However, the more we become culture, brain, and intellect the more the piece weakens."

In all fairness to the good Herr Luedecke, we could concede a certain amount of psychological insight on his part. His ideas are pre-Freud. It was to be some time yet before the master was to affect so profoundly the thinking of psychiatry and psychology in regard to infant sexuality, the interest babies have in their feces, the analerotic characteristics consequential to toilet training, the repressions that one experiences during latency.

As a sort of coda to his many ideas, Luedecke concludes that there is such an abundance of sex in bathroom writing for an interesting reason related to male physiology: during defecation, there is often an erection of the penis stimulated by the pressure on the semen duct by the feces during passage. From this has come much poetry.

In 1906 there was published a book that contains some of the most fascinating examples and observations on toilet writing that I have encountered in my investigations of this subject. Entitled *My Life, My Opinions, and My Work*, it consisted of the memoirs of the widow Wetti Himmlisch, who was much closer to her subject than was the erudite Dr. Luedecke, for during the latter part of the nineteenth century she was a devoted bathroom attendant in Vienna. "Himmlisch" means heavenly, and I truly think Wetti deserved the name. Far from thinking her work demeaning, she took great pride

in it, and before she cleaned the walls, she copied down what she considered the better writings that were inscribed on them.

Wetti's book is a very valuable social document, for she peppered it well with anecdotal material about attitudes toward the toilet as well as a comprehension of the forces that reveal the common denominator in all class distinctions. An example:

> Die grossten Meisterweke der Kuche
> Geben hier die ubelsten Geruche
> Je mehr die Koche zeigten ihre Kunste,
> Je arger hier duften die Abfhrdunste.
> Da hilft nicht Asthetik und nicht Devotion
> Hier bist due ein einfacher Erdensoh.
> The greatest masterworks of the kitchen
> Give off here the most awful smells.
> The more the cooks show their skills,
> The worse do smell the flavor of the excrement.
> What use is esthetics and devotion?
> Here you are a simple son of the earth.

Luedecke may not have admitted to the democracy of the toilet nor to the concept that there all beings are equal. Wetti, however, had no such illusions, even though in her "citadel" there were first- and second-class facilities. Even the most widely divergent political points of view had here a commonality which Wettie appreciated:

> Ob Sozi du oder deutschnational,
> Hier kannst due es nicht zeigen,
> Denn reden darf hier nur der
> Und ach! Der Mund muss schweigen.
> Whether Social Democrat or German National,
> Here is not the place to indicate this,
> For here only the ass may speak,
> And the mouth must be quiet.

It strikes me that Frau Himmlisch was a woman with an admirably hearty and earthy attitude toward the basic and, after all, inevitable functions. Inscriptions that other women of her time might have deemed indelicate, she copied down with great delight. I have

no doubt at all that she appreciated the higher satire implied by this
bit of low poetry:

> *Si l'empereur faisait un pet*
> *Geoffray dirait qu'l sent la rose,*
> *Et le Senat aspirait*
> *A l'honneur de prouver la chose.*
> When the emperor lets one go
> Geoffray would say he smells a rose,
> And the senate aspires
> To the honor to prove it.

Wetti must have been quite a handsome woman, for she worked
for a time as an artist's model. One of the painters who hired her was
a Russian, perhaps a mad one, for he paid the fee to have her do no
more than sit while he walked around and looked at her for several
hours. She said modeling bored her and it is easy to see why. She
obviously found it much more interesting to observe than be ob-
served, and she much enjoyed the variation of patrons who came into
her "hygienic institute" as she liked to call the rest room. She worked
twelve to sixteen hours a day, until by good fortune she came into
an inheritance that enabled her to retire and write her book. One gets
the impression that she missed her work. She felt that in the water
closet there were no phonies. Even the "professional imposters" (con
men), once they were in the toilet, "let themselves go." Wettie said of
her domain that there was no third alternative; here, you can or you
can't.

Wetti was really quite proud of the democratic atmosphere of
her work and despised those who called it a "shithouse." She con-
sidered it an honor that a well-known classical poet did not think it
beneath his dignity to write there. However, one poet, a student
whose work she preserved, failed to achieve the fame he strove for.
It was really quite terrible and sad, for Wetti found not only the re-
mains of his poetry but of the young man himself, for he had com-
mitted suicide in the stall. He left the following message:

> *Mein Schwangengesang*
> *Ich geh in eine bassere Welt*
> *Jetz stantepede ein*

Dort wird ein toller Saus und Braus
Und ewiges Gelage sein
Gehungert hab auf Erden ich,
Dort fresse un besauf ich mich
Und etwas dabei ist gar schon
Manbraucht auf kein Hausle zu gehn

My Swan Song

I go to a better world
Now there will be wild goings-on
And full plates eternally
I have always been hungry on earth,
Yonder I will eat and drink
And one thing will be particularly beautiful,
One doesn't have to go to the toilet.

One might wonder whether it was servility or politeness that prompted Wetti to greet all of her customers with *"Kusst die Hand"* (I kiss your hand), but I don't doubt at all that she had the same interest a director has in his actors when she added, *"Gute Verrichtung"* (May you achieve well). I think she was hoping to inspire them.

Kinsey has observed that women are far more restrained in both output and temerity in what little graffiti is found in their privies. Wetti noticed this way back in her day, commenting that women tended not to indulge in obscenities but limited themselves to just names and admissions of love:

Mei Loisl is a susser Bua
Vom Kussen Kirgt er nie genau [*Viennese dialect*]
My Loisl is a sweet boy
He never gets enough of kissing.

It is not only the wall scribblings that Wetti found oddball. Some of the goings-on were, too. On one occasion, two Negro women tried to go into one stall. Wetti resented their attempt to evade paying a double fee, and ordered them out. The two women were actually one Negro man and one white woman in blackface.

In another instance, a woman ran hastily into a cubicle and

began to moan as if in labor. She was followed closely by two men who heeded not her cries of pain but instead hauled her out. She turned out to be a jewel thief.

The fortune that enabled Wetti to retire and express her nostalgia for this interesting life came to her from a boyfriend she met through her work. He was a gentleman who was so indisposed when he came in that he dirtied himself. Wettie cleaned up and this devotion inspired love.

You would think that the French, of all people, would have made some effort to keep some sort of record of their graffiti. After all, are they not noted for their exuberance in love, in art, in politics? There are, of course, graffiti all over Paris, especially political messages, but the only study that deals with French graffiti is one by a Texan, William McLean. For various reasons, he has chosen to limit himself to erotic drawings of the human form.

This really is too bad, for the ancient walls of this old city are covered with a smooth plaster or mortar that lends itself particularly well to scratching and gouging, and to splashing with paint. McLean's books, *L'Iconographie Populaire de L'Erotisme* (The Erotic Iconography of the People), does make an interesting statement about the who and where of French graffiti. He declares that the French graffitists are mostly blue-collar workers, small employees, shopkeepers, and small business owners, all of whom are socially classified in the low income class. They live and work generally in very neatly defined areas of Paris and its suburbs, he says, in buildings that were built before the big industrial era. The graffiti are to be found on small streets away from heavy traffic, in passageways, alleys, dead end streets, and near vacant lots.

Insofar as the sexual graffiti are concerned, McLean avers that the subject matter is quite limited, being mostly penises, vaginas, naked bodies, hearts and arrows, and inscriptions of words such as cunt and prick. These are rather indigenous to all graffiti all over the world, I should imagine, but McLean sees a variety of erotic meanings in these few themes and their varying combinations. The

arrow and heart is not simple, sentimental love but raw sex, with the arrow sometimes looking much like a penis doing its work of penetration. The shape of the heart is often very like a woman's buttocks.

It follows, therefore, according to McLean, that the graffiti are made by boys and men and rarely if ever by women. Evidence of this is the fact that the woman is represented more fully as a sexual object than the man.

Since we in this country tend to think that if anybody knows about sex, it is the French, we may find surprising McLean's contention that the rawness of these graffiti erotica is evidence of male sexual frustration. Well, perhaps not all the French are free. A Frenchman of my acquaintance has told me that the people who write and draw these graffiti are under the strong influence of bourgeois sexual taboos and, like their counterparts here and elsewhere, they just have to let loose somewhere.

It is entirely possible that one or more of the graffiti McLean found engraved upon a Parisian wall may have been done by Picasso. This nugget of information comes to us from the famous French photographer, Brassai. Brassai has made something of a hobby of photographing the graffiti that have been carved into Parisian walls, and when he showed some of his work to Picasso, Picasso exclaimed, "What life . . . these graffiti have. The wall is something wonderful . . . when I was still young I have even copied such pictures. And how often did I have the temptation to . . . start scratching on it [a beautiful wall] whatever went through my head, but . . ."

And Brassai slyly added, "But you couldn't drag it with you and sell it."

Picasso laughed and said, perhaps with a touch of very justified conceit, "Of course, you have to leave it there to its fate. Something like that belongs to everybody and to nobody. . . ."

Picasso's graffiti are likely to have a better fate than most. The one he did on a bank wall in Paris while waiting to see one of its officers was found quite some time later by one of the directors. He knew his art, for he had it removed just like a fresco and carted it off to his home.

I have not been able, in my researches, to verify this fact but

Picasso in his discussion with Brassai on this subject, stated that Spanish and Italian graffiti are quite different from the Parisian. He insists that the approach is quite nationalistic, and that the phalluses one sees on the walls of Rome are distinctly Italian, and those of Spain still a little different from the Italian. Picasso's erotic etchings are famous and fabulous, but I didn't know his studies for them had included graffiti research.

This is not to say that graffiti are not without ethnic characteristics. Certain types are, and we might, at this point, turn our attention to them.

Ethnic Graffiti
In Sights And Sites

One of the earliest serious studies ever of graffiti dates back to 1593 and is by an Italian. I feel rather a special kinship with this particular man; separated though we are by the intervening centuries, we are united not only by a congeniality of interest in the subject but in a certain similarity in the areas we have found useful study. His name was Antonio Bosio, and from the date mentioned until his death in 1629 his life was devoted to the research and study of the Roman catacombs and its walls. These subterranean galleries of the dead wend their way round and about an area covering 550 miles, anywhere from twenty to sixty feet underground. One can think of our New York City subways, whose walls *I* study, in the same terms, almost. The users, too, of each "system" may have a certain underlying likeness. With a few minor exceptions, subway riders have shown a surprising unanimity of spirit or absence thereof with those who have crossed the River Styx via the catacombs of Rome. The dead in Roma Solterranea Christiana repose with more comfort and room than do the living in the New York Transit System. Should things get worse in the catacombs, the dead are not likely to rise up in protest. Neither, in spite of everything, are the live bodies jammed into the New York system of catacombs.

The history of the Roman catacombs covers a span of eight hundred years and owes its early origin, as do the burial places of the early Christians, to the lingering influences of Jewish practices. The

Jews did not believe in cremation. There are catacombs elsewhere, of course—in Naples, Syracuse, Paris, Alexandria, and even in Mexico—but those of Rome are the most numerous and important from the standpoint of significant graffiti.

I don't wish to imply that the catacombs are important to historians and archaeologists simply because of their graffiti, which, incidentally, are estimated as numbering between 500,000 and 750,-000. Still, what graffiti scholar of today would not feel proud and encouraged by the exceptional sentiment of an earlier time in the exceedingly comprehensive and scientific study done by the archaeologist Giovanni Battista de Rossi in his long work, *Roma Solterranea or An Account of the Roman Catacombs,* published between 1863 and 1877: "As we descend into the interior . . . we are struck . . . by the number of graffiti, as they are called, which cover the walls . . . rude scribblings of ancient visitors. . . . [Of] late years many valuable discoveries have been made by means of them and . . . they have proved to be of immense importance, being . . . the faithful echo of history and infallible guides through the labyrinth of subterranean galleries; for, by means of them, we can trace the course that was taken by pilgrims to subterranean Rome from the fourth to the seventh century. . . . Probably there is no group of ancient graffiti in the world to be compared . . . with those . . . of the[se] crypt[s]. . . ."

De Rossi divided the numerous inscriptions into classes: First, the simple recording of just names, sometimes accompanied by their titles, and which are the classical type, such as Polyneicus, Elpidophorun, Tychis, Meximus, Nikasius, etc. High above the older names are more modern ones such as Lupo, Ildebrand, Ethelrid, Bonizo, etc. De Rossi's second class of inscriptions included good wishes, salutations, or prayers for friends, living and dead. An example is to be found in the catacombs in Rome:

Vivas, Vias in Deo Cristo, Vivas in Eterno, Te in Pace
Mayst thou live in God Christ, for ever, Thee in Peace

The J. Spencer Northcote and Rev. W. R. Brownlow who translated De Rossi, added to De Rossi's collection an example of a series of graffiti written by a man to a woman named Sofronia. Whether she

was his wife, or mother, or sister is not clear, but what is clear is that far from becoming depressed in this abode of the dead, his mood increased in confidence the farther he walked into the shrine of the saints. Before entering the principal sanctuary, he wrote on its vestibule:

Sofronia, vibas cum tuis.
Sofronia, mayst thou live with thine own.

At the entrance itself, he wrote:

Sofronia, vivas in Domino.
Sofronia, mayst thou live in the Lord.

When he reached the principal altar-tomb of another chapel farther on, he stopped to inscribe in larger letters,

Sofronia dulcis, semper VIVES Deo.
Sweet Sofronia, thou wilt live forever in God.

And lastly, in the same area—and now one can almost hear his triumphant cry, more positive than mere hope:

Sofronia, VIVES.
Sofronia, thou wilt live.

In another class of inscriptions, De Rossi lumped together those of a very early age, which consisted of prayers and invocations of the martyrs on or near whose tombs they were scratched. They were rather elaborate, as these for example:

Marcianum Successum Severum Spirita Sanctat In Mente Havete
Et Omnes Fratres Nostros.
Holy Souls, have in remembrance Marianus Successus Severus
and all our brethren.

Petite Spirita Sancta Ut Verecundus Cum Suis Bene Haviget.
Holy souls, ask that Verecundus and his friends may have a
prosperous voyage.

> *Otia Petite Et Pro Parente Et Pro Fratribus Ejus: Vibant Cum Bono.*
> Ask for rest both for my parent and his brothers; may they live with good. [Good meaning in happiness, or with Him that is good.]

The Roman catacombs seem to have been used by non-Christians, too, for in *The Catacombs of Rome*, by Rev. William Ingraham Kip, published in 1854, considerable mention is made of the difference between the inscriptions of the Roman pagans and those of the Christians. "On the pagan side," Dr. Kip said, "we have the pride and pomp of life when, under the old religion, the civil and ecclesiastical states were so closely entwined together. There are the lofty titles of Roman citizenship—the traces of complicated political orders and the funeral lamentations over Rome's mightiest and best. We turn to the Christian side . . . and how marked the contrast! There are the simple records of the poor . . . appealing to the feelings rather than to the head. An incoherent sentence or a straggling, misspelt scrawl . . . the orthography is generally faulty . . . and the sense not always obvious." And he illustrates:

> Pagan:
>
> To the Divine Manes of Titus Claudius Secundus, who lived 57 years. Here he enjoys everything. Baths, wine, and love ruin our constitution but they make life what it is. Farewell, farewell.
>
> Religious:
>
> To Adeodata, a worthy and well-deserving virgin, and she rests here in peace, her Christ commanding her.

Whether life is fun and games for the rich, or serious and sober for the poor, it all ends up the same, a situation apparently fully appreciated by the heathen who wrote:

> While I lived, I lived well. My play is now ended, soon yours will be. Farewell and applaud me.

I rather like that man's anacreontic spirit, although one should I

suppose have some admiration for those who scrawled expressions of hope and confidence in salvation like

Julia in peace with thy saints.

Or

In thy prayers pray for us, for we know that thou dwellest in Christ.

The very statement that one must die to have any peace and the dead must be asked to pray for the living implies that life was very hard indeed.

There are tens of thousands of such inscriptions in the catacombs. One can assume that a dwelling for the dead had for pagan as well as Christian a certain sanctity about it which would prevent any truly ribald or profane expressions, and this may also account for the relative lack of gripes. The early Christians seem to have faced with resignation all types of suffering, so it must have been a brave woman who had the courage to reveal her despair when her child died and to question whether a life in hand isn't preferable to one promised elsewhere:

Oh relentless Fortune, who delights in cruel death, Why is Maximus so early snatched from me?

I have the feeling that once the Italians surfaced into the Renaissance they must have produced some very able graffitists, but it may be that the splendor of the art work from then on has been so dazzling that these tiny fleas of expression are unnoticed in the sonorous outpourings of the giants of culture. Anyway, nobody has recorded them. Nor, so far as I have been able to ascertain, has anyone done any study of the graffiti that surely must exist in the other countries eastward along the Mediterranean and the Adriatic attesting to the ethnicity of the various groups that washed back and forth over the centuries of conquest and reconquest. There does exist, however, some record of the graffiti found throughout the North Arabian desert. One Henry Field undertook to study and collect them for a period

of nine years between 1925 and 1934 while traveling through Iraq, Syria, Jordan, Iran, and Arabia. The Arabian desert has always been what one might call the heartland of the near-eastern nomads, and the graffiti scratched or carved on rocks, at resting places, on buildings, on cairns, or single blocks of limestone and basalt, on walls of wells, etc., have been of great value for scholars studying Arab migrations.

The graffiti, most of which consisted of combinations of lines, circles, and dots, were made to designate the property of a clan or tribe, and the same mark was branded on the camels, for much the same reason it was done in the American West. (Some Arab groups may have tattooed their marks on their wives—to prevent a different kind of poaching, perhaps. This is a theory based on the fact that the Arabic term for "mark of ownership" is *wasm* and for "tattoo" is *washm.*)

Some scholars feel that the very ancient scratchings, crude though they are, are so uniform as to indicate that writing may have developed from them. Others have correlated inscriptions in Greek, Thamudic, Nabataean, Arabic, and Lihyanic alphabets, thus offering silent testimony to the variety and persistence of the traders as well as nomads.

Since my studies of graffiti and their history have been confined geographically to the Western world, I shall not go into any discussion of the graffiti of non-Arabic Africa nor of Asia and the Far East. Not that they would not be interesting. They, if any are, are certainly ethnic in quality, the older ones being extremely rich in anthropological significance, and the contemporary ones (I assume, since no one seems to have studied them) in sociological development. But I am neither anthropologist nor sociologist nor even an historian. As for the graffiti of nomads, we can study those of our own—the American Indians.

The graffiti of the American Indians really come under the heading of petroglyphs or pictographs, mentioned in Chapter Two. What is interesting about them, among other things, is that, although they date back to 10,000 B.C., the American Indians, with very minor exceptions, never chose to go beyond picture writing. It is a form of communication that persists, in much truncated usage to be sure, even today and is certainly familiar to every Boy Scout, every school

child, and any tourist who has ever bought a miniature tepee (made either here or in Japan). Just why these stylized drawings and symbols never metamorphosed into a written alphabet is not clear. Very likely it was because most American Indian tribes, although they on occasion established communal centers, such as the pueblos of the Southwest or the lodges of the Northwest, were essentially nomadic and were discreet groups speaking discreet tribal languages. They never developed the big populations or urbanized centers, as did the Indians of Mexico, Central and South America. This may have been because nature supplied them with all they needed for food and clothing. Buffalo and other wild game were plentiful, on the whole, and, except for corn, there didn't seem to be much need to try to get a steady supply of sustenance from the soil that farming would insure. When the local supply ran out, they moved elsewhere. Under such circumstances, picture messages would be understood where written ones wouldn't be. (This is not unlike China where, even today, there might be several dialects united under the umbrella of a commonly understood written language.)

American Indian pictographs quite often did more than merely convey messages such as "deer are plentiful here" or "a man with smallpox." Often, a tribe remained sedentary long enough to think about man's relationship to the universe, to concoct myths, and to create a few spirits that would have to be placated in order to get rain or a good catch or enough fish. In such instances, the picture writing was incised, scratched, abraded, pecked, or painted on stone. The most widespread and earliest motif, as in almost all petroglyphs, is the hand.

Quite complicated messages were conveyed. Legends, successful hunts, dreams, aspirations, victories in battle, and, most important, ceremonies and puberty rites as well as hunting magic were all graphically delineated. Some of their pictographic ideas were put on birch bark or on the dressed skins of deer and robes of buffalo hides as if to emphasize the Indian's feeling of being at one with nature.

War paint, the symbols used on the face and body, derived from these pictographic ideas. Symbolic descriptions of past victories, war paint was supposed to instill the enemy with fear.

The American Indians were not without a sense of humor, and

quite a number of their graffiti were really idle doodlings done just for fun or to pass some time. Quite often such doodling was done by children in perhaps not so solemn imitation of their elders. Nor is it uncommon to find that many of these doodles are clan symbols having no more significance than the ever-present urban inscriptions "I was here."

That "I was here" syndrome seems to be endemic through the centuries to those who have put some effort, big or little, into getting someplace. It is the ego at work, the self-accolade of achievement as well as a kind of recognition that maybe history *has* been made and posterity *should* be informed. And there is no doubt that a first inscription invites the notation of a second and the second establishes legality of the third, and so on, often through several hundred years. One place in the United States is particularly famous for this reason and so important that it was made a national monument in 1906. This is El Morro, an enormous rock structure which covers twelve acres and rises two hundred feet above the expansive valley floor of the desert just southeast of Gallup, New Mexico.

I am quite fond of El Morro. With my mind's eye I can just see that long string of people, made tiny and inconsequential by the vastness of the desert, pushing on through the centuries, dusted into colorless dun by the windstorms, parched speechless by the dry air, squinty-eyed from the sun, and plain dog-tired from all that walking. Along they come to this great, big rock with steep walls of fine-grained, pearl gray sandstone. It's a good stopping place. With energy restored by rest, food, and drink, the thoughts get organized a little and out comes the pointed tool.

In the case of the Spaniards, who seem to have been the first non-Indians to have seen it, the tool was a sword point. The earliest legible graffito on El Morro is dated 1605. It was incised by Don Juan de Ornate, first colonizer and governor of New Mexico:

> *Paso por aqui el adelantado Don Juan de Ornate del decubri-*
> *mente de la Mar sel Sur a 16 de Abril de 1605.*
> Passed by here the Governor Don Juan de Ornate, from the discovery of the Sea of the South [Gulf of California] on the 16th of April, 1605.

With that kind of hard-won mileage behind him, a little ego-tripping on his part is, in spite of what the Spaniards did to the Indians, forgivable.

The Spaniards never stinted on self-praise, and even if one has never read a history book about the Spanish conquest, one can read volumes in the following statement:

> *Aqui estuvo el General Don Diego de Vargas, quien conquisto*
> *a nuestra Sana Fe y la Real Corona toda el Nuevo Mexico a su*
> *cosat, Ano de 1692.*
> Here was the General Don Diego de Vargas, who conquered for
> our Holy Faith, and for the Royal Crown all of New Mexico at
> his own expense, year 1692.

The quotation referred to a rebellion of some duration, for its possible origin is indicated by Governor Eulate, who had held office quite some time before. He gave this modest account of *his* earlier handling of the matter. The word "gentleman" in the message was crossed out, perhaps by certain members of his party who may have felt he had gone too far:

> I am the Captain General of the Province of New Mexico for
> the King of our Lord, passed by here on the return from the
> pueblos of Zuni on the 29th of July the year 1620 and put them
> at peace at their humble petition, they asking favor as their
> vassals of his Majesty and promising anew their obedience, all
> of which he did, with clemency, zeal and prudence, as a most
> Christianlike [gentleman] extraordinary and gallant soldier of
> enduring and praised memory.

This may have been done at sword's point in more than one sense.

Those Zunis seem to have truly inspired the Spanish graffitists, even to the extreme of poetry, particularly this very famous one which has intrigued scholars of early American history. The translation is by A. W. Barth:

> *Aqui llego el Señor Gobernador*
> *Don Francisco Manuel de Silva Nieto*
> *Que lo imposible tiene ya suyeto*

> *So brago indubitable y su balor*
> *Con los carros del Rei nuestro Señor*
> *Cosa que solo el Puso en este Efecto*
> *de A Agosto y mil seiscientos Beinte y Nueve*
> *Que se bien a Zuni Pase y la Fe lleve.*
> His lordship the Governor here made a call
> Since, now, the impossible (the truth to relate-o)
> His trusty arm and courage holds in thrall
> With the chariots of our sovereign Lord (of all);
> A thing which he alone brought to this state (-0-)
> Of August, 1629, that he (need no more tarry)
> (But) well may to Zuni proceed and the Faith hither carry.

El Morro has on it more than five hundred deciphered inscriptions, and quite a few more that time and weather have smudged beyond recognition. There are all manner of people represented—soldiers, scouts, traders, members of freight and immigrant trains, covered wagons carrying the restless, the adventurous, those hoping for a better life out West. They left their names, their marks, their dates to record their passage, just as did the nomads of the Arab deserts.

There is one other very famous early American graffito now preserved for posterity and tourists. It is carved on a beech tree in central Tennessee. The graffitist is none other than Daniel Boone, and he wrote:

D. Boon
Cilled A. Bar
in ThE
YEAR 1760

He was, as we all know, much more famous for his hunting than his orthographic skill.

The Spanish conquistadores may have had to depend upon chance to supply them with a good wall or rock on which to record their stopping-off stations, and the early Portuguese navigators at first had to do likewise. King John II, however, evidently thought he could simplify things for them and he supplied his explorers with stone pillars surmounted by a cross and bearing the royal arms, name

of the commander, the date the ship left Portugal, and, naturally, the king's name. These pillars were called *padrões*. After Vasco da Gama's time, however, this custom was discontinued and the discoverers had to leave their messages on stones they found where they landed. One of these is in the South African Museum in Capetown. Called the Plettenberg Bay Stone, it is exhibited along with a collection of inscriptions left not only by the Portuguese, but by French, Dutch, and English navigators who also rounded the Cape in search of fortune, glory, and India. These inscriptions are models but not masterpieces of understatement:

QUI Se PErDE	(Here was lost)
A NAO S GO	(the ship *Gonzales*)
ANO 1630	(year 1630)
IZeAO DUAS EM	(They made two embarkations [ships])
BArCAC oIS	

These graffiti clues enabled historians to piece together the adventures of the ship *Gonzales* which reached India on September 2, 1629, and left for Portugal on March 4, 1630. She was wrecked on the Bahia Formosa, now Plettenberg, and the survivors built two boats, one of which reached Mozambique. The other transferred her crew to another ship which finally foundered on the bar at Lisbon.

It is assumed that the English traders, making their way from Surat (an Indian port and center of European trade), who recorded the following were more fortunate:

**THE WILL[IAM] AR[R]IVED. THE FIRST OF SEPTEM-
BER FROM SURAT DEPART[ED] THE 18 DITTO 91628/
CHRIS BROWNE COMMAN[DER] ARTHUR HATCH/
PREACHER OF THE WIL[LIAM]**

Graffiti are, of course, interesting when you can understand what they say. But the graffiti that are recognizable as having definite form and meaning but have so far remained impervious to deciphering are perhaps in some ways more fun, not only because of what and where they are but because of the far-out, not to say esoteric, kind of speculation scholars indulge in about them.

This, for me, is the charm of the two hundred gigantic stone heads found on Easter Island. Found? They can hardly be missed. Set in rows facing the sea they range in height from ten to forty feet and weigh up to fifty tons. You'd think the island would sink under their weight. It is only forty-six miles square, a chunk of volcanic land in the Pacific Ocean, about 2,350 miles west of Chile.

The origin of its population of 850 people is almost as mysterious as that of the heads. The island itself is believed to be a part of a lost continent, and the people are Polynesian in appearance. When Easter Island was discovered by Admiral Jakob Roggéveen in 1722, its natives were cannibalistic and members of immediate families were known to eat each other. The white men who came there did not improve matters particularly. The cats they brought ran wild, and their progeny increased in size and irritability and inhabited the caves. Further, the white men upset whatever ecological balance the natives had established between themselves and the island by bringing in smallpox. The cats might have been coped with; it was not possible to deal with the contagious disease and the natives died in great quantity.

Insofar as the heads are concerned, they are more mysterious than the people. First of all, no one has figured out how they or the stone for them was transported from the lava (or tufa) quarries several miles away. And, too, their age as well as their origin is in doubt. Ethnologist Alfred Metraux thinks they are no more than five hundred to six hundred years old and that they were built by the Polynesian ancestors of the present natives. He sees no linkage in the petroglyphs marking the heads with Egyptian or ancient Hindo hieroglyphics, as do others.

Nor have the fifteen wooden tablets, varying in sizes up to sixteen feet, which have been found on the island, been any help either, although their symbols are perhaps clearer than those on the heads. Incised with a burin made of sharks' teeth, they are representations of birds, fishes, and man accompanied by highly stylized markings which form a completely unique and totally untranslatable (so far) script. It makes one dizzy just to try, because the script is boustrophedon, that is, there are alternate lines from left to right and from right to left, and these alternate lines are inverted. The reader, there-

fore, has to turn the tablet upside down at the end of each line, a tough exercise with pages as large as these! There were, at one time, special teachers, rongo-rongo men, who could interpret the writing. They, unfortunately, have died out entirely. Some scholars maintain that the symbols were aids to prod the memory and enable the clan teacher to recount the tales of war, prayers, and various ceremonies.

But, somehow, I like best of all Francis Maziere's opinion. He has a sort of other-world approach that appeals to me, like I-Ching, or Rosicrucians, or Zen. He is of the opinion that this graffiti writing cannot be looked upon as a literal script, and states in *Mysteries of Easter Island,* "We are of the opinion that the ideographs, like the Quipu or the knotted strings of the Marquesas stand for an element of thought and thence of speech that is not to be encompassed in our form of transcription. Rather do these characters contain a concentrated power of living expression that is possessed by nothing except the mathematical symbols which are developing into the sole universal language." Maziere feels that no frontiers can hinder the transmission and interpretation of mathematical formulae, and this applies to understanding of early symbols. He cites two examples, "All primitive peoples at once recognize and interpret the concentric lines that are to be seen at Karnak and in many other places and that symbolize the waves of life; and then the well-known swastika, whose bent arms began by pointing in the opposite direction to those of the recent notorious example and which, from Tibet to Easter Island symbolizes the setting in motion by man of the two unchanging axes of life—axes that, inscribed in a circle, primarily stood for incarnation and sublimation, that is to say, the vital atom; and there is a certain esoteric knowledge that is aware of their dangerous point of intersection."

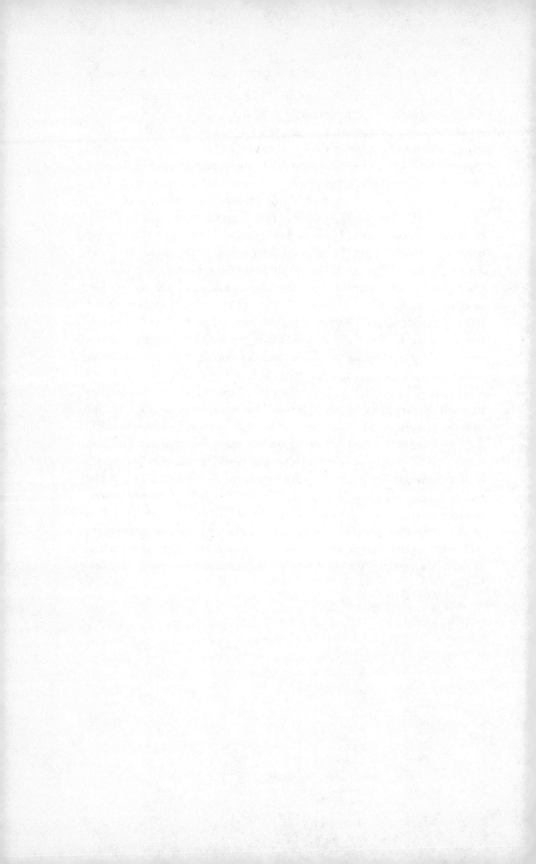

Class, Caste, Outcast, And Politics

To the casual observer, I am sure, contemporary graffiti are no more than the random, spontaneous expression of random, faceless individuals. A passing impulse on the part of an unknown fellow to shock his unseen audience. A moment of maliciousness, that's all. One remembers the clever ones, perhaps, titters at the sexual ones, and is moved one way or another by political ones. It is only the conscientious collector who writes them down and saves them, who sees that they do fall into classes and kinds, that they appear to be written by certain types, that they can fit into various groupings either according to the sorts of people who write them or actual subject matter.

One can assume, although not necessarily prove, that the working class write one level of graffiti, the middle class produce another level, and that the upper class don't write them at all. One makes this judgment on the basis of spelling, quality, or subject matter, vocabulary, literary references, etc. It must be admitted these are generally arbitrary evaluations. For all my very intensive field work, I have yet to catch a graffitist at work. Your guess as to what kind of person writes what kind of graffiti can be just as good as mine.

At any rate, certain specific groups of people do produce a fairly specific type of graffiti and a great many graffiti can be perceived as falling into reasonably definitive classifications.

Regardless of the class of the inscriber or the classification of his

inscription, most graffiti are the expression of one person to the world at large. There did exist, however, up until fairly recently a form of graffiti that was an in-group language related in concept to the pictograph messages of the Indians. It was devised by certain latter-day American nomads, migrant outcasts of society scorned by many as hoboes, bums, and tramps, romanticized by others as knights of the road, men from those famous "all walks" of life who rejected the settled life to wander endlessly, sometimes with no more purpose than to follow a pleasant season across the country, traveling by foot, by thumb, by railway box car. They roamed singly, sometimes in twos or threes, occasionally as groups but never as gangs.

There is no particular evidence that hoboes, as a class or caste, produced more felons than any other social group, yet they have traditionally been viewed by many as only a rung or two higher than common criminals. We may think ourselves less stuffy in attitude these days, but then consider the hostility shown the hippies. Are we really any different now from thirty years ago? Is it solely because we believe the young hippies to be a drug-oriented group that we excoriate them? Or is it because both groups shun "things" and lack proper respect for regulated work, and so run counter to the American Judeo-Christian ethic and entrenched mores?

Although hoboes may have left their places of origin as individuals, they accepted and took care of each other in much the same spirit that members of a religious sect, ethnic group, established fraternity, or hippies will take care of each other. And the way they did it was through their graffiti. It was a highly imaginative, effectively functional written sign language, conveying pertinent survival information such as the presence of vicious dogs, hostile police officers, areas where handouts could be expected, medical aid secured, or chain gangs existed. Chalked on backyard fences, doorsteps of houses, freight yard buildings, walls of public facilities, ashcans, beaneries, lavatories, a great many of the signs were around for twenty years or more. Many are probably still in use, and others may well have changed, as does all small group secretive communication. When the hobo code is broken by the feds, the squares, the johns, the slanguage or signs must be a step ahead and new symbols invented. Just how

they evolved is not always clear, although the origin of many of the following is fairly obvious:

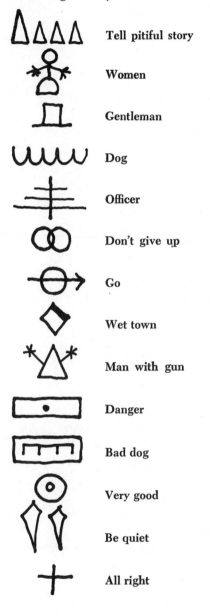

Tell pitiful story

Women

Gentleman

Dog

Officer

Don't give up

Go

Wet town

Man with gun

Danger

Bad dog

Very good

Be quiet

All right

 Chain gang

Doctor

 Town awake, cops active

Town asleep, cops inactive

 Turpentine camp

 Vicious dog guards the premises

Housewife will give·food in exchange for chore

 Unsafe place

Safe camp

Well-guarded house

Good for handout at house

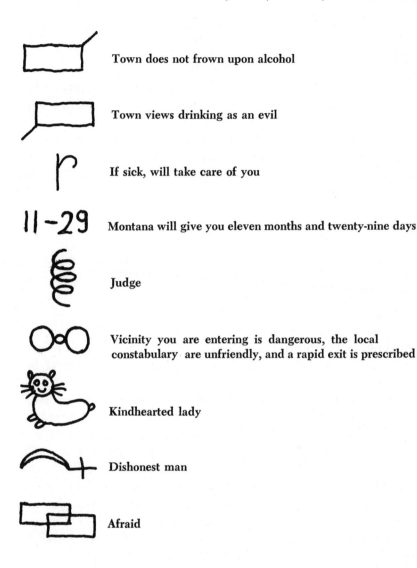

Town does not frown upon alcohol

Town views drinking as an evil

If sick, will take care of you

Montana will give you eleven months and twenty-nine days

Judge

Vicinity you are entering is dangerous, the local constabulary are unfriendly, and a rapid exit is prescribed

Kindhearted lady

Dishonest man

Afraid

Hippies, for all their similarity to hoboes, seem not to have produced a graffiti language that is recognizable as such. They may not need one. What may have supplanted it, for them, are established and identifiable survival centers, such as head shops, where

information as well as incense and votive candles can be secured, used clothing "stores," and organic and macrobiotic food shops for word-of-mouth directions to location of "pads"—the urban counterpart of hobo shanty towns—and communes. The closest they seem to have come to what might be termed graffito expression is in painting the peace symbol, flowers, and the word "love" on walls, windows, side-walks, and cars.

The graffiti of the hobo are the stationary expression of a mobile group. They are factual and functional and, therefore, lack ebullience and humor. There is another mobile group who *are*, however, famous for jocularity: truck drivers.

Truck drivers are notorious for their openly and loudly expressed admiration for women. They are true knights of the road, for their gallantry is bestowed without discrimination upon any form of female, young, old, well endowed, flat, short, fat or skinny. They like to make women feel good, and it would have to be a pretty repressed type who would not feel flattered, albeit shocked, when verbally leered at by a truck driver who risks life and cargo by thus acknowledging her womanliness.

Mexican truck drivers go their American counterparts one better. They not only wave, whistle, comment, and call out as they speed by, but they paint with brush, etch with a knife, or whatever else is at hand on the hoods of their motors, truck doors, or side panels graffiti that are almost as effervescent as their verbal remarks. It is obvious that the Mexican graffitist practices certain Latin etiquette in his public graffiti for it is quite different from his private graffiti. This was noted by A. Jimenez in his book on Mexican humor, *Picardía Mexicana*. In his study of the contemporary graffiti, the bathroom writings he reproduces are quite coarse and humorless, but the truck graffiti are in quite another vein altogether. They are really an original creation in the realm of folk expression.

Señor Jimenez observes, "Warriors used to engrave on their shields mottoes dedicated to their kings or their ladies. In the present day, our truck drivers paint more varied and above all more humorous

signs. The variety and the humor consist in the fact that these signs contain repressed desires, unrepressed desires sprinkled with the most beautiful grammatical errors and written in so poor a hand that the best calligraphers couldn't reproduce it." Frank though they are in their overt sexuality, the following are nonetheless charming sentiments and mark the Mexican truck driver as probably the most romantic in the world:

> *Ay Nanita que curvas y yo sin frenos!*
> Hey, Baby, such curves and I have no brakes!

> *Las mugeres mi delirio*
> *Los peatones mi martirio.*
> Women my delirium
> Pedestrians my martyrdom.

> *Viejito pero mui cumplidor.*
> A little old but very obliging.

This shorthand graffito took a little deciphering and expressed much *machismo*:

> *T BG Y T DG 1 BB.*
> *Te Bese Y Te je Un Bebe.*
> I kiss you and leave you a baby.

A bit of bragging:

> *No Soy Dolar Pero Suvo.*
> I'm not a dollar but I can go up.

> *Pujando pero llegando.*
> Pushing but coming.

> *Pocos pelos pero vien peinados.*
> Few hairs but well combed.

This legend on a truck delivering eggs:

> *Señora o señorita nesesita usted los que traigo cargando, no mas abiseme que paluego es tarde.*
> Mrs. or Miss, if you need what I'm carrying, tell me now, tomorrow is too late.

Safety as well as sex is uppermost in the mind of the truck driver, and many vehicles carry funny warning signs, like this one on the rear bumper meant for those impatient honkers:

Tienes prise? Pasa por abajo.
In a hurry? Go underneath.

Or this, on a dry cleaning truck:

PLANCHAD DE PEATONES
Pedestrians pressed.

As prevalent as are truck graffiti in Mexico, so scarce are they in the United States. Very likely they do exist, possibly in rural areas where there may be still extant the small, personally owned truck such as is so common in Mexico. The Mexican truck driver regards his truck as an extension of himself. Also, because it is usually old and he must care for it continually and personally, he has the same fondness for it as he has for his pets. Car and truck graffiti in the United States are mostly canned, of the bumper sticker variety, although one does occasionally see warning signs such as a death's head over the right side tail light and a hand beckoning one forward on the left side. Or a remark, THIS SIDE, THE GRAVEYARD and THIS SIDE THE ROAD TO LIFE. Not many American truck drivers own those huge monsters they drive, and maybe they just have to stifle their urge to write all over the company's carriers.

During one brief period of national pride or something, when many cars carried a sign which said MADE IN THE UNITED STATES BY AMERICANS, several Volkswagens retaliated with signs reading MADE IN THE BLACK FOREST BY ELVES. And those of us who can recall the days of the Model T might possibly remember a few with natty remarks such as OH YOU KID! Today one rarely sees a private automobile embellished with even up-dated versions of such remarks.

I am inclined to feel that the reason for this is a sort of inverse

class consciousness. The Model T was a working-class car, prosaic, sturdy, hard-working—it was the donkey of the automotive world, and had something of a donkey's ungainly charm as well as stubbornness. One didn't need to treat it with respect, but it was a car people had a lot of personal affection for. It was *not* the car of the upper classes.

Car salesmen made the implications of that last statement very clear by suggesting that cars, the make, size, and appearance, were status symbols. With affluence people became unconsciously convinced that they could hide or blur their class origins behind steering wheels. All drivers of Cadillacs look alike even if they aren't. This is oversimplification, of course, but it's not likely that one is going to mess up a nice, shiny status symbol with irreverent graffiti—not his own and not anybody else's, except in rare instances where a sassy kid will finger write UP YOURS or FUCK YOU into the frost on a windshield.

One would think that millions of cars that sit day and night, forming solid ramparts along the entire length of all our sidewalks would be an open invitation to hundreds of graffiti-prone youngsters, particularly in poorer neighborhoods. This may be an aspect of caste within class in operation here. Cars left on the streets are subject to theft or vandalism, which can be the work of organized, professional thieves, of drug addicts, or thrill-seeking teen-agers. In any case, younger kids recognize cars as out of bounds for their graffiti, except for leaving a hand print in the day's accumulation of grime.

Instead, they turn to the walls. The walls, for the most part, belong to the young. It is estimated that more than one half of the world's children learn to read and write on walls other than school blackboards. In backward and undeveloped countries, the outdoor walls are the places that they see and copy from, and in the poor neighborhoods they form their childhood societies, their alliances, their friendships, and also learn their cruelties via the walls.

They stake out their claims to a territory with a boldly painted terse warning, TONY'S TURF. They declare their love: CHICO LOVES

NANCY, TLF (true love forever). They are harsh and cynical in their name calling: ELDETTA IS A HUA (simplified spelling for *whore*); LEROY IS A FAGIT (faggot, homosexual); NINA IS A LESBO (lesbian).

Herbert Kohl wrote a very informative and perceptive article about the graffiti of young people. Entitled "Graffiti and Culture," it appeared in the April, 1969, issue of the *Urban Review,* and in it he discussed among other things the significance of given names and the names and nicknames children take in order to give themselves different identities. They do this, he says, because they want to take on other personalities, they want to assume different identities. Often they give themselves many names and take on many roles. "We all," he says, "have public identities, and behave in different ways with different groups of people. We have business cards, pins, secret handshakes, badges, etc. In the cases of youngsters from poor neighborhoods, they use the walls that surround them to document and to make public several of these identities."

Thus, on the walls of poor neighborhoods one may find lists of names and nicknames such as Hector the Hooper; Juan, Kid Cool; Maria, Queenie. Initials that go unnoticed by, or are meaningless to adults have a special significance to young people. I myself recall the first ones I ever noticed, and they caught my attention only because I had heard them in jazz circles and knew what the letters stood for. The letters were JAMPF, and meant "jive ass mother fucker."

Mr. Kohl decodifies other frequent contemporary wall initialings such as DTK (down to kill), DTKLAMF (down to kill like a mother fucker). These are usually written after gang names and represent a commitment to fight for the gang's territory.

There are gentler ones, of course. Even tough kids can't totally obliterate every human being's need and longing for affection, and in the meanest of neighborhoods, on the most scabrous of walls, one will still see a gentle TLA (true love always). It's like a tiny weed of hope growing through a crack in the sidewalk.

Young people are quite generous about immortalizing others in addition to themselves on the walls, and as might be expected, particularly these days, their hero worship is apt to be for the anti-hero, the rebel, or the individualist who bucked the tide of convention long before it was fashionable. The hardboiled yet compassionate

Humphrey Bogart heads the list, and running second is that lovable, cauliflower-nosed man who hated children and dogs and couldn't stand lemon in his lemonade, William Claude Fields, better known by his initials, W.C.:

W. C. Fields is alive and drunk in Philadelphia.

Bogey is alive and well and living in Casablanca.

Wall writers of any age like to immortalize the tragic hero, the fellow who lived dangerously, perhaps drank, drove, loved to excess, but gave generously to his art. But they also take note of people simply *because* of their obscurity or the unlikely possibility of their having done anything heroic. Millard Fillmore, a former President, is a good example. Before his brief resurrection by the wall publicists, he was rarely mentioned except by those with a talent for reeling off the fifty states and thirty-seven Presidents in alphabetical order.

Is there any difference between graffiti written on outside walls where the world will see them and those written where the person who inscribes them may be the only reader, where the wall is the prison wall?

Unfortunately, there is a paucity of information on prison graffiti. Although books on penology yield virtually nothing on prison graffiti, some small insight can be gained from accounts of wall writing in occasional prison memoirs. One thing is pretty clear: class and education are as much a decisive factor in the caliber of prison graffiti as they are in outer wall graffiti. Those elegantly phrased Latin inscriptions in the Tower of London were done by political prisoners who are almost by definition given to lofty thinking. The thoughts of the ordinary run of prisoners are as a rule not much above the level of the area eight or ten inches below his navel.

There is a very moving description of prison graffiti in the memoirs of Victor Serge, an exceptionally sensitive writer who was imprisoned for five years in a brutal penitentiary in France. He was himself a

lifelong revolutionary, which may explain his ability to be both sympathetic and detached. He writes:

> The walls speak. To the careful eye, every surface reveals signs . . . scratched in with a pin, or, in dark corners, in thin pencil lines . . . they are always the same in every prison cell: only four or five themes, sex predominating. It is as if the throngs of men thrown together by prison needed only thirty words and a phallic symbol to express the essence of their suffering and their lives. At first glance, the cell is empty, silent, sepulchral. But, after the first five minutes, every square inch of wall or floor has its tale of woe to tell. A thousand hushed voices fill it with changeless, unremitting murmurs. You soon grow tired . . . tired of the constant repetition of the same miseries.

As for the content of these murmurs and repetition, it is sex, often self-pity, from time to time ironic humor and philosophy as well as rue and an appreciation of the tedium of time unalloyed with pastime. Thus the deprivation of sex keeps its pleasures constantly in mind. In describing some of the graffiti such as a heart pierced by an arrow or avowals such as FRED-OF-THE-CATALAN-BAR TO TINA-OF-THE-ALLEY—FOR LIFE, and BIG-JOHN OF THE BASTILLE TO LENA-THE-MOUSE F. L. Serge comments:

> To give or take for life: this is the ritual dream inscribed on these walls by the hands of pimps. Does the idea of self-abandonment really take hold of them? I think, rather, that they suffer . . . from the feline violence of love. Violence is in the domain of the absolute. Other love motifs, brutal commentaries on the previous ones: the phallic symbol, crude urchin's sketch of pointed or fleshy breasts, the slit of the secret lips . . . the ass or whole putline of a woman . . . primitive drawings which evoke the sex act, with the unimaginative lewdness of dirty postcards. . . . How can we avoid the obvious conclusion, looking at these haunting symbols, that a kind of phallic cult persists in the slums of our big cities? The eternity of love is expressed in writing; the permanence of animal lust and all the sufferings it brings in these circumstances cries out in these drawings. . . .

Obscenity, Serge writes, "radiated from the ceiling to the floor,

in writings and in drawings, some of which latter attain the lewd perfection of Persian miniatures." He tells of a life-size drawing of a naked woman whose "lower belly [was] slit open, pointed breasts, mouth twisted, prostituted. The hallucinated artist had not been able to get the proportions right and had been careful and workmanlike only in finishing the sexual parts."

A very common graffito in French prisons is M.A.V., or M.V., which means "*Mort aux vaches*" or "Death to the cops!" It follows almost all of the signatures, and to Serge represents verbalization of one of three fundamental duties of a prisoner: love woman, hate the enemy (the cops), and a solidarity which is expressed by the throwing out of warnings:

> **Dede of Monparnasse is a queer.**
>
> **Riri, squealed on by the Alsatian, two years, burglar.**
>
> **Only seven months more and I'll kill her.**

Or else, solidarity is expressed by a word of advice, found again and again, sharp and clear, signed by countless hands:

> **Never confess.**
>
> **I was dumb, I confessed, I'm screwed, it's all over for me.**
>
> **I confessed: 5 years.**

There is no doubt that in addition to sex, the "stretch," "hitch," or lying-in state is a big theme in prison graffiti, but it isn't always verbalized. It is expressed in the prevalence of the little hash marks gouged into the walls, calendrical notations of the days, months, and years that pass so slowly.

The graffiti of the common criminal, such as described by Serge, indicates the prisoner's indifference to his reason for being jailed. Freedom, not morality, interests him. The drug user, however, seems preoccupied by his crime, almost philosophically so. Harvey Swados, in a *New York Times* article of the Riker's Island prison reports two typical ones that he observed: one pro, and one con, both imply the prisoner's own moral evaluation of his crime:

GIVE ACID A CHANCE, pleaded one.

DOPE IS NOT WHERE IT'S AT, exhorted another.

An ex-con reported that he saw the following one many times. It has a queer desperation:

NO HOPE WITHOUT DOPE.

Women drug addicts, interestingly, are rather intellectual, if their graffiti are any criterion. The following were found in the California Rehabilitation Center for Female Drug Addicts in Norco, California, in 1970:

We have only one life to live and this is no dress rehearsal.

The happiest day is that day in the past that you always run back to when the present proves unbearable.

There's no problem so big or complicated that it can be run away from.

In Burlington, New Jersey, there is a 160-year-old jail that has been turned into a museum. It resembles a medieval dungeon. On its crumbling walls are home-made hash-marked calendars and religious supplications. There is not one scrap of humor such as the classic jailhouse graffito, I'M INNOCENT, THE WARDEN DONE IT. Here the closest thing to wit is the sardonic:

We deserve to go to Heaven,
Because we've spent our time in hell.

Ethnic graffiti is especially preponderant in our time—all too often in the form of hate messages. Jews, the target of many hate scrawls throughout the years, have recently become targets again, and are equated with Negroes and identified with their struggles. I myself saw ugly double-sided nastiness such as JEW IS NIGGER TURNED INSIDE OUT and ALL JEWS AND NIGGERS ARE ONE AND THE SAME.

It is peculiar, I suppose, that public lavatories in some bars are one place where there is genuine integration, and those passing in

and out smile affably at each other. Yet, the walls of the stalls are etched with virulent hate messages, as if in the privacy of the stall what one fears to express openly one brazenly tells the wall, which may answer but never hit back. The nature of the debate often concerns a subject often hinted at but never openly discussed: racial sexual superiority. Which color man is a better lover, better hung, the more enduring performer? Which color woman is more ardent, more cooperative?

Some especially volatile examples:

> Stay seated. This is a Core shit-in.

> Whitey has had it baby, why try to blot it out.
> REPLY UNDERNEATH
> Face it, Blacky is not too bright!

> Congo coons rape nuns.

> I am a nigger, at least this is what you have named me, and that name shall be the death of you white bastards and bitches. This is an oath not a threat.

> N.Y.C. Spic-Coon jungle.

> Do niggers live longer?
> WRITTEN UNDERNEATH
> We fuck longer.
> WRITTEN UNDERNEATH
> What else do you do?

At the turn of the century in Germany, there were quite a number of anti-Semitic messages scrawled on walls that evidently were ignored as being the work of crackpots. Present-day racist graffiti may likewise be more than mere joking or letting off of steam.

The walls have been terse rivals of the soapbox orator and the heckler. Today, the public pontificator can escape the vocally hurled slings and arrows by getting behind the TV screen. The walls more than ever afford availability of both space and audience where man can openly register his gripes of wrath.

Certainly, political analysts and pollsters would do well to examine the walls for indications of political trends and even outcome of elections. In large cities, particularly, people denied the opportunity to express themselves as they might in small town meetings will use the walls. In the last New York mayoral race, graffiti such as PROCACCINO FOR LORD HIGH EXECUTIONER, PROCACCINO FOR PIG, or (on a restaurant window) MELON WITH PROCACCINO—TODAY'S SPECIAL foretold the results of the election with just as much accuracy as the *Daily News* Poll.

There were a few unkind things written about Lindsay, such as HE COULDN'T CLEAN UP THE SNOW, HOW DO YOU EXPECT HIM TO CLEAN UP THE SHIT, but statistically, Mario Procaccino received more insults than votes. In the Goldwater–Johnson contest, HARI-KARI WITH BARRY, URINE IS LIKE GOLDWATER, and other endearments were straws in the wind. Later on, Johnson was put up against the wall when his Vietnam war policies came under fire: JETTISON JOHNSON IN '68, COMMIT LBJ, NOT THE USA, PRESIDENT JOHNSON IS A LATENT HUMAN BEING.

Political campaigning through conventional channels is enormously costly. Politicking on walls is a bargain because masses of people see the message.

Wall inscriptions that attack political figures are no new thing, of course. Abraham Lincoln was the subject of many a cartoonist's poison pencil.

The walls have always and traditionally played an important role in the politics of confrontation, which, quite naturally, doesn't allow for going through regular governmental channels. To get results with this kind of political action, the attack takes the form of militant groups lying in front of buildings, provoking authority by every means short of armed force, and by stark statement of defiance or exhortation painted boldly if crudely on walls and fences.

If one were to describe the last decade, it could very well be called "The Age of Protest." Every group has a lobby of one sort or another: homosexuals, abortionists, prisoners, pot smokers, LSD users, feminists, anti-vivisectionists, pacifists, civil rightists, anti-fluoridationists, sexual freedom fighters, atheists, anticapital punishment people, and countless others. And then there are large segments of the

population with no specific gripe but just generally discontented with things as they are. They all talk to the walls, and if they don't write, they wear a button to talk for them and to repeat what the walls are saying:

Cure virginity

Legalize Necrophilia

Lower the age of puberty

Support the rich

Ecology, the last fad

Under these circumstances, it was inevitable that the graffiti writers would turn to satire and produce some nonexistent causes. Let me caution not to send your checks to such appeals as "help stamp out entropy" or for the support of "retarded unicellular animals" or

Help bring F° k into polite usage

Stamp out philately

Free space

Repeal the law of gravity

There are many cause-and-protest messages that are printed on walls, pavements, and tiles with a ready-made stamp. One such message advocated total equality for women and another was against forced autopsies. One could consider these as relatives of true graffiti, but only through marriage. When they turn up in car card ads, you realize they are part of a commercialized fund-raising campaign.

We don't really see too many revolutionary graffiti in this country. Why, I am not sure, unless it is because there is no unified revolutionary creed to provide guidelines. The Black Panthers and the Black Muslims are united in color but not course of action; the Weatherman and Students for Democratic Society have sharply differing ideas about ultimate goals. About the only battle cry they all

have in common is a version of "Down with the Pigs." And they have no universal symbol, such as the old time revolutionaries had in the hammer and sickle, or clenched fist.

I would like to put into this category of "protest and cause" graffiti those that I call the "suggestion box." The charm and joy of these suggestions are that they cannot be put into practical operation, nor are they ideas that will improve each shining hour. Some are pathetic attempts at whimsy, others are caustic reversals of pollyannaisms: FOR BROTHERHOOD WEEK—TAKE YOUR BROTHER HOOD TO LUNCH; THINK ROTTEN; FIGHT SMOG. BUY A HORSE; DRIVE DEFENSIVELY—BUY A TANK; LOVE THY NEIGHBOR—BUT DON'T GET CAUGHT.

If revolution has not inspired graffiti in this country, the Vietnam Was has. The graffitists show that the overwhelming sentiment is for withdrawal. PULL OUT JOHNSON (or Nixon) LIKE YOUR FATHER SHOULD HAVE. I'D RATHER HAVE MY COUNTRY DIE FOR ME. BETTER RED THAN DEAD.

The war has gone on through three administrations, in the face of moratoriums, draft card burning, student unrest, and national disaffection. The walls carry on, expressing a majority feeling of yearnings for universal peace, humanitarianism, and eventual world government.

WAR, one graffito states categorically, CAUSES CHROMOSOME DAMAGE.

Graffiti In Literature And Art

I would be the very first to acknowledge that to refer to graffiti as literature or art would be a grandiose pretention. But there are those who have seen a special estheticism in the phenomenon of graffiti, and several artists have found the walls quite inspirational. André Pieyre de Mandiargues, in the March, 1958, issue of the French magazine *XXe Siècle* writes, "Certainly the wall is inexhaustible. It is furrowed with crevices . . . reveals . . . traces of vanished paint, wild brush strokes and a hundred thousand inscriptions; it is a sort of greenhouse of scribbles . . . it is the common origin . . . of . . . artists as diverse as . . . Hartung, Atlan, Ubac, Karskaya, Begottex, Zao Wou-Ki, Dova, Crippa, of the 'tachists' and . . . of spontaneous 'graphism! . . .'" It is his conviction that the writing on walls has inspired numbers of those huge canvases with what he refers to as "instinctive gestures" painted on them, and with no reservation at all, avers that "if the free stroke, which had been neglected since the decline of expression, is coming into wider favor again, this is due in great measure to the example of the wall."

M. de Mandiargues may be going a bit overboard, but no more so than Burhan Dogancay, an American artist who finds the walls of New York fully as provocative in providing themes for his paintings. The catalogue of one of his shows quotes him: "Walking about in this magnificent city . . . riding in subways and buses . . . of Gotham, I discovered a new world, a wonderful world, a magic world! . . . 'The

World On The Walls of New York' . . . Madison Avenue posters embellished by . . . unsophisticated literary and artistic additions of the child and young adult, who 'improved' upon the signs in passing. Drawings, colors, harmony, composition, poems . . . they are all alive . . . they are life as it is lived . . . not of make-believe . . . sham . . . [or] courteous pleasantries. . . ." He spoke further of the basic element of spontaneity, the personal touch which gives each street, each wall, its "individual personality," and, like McLean in his observations of French graffiti, feels that graffiti provide a "thumbnail sketch" of the people who live in the vicinity.

Dogancay says, ". . . At first glance, you may say 'Uninteresting; these posters are defaced; the slogans are crude . . . dirty.' But look further and . . . you will agree that 'Johnny loves Mary' is an honest expression of emotion . . . tic-tac-toe . . . competition . . . the crude slogans are basic and, though earthy, are condoned in books which top the best-seller lists."

The strongest argument for legitimizing graffiti as an art form comes from a photographer, Brassai, whose own work which we mentioned in a previous chapter is much respected as art. Brassai has spent over thirty years studying and interpreting the streets and walls of Paris with his camera.

In 1960 he published a book of his photographs and critique of the graffiti of Paris (*Graffiti*, published by C. Beiser Verlag, Stuttgart). He sees his profession as an almost unique means of preserving graffiti, which he appreciates as a remarkable and meaningful art medium. In describing how the words and drawings from the wall jump with forceful simplicity into his face, Brassai says, "They appeal to the photographer, saying, 'Save me, take me with you for tomorrow I'm no longer here.'" And he equates the power of graffiti with that of primitive art because its forthrightness, its artlessness, lack of technical proficiency, and playfulness endow it with the same kind of primeval force and charm.

This is why he feels that, in the future, graffiti will find itself in the realm of the arts. "The totems of the Negro and the Polynesian, the Aztec and the pre-Columbian symbols, Etruscan, and Hittite gods, Indian fetishes, all these have conquered the West," he says, and continues, "At the beginning of the century . . . unknown or despised,

today they have entered the museums of fine arts . . . at first they were atrocities, then curiosities, then objects of research . . . [now] transformed . . . into masterpieces." The primitive (if by that we mean untaught) hand seems to be able to by-pass the control of the conscious mind and directly express the emotions.

"Expression," as Brassai puts it, "has nothing to do with knowledge and skill." To him, "Awkwardness [or lack of affectation] means greatness and lack of skill means talent and these things are signs of genuine creativity."

Thus it is that in the photographs taken of the walls, Brassai is able to show not only their affinity to the depiction of gods and idols done by the peoples of Oceanica and other primitive cultures but how they at the same time are related to modern art and artists. "In the world of art where the avant-garde joins the antique . . . the wall and its graffiti have a special value," he declares in noting how graffitists recognize the sculptural qualities in the holes and pock marks of the wall and incorporate these into their designs; and he speaks of the "same surprise that I had when I first experienced Mexican and Pre-Hellenic art or when I saw a Miro, Picasso, and Klee. There has been an extremely important occurrence (as important as cubism). The discovery of the wall by our new artists . . . the secret influence of the wall on today's painter . . . already noticeable in cubism and in the collages which contained rags and sedimentation. . . . Dubuffet and others . . . let themselves be influenced by graffiti. . . . Max Ernst was especially sensitive to the impetus of the wall . . . even the action painters and calligraphers have been sensitive to the primordial inspiration and the splatterings on the wall."

Brassai, like so many artists, even those whose work is as tied to mechanization as Brassai's is through the camera, feels that contemporary art is a search for the innocent and a rebellion against the "misdeeds of a mechanized civilization." Innocence is the only "effective antidote against excesses of technique and science." The walls, because its artists are innocent (as opposed to sophisticated and intellectual), perhaps because the artists so often are children, offer an inexhaustible source of form, color, content, and timeless language, a strong universe of signs, symbols, spells, witchcraft, devils, fauns, phallic gods, heroes, warriors, animals, monsters, and creatures half-

brute, half-human. To Brassai, the walls speak of life, birth, love, death, metamorphosis, where genitals become a face, the face a heart, and so on.

One could, of course, question whether the walls have influenced modern art as much as has the work of primitive cultures, but I don't believe that the relationship between the spontaneous emotionalism of graffiti and overt symbolism of primitive art can be denied. The difference is that the first is rebellion against a cult of repression and the latter is a cult in itself. Because they both are so close to primordial inspiration, they may have a more up-to-date quality, regardless of their age, than other art forms.

If artists have long been aware of graffiti, graffitists have not been nearly as interested in the work of artists, and although the range of subject matter in graffiti is wide, neither art nor music have received much attention, except (not unnaturally) in the toilets of music and art schools, or sometimes in those of intellectual coffee houses and establishments in and around university areas. Art, since it has become more important as investment than embellishment, is no longer the province of a few art journals and culture hounds. All the large daily newspapers and all the national magazines cover the cultural beat, so the general public and investors are at least aware of the many art movements that fly by in rapid succession: pop, op, kinetic, environmental, electronic, color field, shaped canvas, hard edge, etc. Andrew Wyeth and Andy Warhol are equally well known, and, when over $50,000 was paid for a Wyeth, some cynic reduced the purchase to a dime-store transaction by stating: ANDREW WYETH PAINTS BY NUMBERS.

Right after World War I, there was movement that was something of an anti-art form intended to shock, to disgust, to express disillusionment, not unlike the intention of many art movements today. It was called Dada, and that it is alive and possibly even well is manifest in the recently inscribed messages DADA SAVES and EVERYTHING IS DADA.

Andy Warhol, who has turned his contemporary Dada movement into a whole industry, was the recent subject of a graffiti conversation which went something like this: First, the scribble ANDY WARHOL with the "war" slashed out and "ass" written over it. Then nearby,

with an arrow pointing toward the name Andy, HANDY? and under-neath, NAH. DIRTY. and finally, AND HIS MOVIES ARE BUMMERS TOO.

Insofar as music is concerned, the walls extoll artists whose careers are often as ephemeral as the graffiti that memorialize them. The Beatles, of course, have been noted, and The Rolling Stones. The long hairs (I use this expression in its earlier connotation because everyone has long hair these days and you can't distinguish true grit from false by beard alone) proclaim BACK TO BACH or BRAHMS NOT BOMBS or MOZART REFRESHES BEST. I find it somewhat suspicious that, of the long roster of second stringers, Antonio Vivaldi has been singled out as a favorite and is seen all over in graffito and buttons: VIVA VIVALDI.

I have chosen to include the graffiti of the advertising world in this chapter because advertising is a form of verbal and visual com-munication. Life on jammed trains and buses isn't as beautiful as the ads would have us believe, nor on the littered streets the billboards look down on, nor in crowded subway stations. It's no wonder someone puts a mustache on the face of the girl in the deodorant ad, or knocks out the paper hero's teeth by blacking a few of them with ball point pen or a giggling school girl cuts out a poster rival by drawing a beard on that unpimpled chin.

These are, of course, the mildest manifestations of perhaps justi-fiable hostility and criticism on the part of the ordinary, run-of-the-mill, spur-of-the-moment prankster. We see this kind of thing so often we hardly notice it. But advertising graffiti often advertise that there are quite a few people who are malicious and disturbed, whose fantasy world is filled with ugliness and resentment. These are the ones who mutilate the posters. They gouge out parts of the face, particularly the eyes, exaggerate secondary sexual characteris-tics, such as nipples, put breasts and a curly pubic triangle on the bare chest and shorts of a male sunbather, bushes of hair under the arms of a model using an antiperspirant, drape male sexual organs on a Brotherhood ad. I've even seen sexual drawings made on pictures of infants. People whose graffiti come so close to vandalism must be particularly disturbed.

If advertising posters seem to appeal to the graffitist for embel-

lishment, they also invite dialogue or rebuttal. Copywriters make their messages very short and leave lots of white space around them. Train and bus rides and after-rush-hour waits in subway stations can be quite long, however. There is more than enough time for the message to sink in, even into the slowest thinking mind. The temptation to comment is understandable, particularly in view of ridiculousness if not actual stupidity of the advertisement. An ad urging people to drink milk will be scrawled with cynical (but medically sound, mind you) retort: YEAH, BUT IT'S GOT CHOLESTEROL GOOD FOR HARD ARTERIES. Cigarette posters will very frequently have addenda averring, THE BEST OF THE FILTER-TIP COFFIN NAILS. Another card extolling the advantages of steno-type was scorned with, I LIKE THE TOUCH AND FEEL TYPE MYSELF.

On a poster advertising a funeral parlor which said, WE UNDERSTAND a graffitist added: HOW TO EXPLOIT SADNESS AND DEATH FOR OUR PROFIT.

(poster) **If the President finds time to help the mentally retarded, what are you doing that's so important?**
WRITTEN UNDERNEATH
Working to get them out of Washington.

(poster) **Did you make New York dirty today?**
ADDED
New York makes ME dirty every day.

(poster) **Don't be a high-school dropout.**
WRITTEN ON IT
No, stay in school and learn to read and riot.

(On poster reading): **"You don't have to be Jewish to love Levy's real Jewish Rye"** the following comments were added:
To be offended by this ad.
To be called one.
To oppose the war in Vietnam.
To go to Columbia University, but it helps.
To wear levis.
To be circumcized.
To be a lousy lover.

Advertising posters about movies frequently unleash a graffitist's

ambition to be a cartoonist, for not only will the star's face be subjected to additional "make-up" but he will have, emerging from it, a balloon that indicates that Julie Andrews, clean-looking as she is, is really a call girl. Or, Doris Day gets her kicks by peddling drugs.

Government recognition of graffiti came in the form of a full-page ad which urged the purchase of U.S. Savings Bonds with a reproduction of what appeared to be a hastily scrawled ominous message similar to the one used when a Broadway show closes, "Due to lack of interest, tomorrow has been cancelled."

Several corporations have held graffiti contests of one kind or another, the most famous of which was the well-publicized one sponsored by *Time* magazine and open only to members of the advertising fraternity. The graffiti that were deemed to be the cleverest were displayed in a special exhibition in Grand Central Station in Manhattan. It was long enough ago (May, 1967) that I can now confess that it was I who wrote prominently over one of the exhibits: GOOD GRAFFITI CANNOT BE FORCED. However, there were a few fairly interesting entries:

> Double your pleasure . . . double your fun . . . Xerox your pay checks.
>
> Drink Canada dry. Visit Expo '67.
>
> Since using your shampoo, my hair has come alive.
> —Medusa
>
> The White Knight free-lances.

The Riegel Paper Company also held a contest, and the brochure detailing the rules requested that the entries be kept clean. I found their sample suggested types somewhat less than inspirational as well as unoriginal: HELP STAMP OUT DEADLINES or, a definite crib from the much more clever one I previously mentioned in relation to art, OUR ART DIRECTOR PAINTS BY NUMBERS. There was one I thought did show a spark of inventiveness: FLOW GENTLY SWEET ALFTONE.

The contest the Scripto Pen Company conducted struck me as being one of those ideas that must have sounded great in the conference room and proved a disaster in practice. They put up large

posters of a pretty face duplicated on it eleven times and the copy invited people to draw beards and moustaches on one or all of the faces. The whole thing struck me as silly in the extreme. For one thing, it would hardly have inspired anyone to rush out and buy a Scripto pen and come back and start madly drawing moustaches. The paper was amenable to the use of any kind of ink or pencil, not just Scripto's. For another, why exacerbate the war between the sexes? Putting moustaches or a beard on a woman is not one bit funnier than putting breasts on a man.

Once in a great while, someone will latch on to the notion that graffiti are a great way to advertise or reach the public without going through the usual commercial channels. One such person was a gentleman who wrote a song entitled: "An Onion And You." He expended considerable energy but very little money, for he wrote the title in chalk a few thousand times all over the city. The tune never did become famous, but the composer got some publicity because of his industry.

People don't take such graffiti advertising too seriously. It is doubtful, even, if the phone number solicitations one so frequently sees on walls, particularly in lavatories, are ever followed up. I called two numbers, once, just to check them out in the name of scientific investigation. One was for a regular business firm and the other a luncheonette. The numbers were probably put on the wall by disgruntled employees who hoped the managements would be annoyed by crack-pot callers.

Considering the extent to which we are bombarded with ads, it is strange that graffitists do not use them more as points of departure for their flights of fancy. In the case of subway cards, this scantiness may be due to the temper of the times. When muggings and vandalism began to increase during off-hours, subway trains were reduced in length so that fewer cars would ride empty. This meant graffitists were deprived of the privacy they seem to need.

One can ascribe to graffiti all kinds of esoteric qualities: it has sociological meaning, historical significance, is a human activity that links contemporary man to his early progenitors, reveals the prevalence of neuroses, etc. But when you get right down to it, as far as most graffiti readers are concerned, what makes graffiti worthy of

note is that they are either funny or dirty or both. And the most admirable graffiti of all are those that incorporate the element of caprice, the ones that have an element of the surrealistic, a wry twist, a touch of the sardonic or irony, even a pun. If there is any one single quality of graffiti that puts them in the domain of literature, it is their capriciousness.

What about a date?
UNDERNEATH
July 3, 1776.

Brooklyn is alive and somewhere in New York.

My heavens, where did I leave my crotch?

The capricious graffitist doesn't have time to write a long joke. He has to make his yak quickly and then beat it. But it evidently doesn't bother him that he will not be around to witness its effect. I suspect that he is in love with his own sense of humor. His creation, if it is indeed a creation and not a crib, tickled him, and since *he* knows what's funny, he is sure it will fracture others. Consider:

Absinthe makes the heart grow fonder.

Eat Shit! A million flies can't be wrong.

I'd give my right arm to be ambidexterous.

Last sperm in is a rotten egg.

The more you cultivate people, the more you turn up clods.

I would say that the major portion of wall writings that contain allusions to literature is done by students. They seem to have the interest (or perhaps are forced) and time to read. From what little graffiti I have been able to collect in this area, I would conclude that assigned reading may bug them but unassigned reading inspires them —but to not very great heights of expression. In 1966, some twelve years after it was first published, a three-volume, 1,781-page fairy tale called *The Lord of the Rings* by J. R. R. Tolkien, surfaced from the juvenile literature library stacks to become a best seller. Its hero is a hobbit, a decidedly physically unattractive little manlike creature with

hairy feet, who gets tangled up with ogres, trolls, dwarfs, and giants in a confusion of adventures fully as complicated as the Ring of the Nibelungenlied. Tolkien invented a language, a calendric system, and a family tree, and filled his long tale with plenty of good and evil, bloody battles, magic, and lots of thunderous storms and bad weather.

American youth took the book and its leading creature to its heart, established fan societies, learned the language, had programs on WBAI and Pacifica Radio, kept in constant touch with its author —and produced one graffito: FRODO LIVES. So sacrosanct was it that nobody had the guts to ask where.

Again, as in art, if literature has not found its way into graffiti, graffiti has found its way into literature. Brigid Brophy, in a novel entitled *In Transit,* quotes some graffiti I feel sure she must have really seen and made use of to give her work verisimilitude. Her hero has gone into a public toilet, and, while trying to find a place for his briefcase, reads over the variety of inscriptions left by others before him. He ascribes FRENCH LETTERS WITHOUT TEARS to an unknown American tourist, and then notes a graffito RAY'S MIRANDA and credits it to a "homosexualatinist."

In Miss Brophy's words: "The section of the wall beside the rack was a regular Poet's Corner-Nineties post, O'Rooley particularized, to judge from their latinliturgical preoccupations. Beneath the laudation of Ray, a different hand had chalked PENIS ANGELICUS. The first hand had then returned and written finally ANUS MIRABALLIS."

Miss Brophy reveals a nice insight into graffiti motivation when she writes, "Filled with a sense of euphoric kinship with his unseen brothers, the unknown hands who left their marks, O'Rooley scrabbled in his pocket . . . fetched out his pen . . . looked around for a spare stretch of wall." He doesn't find much space, but notes a German punster's work, DER GRAF FITO WAR HIER, what the author describes deliciously as a "positive scholars' palimpsest." The novel goes on:

> **The original hand had written:**
> BUT YOU'D LOOK SWEET UPON THE SEAT
> **To this a scholiast had supplied**
> OF A BISEXUAL MADE FOR TWO
> . . . O'Rooley decided to aim for simplicity . . . he wrote
> BLESS YOU, BETTY BOUNCER.

And here the author does indeed grasp the graffitist's manner of thinking: ". . . and how, he wondered, would Betty Bouncer from henceforth be imaged by generations of those who pass water while passing through Transit?"

CHAPTER EIGHT

W. C. Latrinalia, Sex And Homo-Sex

For generations, the wall used to be among the very few places one could openly read or view hard-core pornography. The situation today, of course, is considerably different. Where have all the birds and bees gone? Chased away by all those Sensuous Women, Dr. Reuben, Masters and Johnson, Henry Miller, John Lennon, and hundreds more. One feels guilty not if one reads the stuff, but if one doesn't.

And how does all this availability—indeed, inescapability—of once forbidden matter affect graffiti? Has such overwhelming competition for public attention stifled it? Is it less indelicate, indecent, vulgar, smutty, nasty, or pornographic? Has the output lessened?

No, not at all. If anything, the scrawling of sexual graffiti has in fact, burgeoned, and if you haven't yet learned about sex from a book you certainly will from the walls. It is almost as if sex were a recent discovery and Americans were embracing it as a newfound toy to be played with in and out of books, bedrooms, and bathrooms, public and private.

Although there has been a sharp increase in "dirty word" graffiti in ladies' rooms, particularly in the colleges and universities, women's rest rooms in public places tend to be cleaner than men's johns.*

Part of this is due to the fact that managements know women

* The word "john" for toilet gained fashion in the 1930s in American women's colleges. In the twenties at Vassar, the "head" was called "Fred."

will not tolerate slovenly conditions and often won't return to an establishment whose toilets are unpleasant. Ladies care. But, interestingly, their graffiti do not complain about the mess so much as the lack of a good mirror and adequate lighting.

Men complain about the condition in privies, too, but their ire is directed not toward the management but toward the previous and upcoming users of the equipment. One of the major themes—I consider it a folklore, almost, because it is common to all eras and in many countries—is the injunction to stand close to the urinal so as not to wet the floor. The simple graffiti is quite intriguing. The writers are not really worried about spillage or urological flooding. The reproof lends itself to extensive variation in the use of slang words for penis, and implicit in the admonition is the insulting suggestion that "your, fella, but not my'" horn, peg, hose, joint, bat, pistol, ad infinitum is too small and too inadequate in strength of propulsion to hit the target, and *ergo,* not up to its other functions, either.

> **Young bucks with short horns step up close.**
> *Men's room, Wyoming*
>
> **Take a giant step, it's not as long as you think.**
>
> **Stand up close. The next man might have holes in his shoes.**
>
> **Stand up close. The next fellow may be a Southerner and be barefooted.**
> *Camp Maxey, Paris, Texas, 1945*
>
> **Stand closer, the monks have bare feet.**
> *From* Graffiti *by Richard Freeman, England*
>
> **Stand close, don't flatter yourself.**
>
> **Stags with short horns, please stand close!**
>
> **Puritans with short muskets step up to the firing line.**
> *Damariscotta, Maine, c. 1950*
>
> **Pilots with short engine mounts—please taxi up close.**
> *Men's toilet, Alberta, Canada*
>
> **Pilgrims with short muskets stand within firing range.**
> *Toilet in Boston, Mass.*

Old rams with short horns please stand up close.
Fort Lewis, Tacoma, Wash., c.
1945

Men with short bats stand close to the plate.

If your hose is short and your pump is weak
You better stand close or you'll pee on your feet.

Bulls with short horns stand close.

Cuddle up a little closer, it's shorter than you think.

There is a quality of playfulness in the "stand close" graffiti, but the lack of toilet paper is not regarded with humor and often goads wall writers to inscribe indignant and desperate messages.

Ein Arschwisch war jetzt lieber mir als sonst ein wertvolles Papier.

Something to wipe my ass with would now mean more to me than any other scholarly paper.
Men's room, Breslau, (Anthropophyteia, *vol. 6, 1909*)

En este triste cagadero
Busco en vano el papel
Con los tres ojos abiertos
Y no puedo dar con el.

In this sad shit house
I look in vain for paper
With three wide open eyes
I cannot find it.
Hotel Cosmos, Trujillo, Peru,
1890

Here I sit in stinking vapor
Some sonuvabitch stole the paper.

Women, although their rest rooms just as often run out of this essential, don't write about their irritation. Either they go directly to the management or, more likely, they use the facial tissues they carry with them. They use the lavatories as much for freshening up their faces as for other purposes, and so come well equipped for contingencies. Since so many toiletry companies are now adding cosmetics

for men to their lines and over-the-shoulder bags are now being made especially for the male, perhaps this particular grouch will soon disappear from the walls of the male lavs. Or maybe the unisex trend will extend even into w. c.'s, and men will be able to borrow Kleenex instead of two fives for a ten.

Men sometimes give housewifely directives requesting that cigarette butts or toothpicks not be thrown in the urinals. These, too, are frequently springboards for humor of a more earthy nature.

> Do not throw toothpicks in the bowl
> The crabs here can pole vault.

> Do not throw cigarettes in the urinal we do not piss in your ashtrays.

> Do not throw cigarettes in the urinal as they come soggy and difficult to light.

> Be a man, not a fool
> Pull the chain, not your tool.

Graffitists often have a social conscience. A few summers ago, New York City suffered a severe water shortage, and resourceful graffitists produced such a rash of "don't flush" messages, the city was saved from total dehydration.

> Save water, don't be a four flusher.

> Save water—do not flush until it's dark yellow.

During the eighteenth century when chamber pots were common, they were treated as functional *objets d'art* and were elaborately decorated with all sorts of intricate decorations. Not a few were quite pertinently embellished with sayings which very likely are the forerunners of the advice we see today in public privies. One of the enjoinders on these jerries (as chamber pots were affectionately called) was so popular it became a postcard:

> Use me well, and keep me clean
> And I'll not tell what I have seen.

Why women don't graffetize in toilets as much as men has been a subject of interest and speculation to sociologists and psychologists for some time. The Kinsey report *Sexual Behavior in the Human Female* cites the following observations made in the German *Anthropophyteia* collection back in 1907-12 which was, in large part, a survey of men's toilets: "Most of the female inscriptions referred to love, or associated names . . . or were lipstick impressions, or drawings of hearts, but very few were genitals or dealt with genital action of sexual vernaculars." The report wondered whether this was because women are "less inclined to make erotic wall inscriptions because of their . . . greater regard for the moral codes and the sexual conventions." It also is felt that women are not as erotically aroused as men by seeing sexual action, actual or portrayed, so wall inscriptions have little erotic meaning for them. Kinsey corroborates this opinion, but I wonder.

My own early searchings rarely turned up anything raunchy in ladies' rooms, either, except a few bars. (Perhaps women have a greater respect for clean walls. Washing walls is a cruddy chore.) Present-day frankness about sex and the Women's Lib influence may well change this. In our educational institutions, particularly at the university level, the girls have already broken loose with a vengeance. Mushy sentiments and advice to the lovelorn are a big topic. The men still lead in the four-letter-word department but the women are catching up. The most prevalent theme of all, however, advises the disposal of virginity, posthaste: I'M A VIRGIN, BUT I'M ON THE VERGE; CHASTE MAKES WASTE.

The Kinsey report states, ". . . whatever the conscious intent of the inscriber, wall inscriptions provide information on the extent and nature of the suppressed sexual desires of females and males." Kinsey implies that much of what was written was just bragging and really exposed unsatisfied desires, that it dealt with activities which "occur less frequently in actual histories." Since the inscriptions are anonymous, and located in restricted, hidden, or remote places, they must be done by those who wouldn't dare express their erotic interests openly where they could be identified.

"Comparisons of the female and male inscriptions epitomize,

therefore, some of the most basic sexual differences between females and males," Kinsey declares.

Why is most pornographic wall writing done in privies? And why is the bulk of it concerned with excreta?

An interesting theory has been suggested by Dr. Alan Dundes of the University of California at Berkeley. He made a study of bathroom graffiti (which he aptly termed Latrinalia), and in his paper issued in spring, 1966, by the Kroeber Anthropological Society, he states that anything, with the exception of tears, that leaves the body from any of its apertures is considered dirty and disgusting—so much so that the direct words for quite necessary bodily functions have been replaced by euphemisms. One "sees a man about a dog" or one "freshens up."

Everything about the toilet and the excreta of the body is taboo and is not openly referred to in polite society. This attitude is so deeply ingrained in our mores, says Dr. Dundes, that it has caused the study of Latrinalia to be scrupulously avoided by the vast majority of social scientists.

Housewives, abetted by decorators, go to great lengths to obscure the original function of bathroom equipment by means of elaborate prettification. If not out-and-out disguised with wicker and wood, toilet bowl and tank can be swathed in brightly colored acrylic fur or ceramically printed with paisley or blue forget-me-nots—not to mention decorated toilet paper, the absolute end in functional art.

Since so much pornographic wall writing is provoked by frustration, anxiety, and the desire to express what a person cannot state openly the preponderance of the word "shit" in graffiti and conversation may simply be a form of rebellion.

Further, having relieved himself physically, the scrawler may as well relieve himself of the excreta of his mind while he is about it, in the same place and at the same time. There is no doubt that there is a relationship between inscribing taboo words on a wall and playing with feces, which very small children often do. For some adults, the

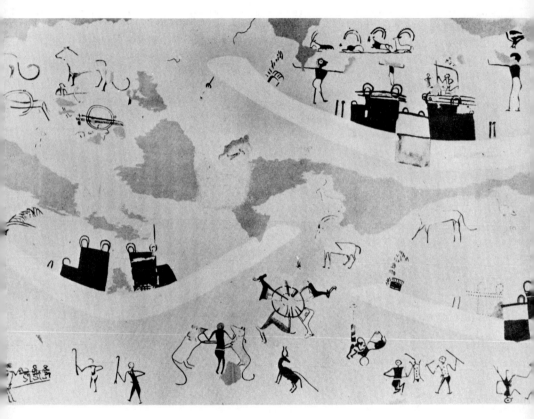

Hierakonpolis, Egypt, 3200 B.C. Oldest known picture made on a man-made brick wall. This funeral scene found in a predynastic tomb can be "read."

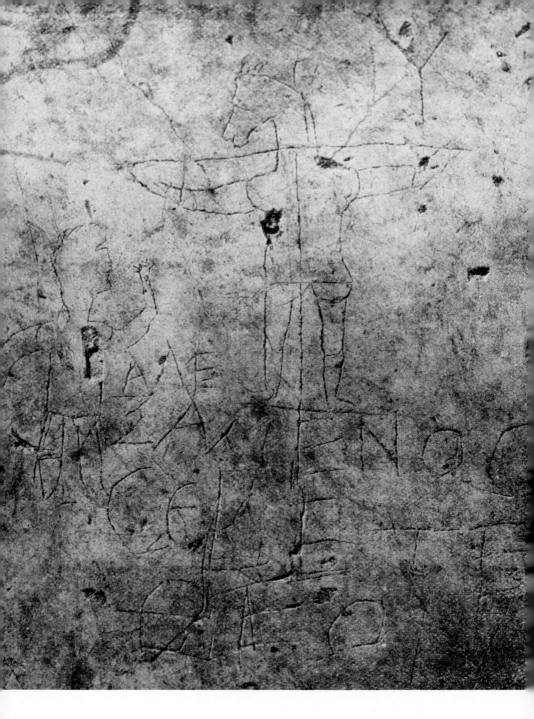

Kircherian Museum, Rome. Caricature graffito of Jesus Christ drawn only a few years after the first preaching of the gospel in Rome by the Apostles. Christ is represented with the head of a donkey. To the left of the cross is the figure of a Christian youth in adoration. The legend on the picture reads, "Alexamenos worships his God."

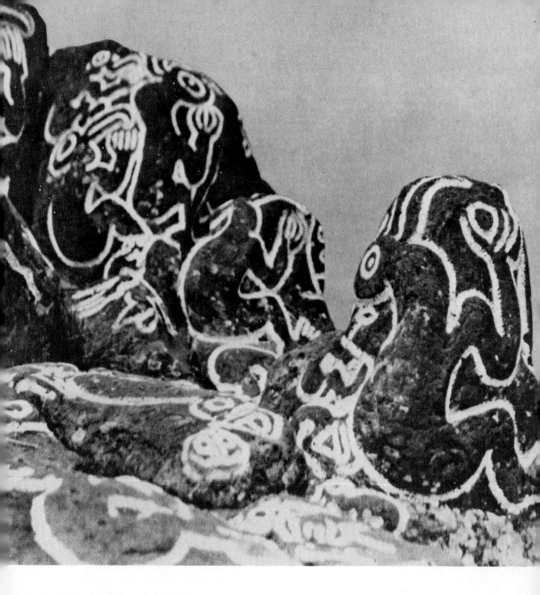

Easter Island. Picture-writing. Date unknown.

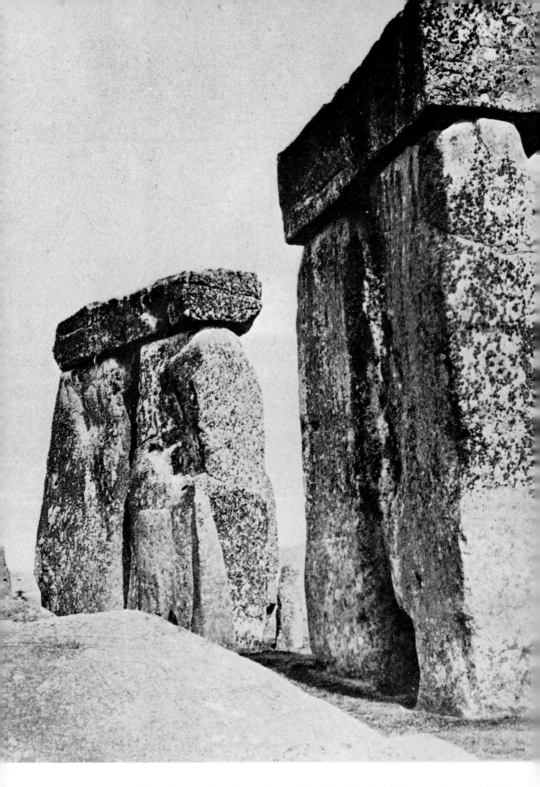

Stonehenge. Salisbury Plain, Wiltshire, England, Bronze Age, c. 1500
B.C. Pick marks are on side of base.

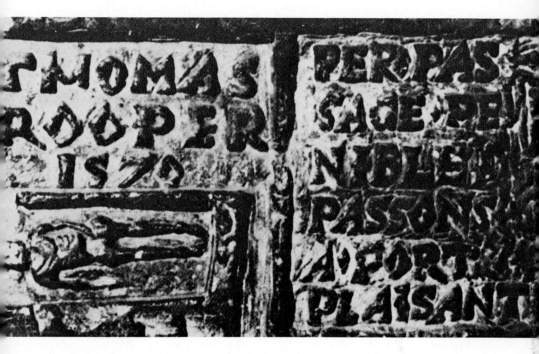

Beauchamp Tower, Tower of London, 1570. Thomas Rooper's inscription, "Per passage penible passons à port plaisant" (By the painful passage let us pass to the pleasant port).

Clubhouse on East 11th St., New York City, resembling a stage set.

Some chalk converts this street fixture into a stark totem pole.

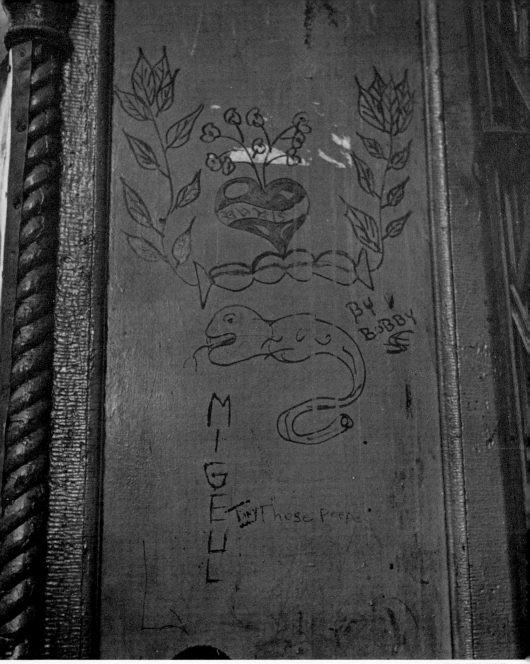

Building entrance, New York City.

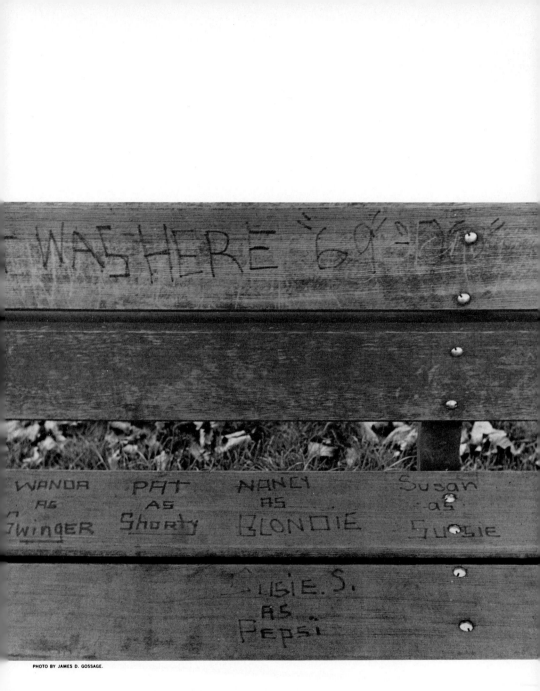

Youngsters take on other identifications and personalities for their friends. In their imaginations they are different people at different times. East River Park, New York City, 1969.

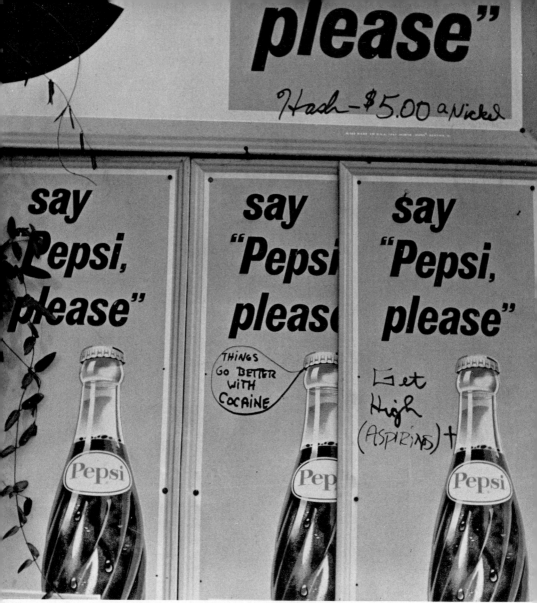

Graffiti often reveal a pervasive interest in drugs. A nickel bag of hashish costs five dollars. The Pepsi bottle inspires take-off on ad slogan. Aspirin and cola is supposed to produce a high.

Door of men's room.

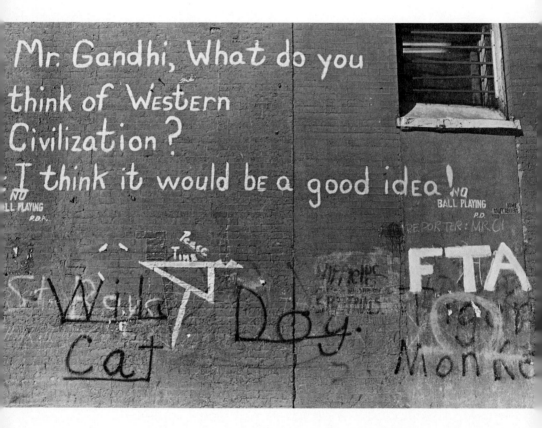

The very neatness of the writing of the Gandhi graffito indicates that it was not spontaneous inspiration. The letters FTA are also quite commonly seen, especially in Vietnam; it stands for Fuck the Army.

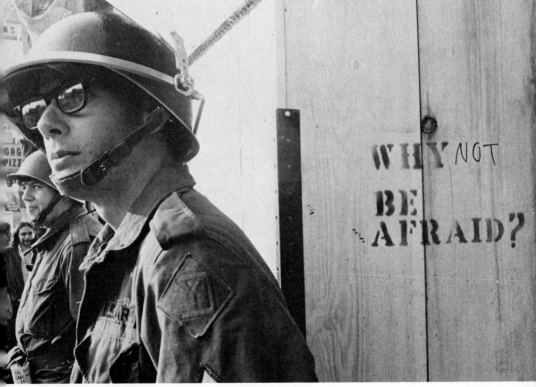

A National Guardsman stands watch during a May Day rally near
Yale University. New Haven, 1970.

SAN—TOY

ΤΟ ΦΑΡΜΑΚΟ ΤΟΥ ΕΡΩΤΟΣ
ΕΙΝΑΙ ΤΟ ΠΟΤΗΡΙ
ΤΗΣ ΛΙΣΜΟΝΙΑΣ
ΛΙΣΜΟΝΙΑΣ
ΑΝΔΡΟΣ
ΑΤ
ΒΜ

PHOTO BY JAMES D. GOSSAGE.

Ellis Island, Upper New York Bay. Here immigrants and deportees were processed until it was shut down in 1954. The graffito written in Greek translates as, "The only thing that can cure love is the glass of forgetfulness."

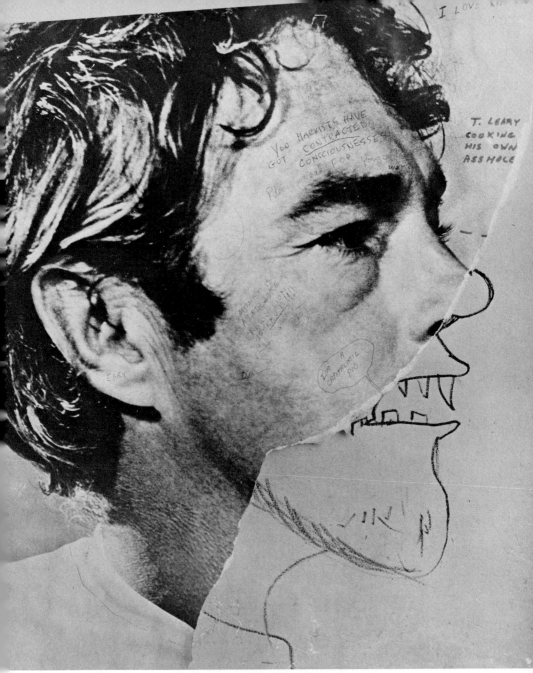

Ladies' room at the Alternate U., a center for revolutionary thought on West 14th St., New York City. The Gay Liberation Front also meets there as you can see by the confession in the upper right-hand corner.

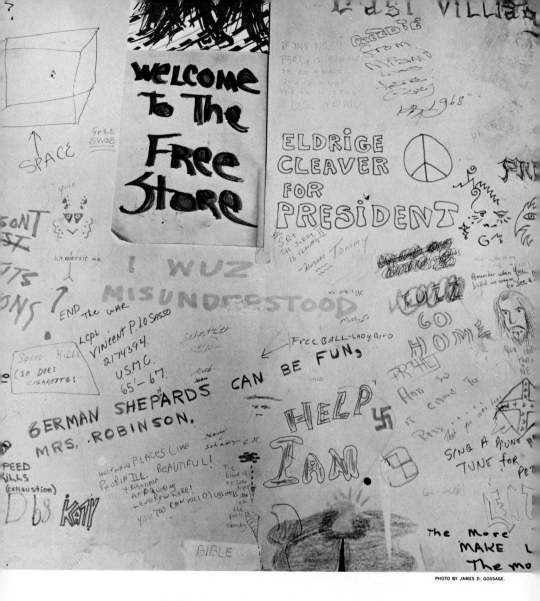

Wall in lobby of Free Store Theatre, East Village, New York City.

Men's room wall.

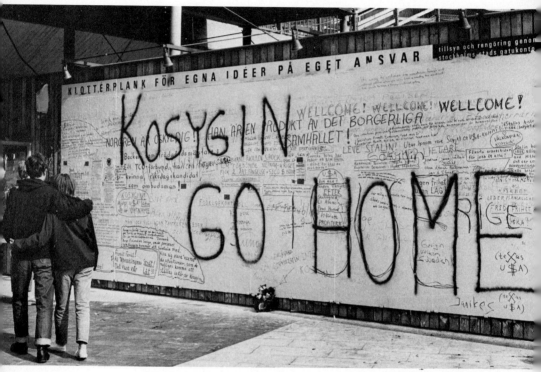

Stockholm, Sweden. Official wall *(Klotterplanket)* put up by city and whitewashed every day for passersby to express themselves.

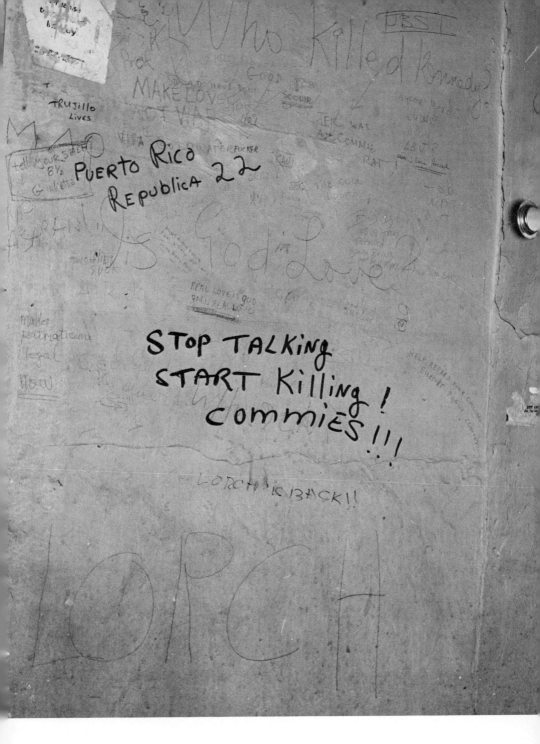

Men's room wall, East Village coffee house, New York City, 1967. At this time right-wing legends were quite rare on walls.

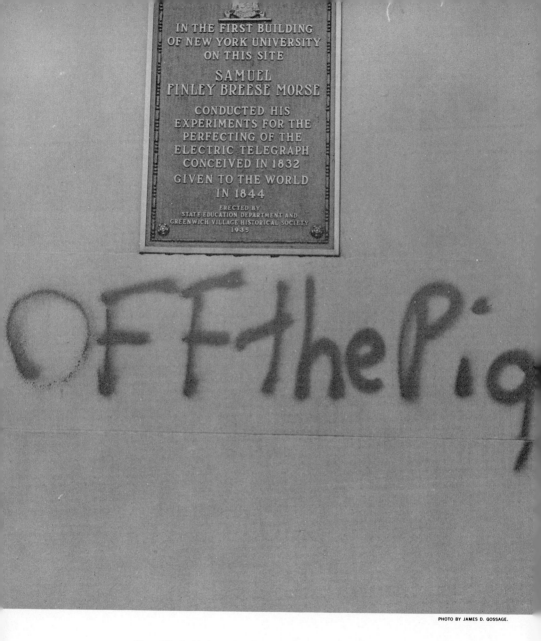

New York University Building, Waverly Place at Washington Square East, New York City.

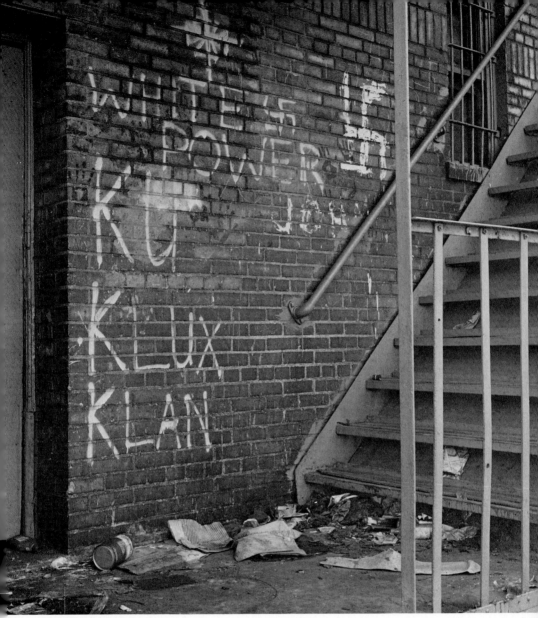

Wall with racist sentiments against blacks, and a swastika so that Jews should not feel left out.

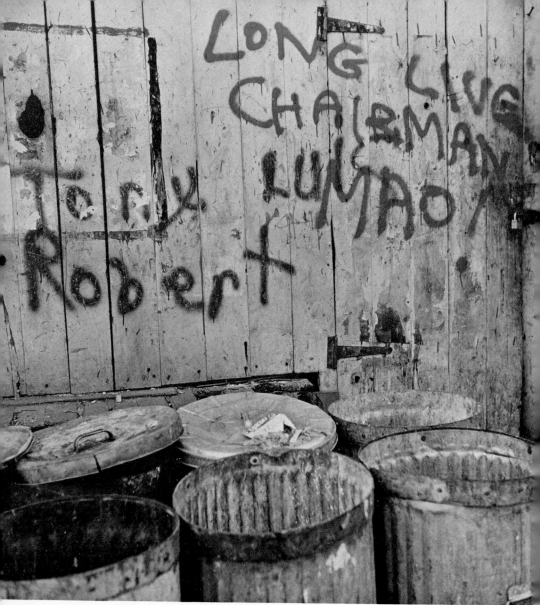

Looks like a palimpsest with Mao substituted for Lumumba.

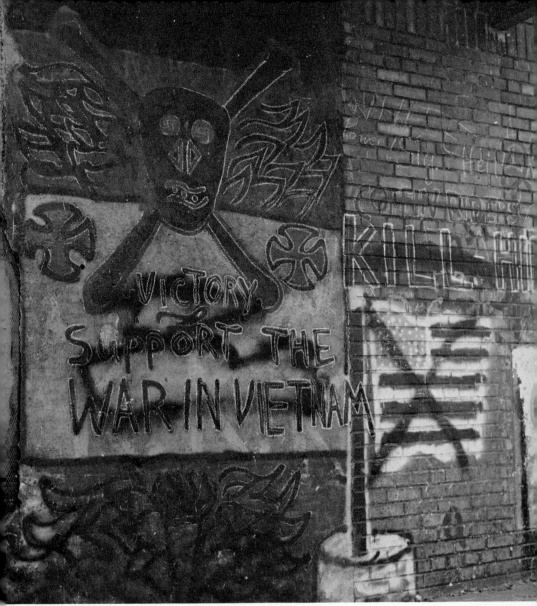

PHOTO BY JAMES D. GOSSAGE.

Rear of theater. Patriotic sentiment lumping hippies along with the V.C. German iron crosses suggest that the enemy also includes Jews.

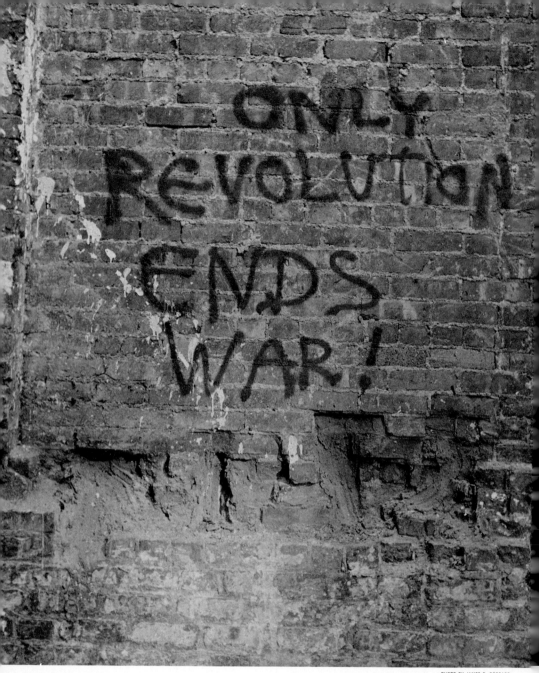

Wall of vacant lot.

privacy of a public lavatory affords *them* the chance to be naughty by smearing the walls with orthographic offal.

For others, it may be their only creative outlet. Bruno Bettelheim is convinced that men the world over are pregnancy-jealous, envious of the birth-giving process, the acme of creativity. Not being able to give birth to children, many males take pride in the issuance of large turds. To them, it represents strength and virility.

Dr. Karl Abraham, in his *Selected Papers,* offers another possible theory for the plethora of wall writing. "Many neurotics," he says, ". . . worry . . . over waste of time. . . . Only the time . . . they spend alone or at . . . work . . . seems well employed. Such patients frequently undertake two occupations at once . . . they like to . . . learn, read, or accomplish other tasks during defecation. For these neurotics, the w.c. is the true place of production . . . solitude is an assistance." Dr. Abraham and Otto Fenichel observe that reading while on the toilet is a way of taking in material and thus balancing off the loss of material. Much German graffiti of the turn of the century was a consequence of lack of reading matter: Managements generally provided newspapers for tidying up; when other paper or none at all was supplied, the result was an increase in the output of wall writing.

Sexually oriented graffiti are not limited to a preoccupation with feces. Heterosexual, romantic love simple, simple-hearted, and simple-minded, constitutes a high percentage of it—and the dullest. Yet, all those hundreds of names of sweethearts held within the embrace of a heart or simply coupled together with "loves" are touching. Better, anyway, to inscribe the name of one's beloved on a wall rather than having it tattooed on one's body—"body graffiti." A name on a wall is easier to scrawl—and wash off—than a tattoo on a torso.

The sexual revolution may (but I don't really believe it) put love out of business. With sex as available as the next meal, yearning and jealousy are becoming square emotions, infidelity no longer provokes fury, daydreaming and waiting for Mr. or Mrs. Right are becoming old hat. And maybe that will clear the walls of "John loves Jane." I suspect that French graffiti are so largely political rather than amorous because one reaches a point of sexual sophistication where wall writing about romance becomes sappy. In Stockholm one is hard

put to find a wall message about Greta's golden tresses, but injunctions such as GIVE 11-YEAR-OLD GIRLS THE PILL are a common sight.

If the coupling of boy-and-girl names doesn't register with us, the uniting of two names of the same gender with a verb suggesting love or sexual activity will. Such graffiti are not usually a declaration by one of the partners but are rather the insults of boys teasing other boys or girls being mean about another girl. The graffiti done by homosexuals are of a different content.

The majority of homosexual inscriptions are to be found on lavatory walls and are usually requests for assignations. Such graffiti will list physical dimensions, telephone numbers, or advertise talents in unusual techniques. In this culture where homosexuality, in spite of liberalized attitudes, is forbidden by law or custom, the men's room serves in the capacity of a dating bureau.

Some homosexual graffiti seem to have an auto-erotic quality, as indicated in the Kinsey report on who writes what and why: "The male usually derives erotic satisfaction in anticipating that the inscription he makes will arouse other males . . . who may . . . see them. It is notable that the wall inscriptions are concerned more with male genitalia more often than with female genitalia . . . it is possible that homosexual males . . . may be aroused in making such inscriptions . . . because they anticipate how other males will react upon seeing them. The heterosexual male has no such incentive, since he knows . . . no female will see his writings."

Homosexuality seems to preoccupy Americans to an almost inordinate degree, as if it were some exotic disease. But the truth is, it has been present in every age and in every society, and even exists among animals. There is no statistical evidence that there are more deviants today, in ratio to population, than in other times. It just may seem so because these days we are being taught or urged to tolerate if not be tolerant of the nonconformists, those of other races, creeds, color, manner, and even sexual behavior. There is no longer the same shame attached to being different, so those who used to hide can now come out in the open.

In a recent scientific paper written by Lee Sechrest and Luis

Flores, the homosexual wall writings of Americans were compared to those of the Filipinos. It made the point that although homosexuality is a well-known phenomenon in the Philippines, there is a low level of concern about it, as reflected in the wall inscriptions. "In the American sample, 42% . . . involved homosexuality in some way while only 2% of Filipino inscriptions concerned homosexuality at all. And 22% of . . . the American inscriptions involved specific invitations to or requests for homosexual relations. Another 6% of American inscriptions consisted of accusations of homosexuality or homosexual behavior."

Many of the inscriptions on the toilet walls are of a propagandizing nature, wherein the inverts (a word preferred by homosexuals to perverts) attempt to win converts: GO GAY, LAVENDER POWER, GAY POWER, GAY IS O.K., GAY LIBERATION are but a few of the most common ones. Another, which promises the strange pleasures of deviation, is COME ON OVER TO THE S AND M SIDE. (S and M stand for sadism and masochism.)

The British *Journal of Criminology* of January, 1963, makes an interesting comment about the findings of J. Housden, who spent two years collecting graffiti from lavatories in Greater London. "The largest number of inscriptions referred to transvestism, fetishism, homosexuality and masochism. There were more than twice as many references to transvestism as to homosexuality . . . [which] suggests that transvestism and fetishism are probably far more common than is usually thought."

Keepers of public morals look upon homosexuals as vampires who persuade youth toward vice. But I wonder if the draft and the Vietnamese conflict are not more persuasive. The Army rejects a very large number of men because of outright, proved homosexuality or because of pretty accurately feigned fagginess. Those who don't know how to be queer can learn from a book entitled *1001 Ways to Beat the Draft*, which gives detailed instructions. It was summed up in a prevalent graffito and a button which said, MAKE BOYS, AVOID THE DRAFT.

A now far-famed homosexual graffito alleged

My mother made me a homosexual.
AND A WITTY CYNIC ADDED
If I sent her the wool would she make me one, too?

I have heard of no graffiti where girls blame their fathers (or their mothers) for their lesbian tendencies, possibly because there are far fewer lesbian graffiti. Those I have encountered, like the gay male ones, in extolling the absence of possible consequences of hetero- sexual behavior, have an aspect of seduction: GIRLS ARE BETTER THAN BOYS—YOU CAN'T GET PREGNANT FROM A GIRL. What with the availability of the pill, such enticements may now be ineffectual.

The most common sexual graffiti of all is the word "fuck." As old as this word is, as well known, as much as it is openly bandied about by the present generation of youth, when it appears on a wall, it still so shocks that many an outraged reader will make orifices of its apertures.

This famous word did not appear to scholars until A.D. 1278, at which time it had an *er* suffix and was a descriptive appendage to a certain John. It was not uncommon in the Middle Ages to have a characterizing adjectival phrase attached to one's name, such as Charles the Simple, Louis the Pious, so why not John the Fucker, if that was his most salient quality? It is considered, as we know it, to be of Anglo-Saxon origin, although it may have a root or two of Greek-Latin ancestry, through the Latin *futuere* or *futuo* (to have connection with a female) or the Greek *phuteyo* (to plant) and the French *foutre* (a slang term meaning to thrust). The German (Saxon) can offer *ficken* (to bang or strike), the Swedish *fika* (to hunt after), and the Middle English *fyke* (move restlessly).

In the Army, the word is as basic as rations and so standard as not to be noticed at all. H. L. Mencken noted that when the "sergeant ordered his men to get their fucking rifles, it was just routine, but if he merely said 'Get your rifles!' they knew that there was immediate action and peril afoot."

My own activities as a collector and researcher in graffiti have so inured me to the word that it long ago lost its sting of obscenity, but I was surprised when studies turned up evidence that the expression of this and other obscenities is not a sign of depravity or dirty- mindedness and is in fact salubrious and good for the psyche as well

as the soul. Ashley Montagu explains that cursing is an appeasement, an "emotional orgasm, which along with weeping and laughter, restores the normal psychophysical equilibrium." He is supported by Dr. Raymond Hollander, who, in the *Psychiatric Quarterly* of October, 1960, discussing obscene language, states: "When tension increases, it is thus discharged . . . used in anger, and then again with love, to give a sense of belonging and its opposite—now in happiness . . . sorrow, despair, or boredom. Cursing can be considered to have been displaced from its aim of aggressive rage. . . ." Writing obscenity on a wall, especially a word that is not found even in the ten-volume Oxford English dictionary ought surely to loosen a few emotional knots in an uptight person.

The most companionable and therefore most commonly practiced sexual activity, the one most essential to the passing of life itself from one generation to another, has, until recent years, been also one of the most avoided subjects in public conversation. It is therefore not too surprising that it is so common in graffiti. What is surprising is that the next common sexual practice—it is estimated that at least 80 percent of all people engage in it—is not a popular graffiti subject at all. Once considered a scourge to the emotions that could lead to impotence, frigidity, and even insanity, it is now often recommended and urged as legitimate and even necessary. Yet it is not a popular subject for graffiti. Sexologists, psychologists, and psychiatrists have taken much of the onus off onanism, but the graffitists seem reluctant to do the same. Perhaps this is because masturbation is the loneliest kind of sex play. Or, some of the previous critical scorn may still be attached to it. Sexual prowess with another person, regardless of conversational taboos, has always been a matter of pride. Even if a graffitist is fantasizing, he is apt to brag about how many times he made it with someone else, but be very silent about how often he made it with himself. As solitary an act as the writing of a graffito is, masturbation is evidently too solitary even for his taste.

However, with the new morality, graffiti show a livelier attitude toward auto-manipulation, and there is the famous graffiti comment on it: ONE THING ABOUT MASTURBATION, YOU DON'T HAVE TO LOOK YOUR BEST.

The last of the dirty words to have any sting to it these days is

SUCK. Again, this is an obscenity that affords the scrawler a great release of gut feeling; it expresses his hatred, hostility, venom, and contempt for a simple slang word representing what many consider the highest, most intimate expression of love. Decoration on old pottery, delicate sacred statuary in Indian temples, and lovely Japanese prints all are evidence that cunnilingus and fellatio were acceptable and recommended sexual practices in past civilizations. Still, the Judeo-Christian code condemns it and the law sometimes views it as illegal even if indulged in by married couples. Gershon Legman, who coined the phrase "oral genitalism," describes it, after the use of the hands and the sexual parts themselves, as the "most valuable erotic technique and the most efficacious . . . also the most misunderstood and the most maligned." In spite of this blessing, malice, deprivation, and frustration are inevitably behind that scrawl: SUCK.

Collector's Choice:
A compendium of selected graffiti

ADVERTISING

Pall Mall can't spall.
 (Time *magazine's graffiti contest open only to ad men, May, 1967.*)

Reach a media man—advertise on swizzle sticks.
 (Time *magazine's graffiti contest.*)

Smokey the Bear is a hairy boy scout.
 (Time *magazine's graffiti contest.*)

The White Knight cheats at polo.
 (Time *magazine's graffiti contest.*)

Juan Valdez takes tea breaks.
 (Time *magazine's graffiti contest.*)

You meet the nicest Hell's Angels on a Honda.
 (Time *magazine's graffiti contest.*)

The Edsel is coming out in paperback.
 (Time *magazine's graffiti contest.*)

I dreamed I could wear a Maidenform Bra.—Twiggy.
 (Time *magazine's graffiti contest.*)

I find Time easy to digest . . . except for the staples.
 (Time *magazine's graffiti contest.*)

Poster: "I got my job through *The New York Times.*"
WRITTEN BELOW
So did Castro.

On a prophylactic machine:
It takes the worry out of being close.
 (*Shafter, Nevada, rest room.*)

You don't have to be Chinese to love Ho Chi Minh.
UNDERNEATH
He's not Chinese either.
 (*Lion's Head, Greenwich Village, New York City.*)

You took a long time to come.—Vagina Slims.
 (*Coed toilet, Alternate U., New York City.*)

Poster: "Some people don't read *The Daily News.*"
UNDERNEATH
Thank God!
They wipe their asses with it.
That's why they buy the NEWS.
They make love instead.
They line their garbage cans with it!

To poster reading, "What will you do when this circuit learns your job?" was added:
Buy a circuit breaker.
Pull out the plug.
Buy two and retire.
Go on relief, stupid!
Make one that can do yours.
Marry it, of course.

Poster: "Worship Together This Week."
UNDERNEATH
Is it your business?
Don't advertise religion.
Keep our God free of churches.
Just a universal conspiracy for idiots.

Poster: "Don't be a high-school dropout."
WRITTEN ON IT
No, stay in school and learn to read and riot.

Forest fires prevent bears.
(*On Smokey the Bear poster and button.*)

On a poster advertising a funeral parlor which said, "We understand" was added:
How to exploit sadness and death for our profit.

Chiquita Banana is a pusher.
(Time *magazine's graffiti contest.*)

Sara Lee is a diabetic.
(Time *magazine's graffiti contest.*)

On a Gillette billboard ad:
Jesus Shaves!

Do the Chinese look in the White pages?
(Time *magazine's graffiti contest.*)

What this country needs is a good 5 cent anything!
(*On candy machine that contained only ten-cent items. Subway station, New York City.*)

You kill 'em we chill 'em.
(*Scrawled on an undertaker's ad.*)

They laughed when I sat down to play—how did I know the bathroom door was open.

El Exigente killed Che Guevara.
(Note: El Exigente is the coffee taster in the ads for Savarin.)
(*IRT subway station, New York City.*)

Don't be half-safe. Be cocksure.
(*IRT subway station, New York City.*)

Dow—better murder through chemistry.
(*Men's room, Harvard Univ., Cambridge, Mass.*)

Poster: "Did you make New York dirty today?"
ADDED
New York makes ME dirty every day.

Are you nervous, tense? Try my 8″ relaxer.
 (*NBC Studios, New York City.*)

CAPRICE

My sons are extraterrestrials.

Merry Christmas and a Hippy New Year.
Greenland—love it or Lief it. Lief Ericson.
 (*Princeton, 1970.*)

Mira! Mira! on the wall.

Nudists are people who wear one-button suits!

TVA levitates.

They all moved to the country and took jobs as barns.
 (*Tavern in Seattle, Washington.*)

Peter Graves, your penis will self-destruct.
(Note: Mr. Graves is the star of *Mission Impossible,* a TV adventure series.)
 (*Men's room, Jeanne's Patio Restaurant, Greenwich Village, New York City, 1970.*)

SDRAWKCAB is backwards spelled backwards.
 (*Men's room, telephone directory proofreader's office, midtown, New York City.*)

In Hoc Signo Hasso.
(Note: Variation on the motto of the Emperor Constantine, *In Hoc Signo Vinces,* "In, or by, this sign thou shalt conquer.")
 (*Ninth Circle Restaurant, Greenwich Village, New York City.*)

Machines are made by men and thee.
But only Moms can make a me.
(Note: A credit should go to Joyce Kilmer and to Pops, too.)
 (*Men's room, The Blue Unicorn coffee house, San Francisco, Calif.*)

100% of all students who take physics pass it.
ADDED
Students who take Physics deserve it.

There was a young couple named Kelly,
Who went around belly-to-belly,
Because in their haste
They used library paste
Instead of petroleum jelly.
 (*Men's room, Dwinelle Hall, Univ. of Calif., Berkeley.*)

Green plants are friendly.
 (*Bottom of the Barrel, folk-beat café, Atlanta, Georgia.*)

He who hints
For a blintz
Gets his wish
With a knish.
A pox on your lox;
I'll inveigle
A bagel.

I love grils.
UNDERNEATH
It's spelled girls.
UNDERNEATH
What about us grils?

Brooklyn is alive and somewhere in New York.

Hey you, get off my cloud.
(*Ladies' room, "55" bar, Greenwich Village, New York City.*)

As Samson said to Delilah, "Couldn't you at least have left the side-burns?"
(*Boarded-up store front, New York City, 1970.*)

The last book on elephant physiology was written in 1936—this was also the first.
(*Univ. of Michigan, Ann Arbor.*)

Old postmen never die, they merely lose their zip.

The bald eagle wears a hair piece.
(*Univ. of Michigan, Ann Arbor.*)

Things are more like they used to be than they are now.
(*The Alibi, a bar in Bloomington, Ind.*)

GRAFFITREE

(Note: There were two big beautiful elm trees in front of the student union at Cornell Univ., but this year the Dutch elm disease struck one. There is now only one big beautiful elm tree, and one 6'-high stripped stump where graffiti appeared almost instantaneously, 1969.):

Is Euthanasia in the case of Dutch Elm disease justified?

This tree died for our sins.

Thus should be the fate of Spiro Tree Agnew.

This is the Math tree, it has ordered pairs and square roots.

That tree over there [arrow pointing to the other tree] is very angry. Would you like somebody to write all over your dead brother?

This tree is a dorm
For deep in the elm
Is dwelling a worm
Whose name is Anselm.

Please stop scratching on my walls.—Anselm.

Où sont les graffiti d'antan? [Where are the graffiti of yesteryear?]

You too can prevent forests.

Graffiti space for dogs.

(*Found on Charles St. subway station, Boston, Mass.*)

Dear Johnny if you don't see my message on this wall then you know
I wasn't here.

The world is flat. Class of 1491.
 (*Princeton, 1970.*)
UNDERNEATH
All the girls in our world are flat. Class of 1973.
 (*Princeton, 1970.*)

DEATH

Death is a yellow curtain, after death there is no pain.

REPLY
Yeah, all the pain comes before!
 (*Florida State Univ., Tallahassee.*)

Death is camp.

Death is Life's answer to the question "why?"
 (*Men's toilet, telephone directory proofreader's office, New
York City.*)

Death is nature's way of telling you to slow down.
 (*Various walls and buttons.*)

La mort est nécessairement une contre-révolution.
Death is necessarily counter-revolutionary.
 (*Oriental Languages, Sorbonne, Paris, May, 1968.*)

Death is only a state of mind.
UNDERNEATH
Only it doesn't leave you any time to think about anything else.
 (*"55" Bar, Greenwich Village, New York City.*)

Death is the greatest kick of all, that's why they save it for last.

Death is the price of evolution.
(*San Francisco State College, Calif., 1970.*)

Everything is still free, especially death.
(*On fence at site of brownstone that was blown up by the three overactive political activists, New York City, 1970.*)

The greatest high is suicide.
(*Ladies' room, Hofstra College, Hempstead, L.I.*)

Eat, drink and be merry for tomorrow you may be radioactive.

I wish I could come back as a bug, to bite an ass.
(*Le Metro Caffe Espresso, New York City.*)

DRUGS

God is alive and living in a sugar cube.
(*Wall near Tompkins Square Park, New York City. Also on a button.*)

Batman is a junky.
(*Men's room, Lion's Head, Greenwich Village, New York City.*)

Develop in acid for beautiful pictures.
(*Men's room, Germain School of Photography, New York City, 1970.*)

With booze you lose, with dope you hope.
(*Men's room, Holly Tavern, Bellingham, Wash., 1970.*)

Pay your taxes, it goes for welfare, to pay for heroin.
(*Wall in South Bronx, N.Y.*)

Blow your mind . . . smoke gunpowder.

End psychedelic unemployment—send me a dollar.

LSD is there only if you care.
(*Lexington Ave. Subway, New York City.*)

L(ibrary) S(ervices) D(ivision)
(*Library staff lounge, Fort Belvoir, Va. Reported in* American Library Association Bulletin, *April, 1969.*)

One good turn-on deserves another.
(*Various West Seventies walls in New York City and on a button.*)

Nirvana needed.
(*Various walls and also on a button.*)
Old Hippies never die, they just trip away.

There's a methedrine to my madness.

For me it's the green grass of home.
WRITTEN UNDERNEATH
The grass in greener in Tiajuana.
WRITTEN UNDERNEATH
Who wants green grass.
 (*Men's room, Columbia Univ., New York City.*)

Free Pot . . . TH 5-8000 Ext. 201
(That is the Berkeley Police Dept., Vice Squad.)
 (*The Meditarranium, a Berkeley trattoria.*)

A friend in need is a pest get rid of him.
UNDERNEATH
But, a friend with weed is a friend indeed.
 (*IRT subway station, New York City. The second statement can also be found on a button.*)

Come alive, you're in the banana generation.
 (*Men's room, St. Adrian Company, New York City.*)

Love is essence.
UNDERNEATH
But pot is best.
UNDERNEATH
Essence stinks.
 (*Ladies' room, Max's Kansas City restaurant, New York City.*)

Help the generation of heads—be one. LSD users.
 (*The Village Gate, Greenwich Village, New York City.*)

Grass is nature's way of saying, "high."
 (*On subway poster in IND subway station, New York City, 1970.*)

LBJ takes trips.
 (*Ladies' room, Le Metro Caffe Espresso, New York City.*)

Acid heads!
Call me anytime and I'll tell you where life is
really at.
684-55—Lucy.
 (*The Forum Coffee House, New York City.*)

Acid indigestion can be fun.
 (*Toilet in Washington Square Park, New York City, 1968.*)

Acid—takes the worry out of being.
 (*Men's room, St. Adrian Company, New York City.*)

L'alcool tue. Prenez du L.S.D.
Alcohol kills. Take L.S.D.
 (*Univ., Nanterre, May, 1968.*)

Be placid with acid.
 (*Men's room, Stanley's Bar, New York City.*)

Don't be a bring-down.
 (*Sidewalk in Tompkins Square Park, New York City, and on a button.*)

Joe exists to get high.
Bill gets high to exist.
> (*IND subway A train, New York City.*)

Legalize pot!
legalize heroin!
legalize outlaws!
legalize me!
and legalization.
> (*Ladies' room, Limelight restaurant, Greenwich Village, New York City.*)

Legalize narcotics for addicts.
> (*Various walls and on a button.*)

Lenny Bruce died of an overdose of police morphine.
UNDERNEATH
He died of shit.
> (*Ladies' room, Max's Kansas City restaurant, New York City.*)

The inclination to turn on, like the inclination to make love, is unlikely to be affected by the will of Congress.

Melts in your mind not in your hand.
> (*Various East Village, New York City, walls and on a button.*)

LSD is fattening.

All flesh is grass.
UNDERNEATH
Smoke a friend today.

Legalize Spiritual Discovery.
> (*Various walls and on a button.*)

Psychedelize suburbia.
> (*Various walls and on a button.*)

War causes chromosome damage.
(Note: The shape of the chromosome was altered in LSD-takers. The graffito is clever in trying to take the onus off LSD by turning the spotlight on a greater evil.)
> (*Men's room, Rutgers Univ., New Brunswick, N.J.*)

Peanut butter is better than pot.
> (*Free Store Theatre, New York City. Also on a button.*)

Hands off Tim Leary.
> (*Various walls, Boston and New York City, and button.*)

Help feed my hobbit.
> (*Café Figaro, Greenwich Village, New York City, and on a button.*)

Turn on, tune in, drop dead.

Weary Leary isn't really eerie dearie.
> (*The Exit Coffee House, New York City.*)

Buy Pot Art.
> (*Men's room, Blind Lemon Pub, Berkeley, Calif.*)

The Devil says: legalize abortion, pot, homosexuality.
(*IRT subway, New York City.*)

Tim Leary is an alcoholic.

I'm leery of Leary.

Give me librium or give me meth.
(*Scrawled in chalk on a piece of sculpture, East Village, New York City.*)

My mental condition is highly illegal.
(*Ladies' room, Café Figaro, Greenwich Village, New York City, and on a button.*)

Tea is a groove
and AMT [Amphetamine] is really boss,
LSD is a trip,
Hash is too much, but
being high on love is the most precious because you don't buy it
or con it or substitute.
(*Ladies' room, Limelight restaurant, Greenwich Village, New York City.*)

The Unicorn Tapestry smokes pot.
(*Washington Square Arch, New York City.*)

Please hemp me.
(*Various walls, Chicago and New York City, and on a button.*)

Jesus was a "head."
(*Lexington Ave. subway, New York City.*)

Fly half fare—cut rate grass.
(*Wall at St. Mark's Place, New York City.*)

The whole world is going to pot.
(*Uptown construction fence, New York City, and also on a button.*)

Pot, Peace, Pussy, Perversion.
(*Door at Clinton St., New York City, and on a button.*)

ENGLAND

MERRIE ENGLAND
When I lay with my bouncing Nell,
I gave her an inch, and she took an ell:
But I think in this case it was damnable hard,
When I gave her an inch, she'd want more than a yard.
(*A wall at the Plough Ale-House in Fore-Street near Cripple-gate, England, early eighteenth century.*)

RED-LION, AT SOUTHWELL, IN A WINDOW.

Clarinda lay here
With a young Cavalier;
With her Heart full of Fear,
For her Husband was near.
 L. L. Feb. 2, 1728

BRENTFORD AT THE RED-LION, THE GREAT ROOM.

Says Sir *John* to my Lady, as together they sat,
Shall we first go to Supper, or do you know what?
Dear Sir *John* (with a Smile,) return'd the good Lady,
Let us do you know what, for Supper's not ready.

HAMPTON-COURT, AT THE MITRE, 1718.

Friend Captain T,
If thou can'st C,
Mind what I have to say to thee,
Thy Strumpet Wh--re abominable,
Which thou didst kiss upon a table,
Has made thy manly Parts unable.
 Farewel, &c. Z. B.

FROM A BOG-HOUSE AT HAMPSTEAD.

Hard stools proceed from costive Claret;
Yet mortal Man cannot forbear it.
So Childbed-Women, full of Pain,
Will grunt and groan, and to't again.

ON A BEAUTIFUL SEMPSTRESS, IN A WINDOW AT CHARING-CROSS.

Dolly, with Beauty and Art,
Has so hemm'd in my Heart,
That I cannot resist the Charm.
 In Revenge I will stitch
 Up the Hole near her Breach,
With a Needle as long as my Arm
 R.

Give me the Lass who has a Taste of Love;
She I will kiss luxuriously, by *Jove;*
But when I meet a Woman's cold Embrace,
She baulks my Love; and she may kiss my A-se.

WOODSTOCK, IN A WINDOW.

Have you not in a Chimney seen
A sullen Faggot, wet and green,
How coyly it receives the Heat,
And at both Ends doth fume and sweat:
So fares it with the harmless Maid
When first upon her Back she's laid.
 But the kind experienc'd Dame
Cracks and rejoices in the Flame.

AT THE RED LYON AT EGHAM, AND IN THE WINDOWS AT MANY OTHER PLACES.

Cornutus call'd his Wife both Whore and Slut,
Quoth she, you'll never leave your Brawling—but—
But, what? quoth he: Quoth she, the Post or Door;
For you have Horns to But, if I'm a Whore.

What the devil should we meddle
With diddle daddle, fiddle faddle;
We shall lose the girls that please:
Go to bed, and take your ease.
(*Signed by two gentlemen.*)
UNDERNEATH
I know they'll ease you both,
for I have been aboard of them.
UNDERNEATH
I shall tell best at the next meeting;
The proof of the pudding is in the eating.
(*Early eighteenth century.*)

If kisses were the only joys in bed,
Then women would with one another wed.
(*On a window in Mainwaring's Coffee House, Fleet St., London, c. 1720.*)

FROM A WINDOW AT THE DOLPHIN INN IN SOUTHAMPTON.
The Wedding-Night past, says Sir *John* to his Mate,
Faith Madam I'm bit (tho' I find it too late)
By your d-n'd little Mouth, or else I'm a Whore's Son,
For the Cross underneath's quite out of Proportion.
Good Sir *John*, says my Lady, then under the Rose,
I'm as bad bit as you, by your plaguy long Nose:
You have not by half so much as I wanted,
I've more than you want, yet y're not contented.

ON A GLASS WINDOW AT THE DOLPHIN INN.
For what did *Venus* love *Adonis*,
But for the Gristle, where no Bone is?

She that thinks upon her honour,
Heeds no other guard upon her.
UNDERNEATH
She that has a man upon her,
Never thinks upon her honour.
(*Red Lyon at Egham, early eighteenth century.*)

What care I for Mistress May'ress;
She's little as the Queen of Fairies:
His little Body like my Thumb,
Is thicker far than *other some;*
Her conscience yet would stretch so wide;
Either on this, or t'other Side,
That none could tell when they did ride.
UNDERNEATH
Swim for thy Life, dear Boy, for I can feel neither Bottom nor Sides.

ON A PANEL AT THE FAULCON IN ST. NEOT'S, HUNTINGDONSHIRE.
My Maidenhead sold for a Guinea,
A lac'd Head with the Money I bought;
In which I look'd so bonny,
The Heart of a Gamester I caught:
A while he was fond, and brought Gold to my Box,
But at last he robb'd me, and left me the Pot.

ON A WINDOW AT CANBURY HOUSE.

The Breast of ev'ry *British* Fair,
 Like this bright, brittle, slippery Glass,
A Diamond makes Impression there,
 Though on the Finger of an Ass.

ON THE WINDOW OF A GREEN HOUSE NEAR TUNBRIDGE.

Sitting on yon Bank of Grass,
With a blooming buxom Lass;
Warm with Love, and with the Day,
We to cool us went to play.
Soon the *am'rous* Fever fled,
But left a worse *Fire* in its Stead.
Alas! that *Love* should cause such Ills!
As doom to *Diet-Drink* and *Pills*.

FROM THE WHITE-HART AT AETON.

Kitty the strangest Girl in Life,
For any one to make a Wife;
Her Constitution's cold, with warm Desire,
She kisses just like Ice and Fire.

ON THE OCCASION OF A BUTCHER'S MARRYING A TANNER'S DAUGHTER AT
 READING.

A fitter Match there never could have been,
Since here the *Flesh* is wedded to the *Skin*.

MERTON-COLLEGE, OXON, IN A WINDOW.

*A new reading about the three children in the Fiery Furnace. From
 the Hebrew.*
 Shadrack, Mashac, and *Abednego:*
 If *Shadrac* had a Fever and Ague,
 Then read in *English*,
 Shadrack may shake, and a bed may go.
 R. F.

WRITTEN ON THE PILLORY IN A CERTAIN MARKET TOWN IN SHROPSHIRE, ON
 TWO MILLERS, NAMED BONE AND SKIN. WHO EXACTED EXTRAVAGANT TOLL.

 Bone and Skin,
 Two Millers thin,
Would grind this Town and Places near it!
 But be it known
 To Skin and Bone,
That Flesh and Blood won't bear it.

LADY'S DRESSING-ROOM, EARLY EIGHTEENTH CENTURY.

Brunetta, I grant you, can give her swain death;
But 'tis not with her eyes,
but with her ill breath.

 From the Story above,
 The Girls that love,
Have learn'd the Use of Candles;
 And since that, by *Jove*,
 And the God of Love,
We have lost the Use of Handles.
 W. S.—pe, Feb. 2, 1714.

'Tis hard! 'tis wonderous hard!
 That the Life of a Man
 Should be but a Span,
And that of a Woman a Yard!

ON MRS. COWFER'S WINDOW, IN RUSSELL ST., COVENT-GARDEN.
 Love, 'tis said, his Arrows shooting,
 Wounds is ever distributing;
 But before I felt, I knew not,
 That in Poison dipp'd they flew hot.

 To *Jenny* I owe
 That this Secret I know,
 For her I felt Smart
 At first in my Heart;
Which quickly she cur'd: But alack and alas!
I now feel a Throbbing in a much lower Place.
To *Jenny* I went; but, alas! it was in vain:
Though she gave me the Wound, she can't cure me again.

WRITTEN ON THE DOOR OF TWO CELEBRATED MILLINERS.
 Within this Place
 Lives *Minerva* and *Grace*,
An Angel hangs out at the Door;
 If you rise in the Night,
 And call for a Light,
Then presently down comes a Whore.

AT THE TUNS IN CAMBRIDGE. WRITTEN WITH A PENCIL ON THE WALL.
Marriage in Days of old has liken'd been
 Unto a publick Feast, or Revel Rout,
Where those who are without would fain get in,
 And those who are within would fain get out.

WRITTEN ON A WINDOW AT A PRIVATE HOUSE, BY A DESPONDING LOVER IN
 THE PRESENCE OF HIS MISTRESS.
This Glass, my Fair's the Emblem of your Mind,
Which brittle, slipp'ry, pois'nous oft we find.
UNDERNEATH
I must confess, kind Sir, that though this Glass,
Can't prove me brittle, it proves you an Ass.

AT RUMFORD, ON A WINDOW.
There's Nothing sure can vex a Woman more
Than to hear the Feats of Love, and be Threescore.

BOGHOUSE AT EPSOM-WELLS.
Privies are now Receptacles of Wit,
And every Fool that hither comes to sh-t,
Affects to write what other Fools have writ.

FROM THE TEMPLE BOGHOUSE.
No Hero looks so fierce in Fight,
As does the Man who strains to sh-te.

IN A BOGHOUSE AT THE NAGS'-HEAD IN BRADMERE.
You are eas'd in your Body, and pleas'd in your Mind,
That you leave both a Turd and some Verses behind;

But to me, which is worse, I can't tell, on my Word,
The reading your Verses, or smelling your Turd.

When *Phillis* wore her brightest Face,
All Men rejoic'd in every Grace:
Her Patch, her Mein, her forward Chin,
Cry'd, Gentlemen, Pray who'll come in:
But now her Wrinkles are come on her,
All Men who ever were upon her,
Cry out, a Fart upon her Honour.
 C. M.

To Mr. D——b, on his being very hot upon Mrs. N. S. 1714.
When the Devil would commit a Rape.
He took upon him *Cupid*'s Shape:
When he the Fair-One met, at least,
They kiss'd and hugg'd, or hugg'd and kiss'd;
 But she in amorous Desire,
Thought she had *Cupid*'s Dart,
 But got Hell Fire,
 And found the Smart.
N. B. And then the Surgeon was sent for.

Jenny demure, with prudish Looks,
Turns up her Eyes, and rails at naughty Folks;
But in a private Room, turns up her lech'rous Tail,
And kisses till she's in for Cakes and Ale.
 L. M. July 17, 1727.

Wedding and Hanging, both the Fates dispatch.
Yet hanging seems to me the better Match.

The Nature of Men from the same.
To a Red Man read thy Read;
To a Brown Man break thy Bread;
At a Pale Man draw thy Knife;
From a Black Man keep thy Wife.

On a Gentleman's saying he had calculated his Son's Nativity, the
 Boy being then about nine Days old.
Lavinia brought to Bed, her Husband looks
To know the Bantling's Fortune in his Books.
Wiser he'd been, had he look'd backward rather,
And seen for certain, who had been its Father.

Gammer *Sprigins* had gotten a Maidenhead,
And for a Gold Guinea she brought it to Bed;
But I found by embracing that I was undone;
'Twas a d—n'd p-ck-y Wh-re, just come from *London*.
 R. L. 1710.

I become all Things to all Men, to gain some, or I must have starved.
Moll. Friskey.

St. *George* to save a *Maid*, a *Dragon* slew,
A gallant Action, grant the Thing be true.
Let some say there's no *Dragons*.—Nay, 'tis said,
There's no *St. George*—Pray Heav'n there be a *Maid*.

TOWER OF LONDON

Quanto plus afflictionis pro Christo in hoc saeculo
tanto plus gloriae cum Christo in futuro.
Gloria et honore eum coronasti Domine in memoria
aeterna erit justus.
As much suffering for Christ in this world
So much the greater glory with Christ in the world to come.
Thou hast crowned him, Lord, with glory and honour;
The just man shall be remembered forever.

> (*Written by Philip Howard, 1st Earl of Arundel, in the Beauchamp Tower, The Tower of London, just before his death, June 22, 1587.*)

Dis poi che vole la fortuna che la mea speransa va al vento pianger
ho volio el tempo perdudo e semper stel me tristo e discontento
William Tyrrel 1541.
I feel like weeping, that my fortune flies and my hope goes to the
wind, and my last days are always a source of sadness and discontent to me.

> (*Beauchamp Tower, Tower of London.* Trans. in Graffiti *by Richard Freeman. London, Hutchinson, 1966.*)

Feare fortuns flateri, fraile of felicitie, dispayre not in danger, God
is defender.
Blessed ar they that suffer persecution for righteueusnes.

> (*Salt Tower, Tower of London, sixteenth century.*)

Sacris vestibus inductus dum sacra mysteria servans, captus, et in hoc
augusto carcere inclusis. R. Fisher.
While robed in the sacred vestments and administering the sacred
mysteries, I was taken and held in this narrow cell.

> (*White Tower, Tower of London, 1612. Written by Father Robert Fisher with a nail.*)

Deo servire penitentium inire fato obedire, regnare est.
To serve God, to endure penance, to obey the fates, is to reign.

> (*Beauchamp Tower, Tower of London. Written by Arthur Poole, 1564.*)

Sicut peccati causa vinciri opprobrium est, ita e contra pro Christo
custodiae vincula sustinere maxima gloria est. ARUNDELL, 16 of
May 1587.
Inasmuch as it is a disgrace to be bound because of sin, so, on
the contrary to suffer the bonds of captivity for Christ's sake is the
greatest glory.

> (*Beauchamp Tower, Tower of London, 1587.*)

135

Be thou faithful unto death and I will give thee a crown of life.
(*White Tower, Tower of London. Written by T. Fane in 1553. He took part in Wyatt's rebellion.*)

He that endureth to the end shall be saved.
(*White Tower, Tower of London. Written by Robert Rudston of Dartford.*)

20TH CENTURY ENGLAND

I do not like this place at all,
The seat is too high and the hole is too small.
REPLY
You lay yourself open to the obvious retort,
Your bottom's too big and your legs are too short.
(*Somerset House, England. Cited in* Cleanliness and Godliness *by Reginald Reynolds. New York, Doubleday, 1946.*)

Who will save his used French letters and let me have them?
(Note: French letters is a slang term for contraceptives.)
(*London rest room.*)

Oh please don't cane me too hard master.
(*Lavatory at Notting Hill Gate underground station, London. Cited in* Graffiti *by Richard Freeman.*)

Stand closer, the monks have bare feet.
(*From* Graffiti *by Richard Freeman.*)

Oh father, oh father I've come to confess
I've just left a girl in a terrible mess.
Her blouse is all tattered, her tits all bare.
And there's a lump in her belly that shouldn't be there.

Oh son, oh son with you I am vexed
When I was your age I used a Durex.

Oh father, oh father don't be unjust
I used one too, but the bloody thing bust.
(*Toilet wall in London.*)

EXCRETA

Happiness is getting here on time.
(*Men's room, Berkeley, Calif., Beer Hall.*)

Don't eat yellow snow.
(*Men's toilet, bar in Alaska.*)

This is the pause that refreshes.
(*Written on the doors of many toilets.*)

Veni, vidi, wiwi.
(*Harvard Club, New York City.*)

When adam was a
small lad before
paper was invented
he wiped his ass on
a tuft of grass & went
away contented.
(*Banff, Alberta. August 2, 1928.*)

There is nothing so overrated as a bad fuck and nothing so under-
rated as a good shit.
(*Ladies' room, San Francisco State College, Dec., 1968.*)

John's Diner
(*Written on a portable toilet at a construction.*)

Gefilte feces.
(*Steinberg's Dairy Restaurant, New York City.*)

God bless the toilet—it takes our sins away.
(*Men's room, The Jabberwock, Berkeley, Calif.*)

The Leaning Tower of Pisser.
(*Engagé Coffee House, Greenwich Village, New York City. Out
of business.*)

Smile, You're on Candid Camera.
(*Ladies' room, Unemployment Insurance Office, Remsen St.,
Brooklyn. Also in hundreds of toilets, as this is one of the most
popular of the one-liners.*)

However hard you shake your peg
At least one drop runs down your leg.
(Note: British version.)

Sam, Sam, the janitor man
Chief superintendent of the crapping can.
He washes out the bowls and picks up the towels
And listens to the roar of other men's bowels.

En este lugar sagrada
Donde caga tanta gente,
puya el más cachado,
y caga el más valiente.
In this sad place
Where so many people shit.
The cowardly squeeze
The valiant shit freely.
(*Hotel Cosmos, Trujillo, Peru, 1890.*)

If smell of t-d makes wit to flow,
Laud! what would eating it do.
(*Pancras bog house, London, 1731.*)

Here I sit all brokenhearted,
Paid a dime and only farted.

Face it—this is the most worthwhile thing you've done all day.
(*Ladies' room, Graffiti Restaurant, New York City.*)

*Allen Walker Read, *Lexical Evidence from Folk Epigraphy* (Paris, 1935).

137

FINE ARTS

Ives lives 1874–Eternity.
(Note: Lovely tribute to Charles Ives, composer, 1874–1954.)
(*Men's toilet, Judson Memorial Church, Greenwich Village, New York City, 1969.*)

METROPOLITAN OPERA HOUSE
(Note: Despite many appeals such as letters, telegrams, day and night vigils, the old Metropolitan Opera House in midtown New York could not be saved. In the middle of January, 1967, demolition began. The fences around all four sides of the building were covered with graffiti. The following are the statements written there.)
Stay the execution.
Bug the Mayor and Rocky.
Save the Met. Call out the reserves.
Rock the Rock [Rockefeller].
First the Met—now the Astor and Paramount.$$$
Why must everything historical and beautiful be destroyed for modern devices in this city?
Slaughter of the arts.
Your Maker will strick [sic] you dead if you destroy the Old Met.
The "Old Met" will not die.
REPLY
You wanna bet.

Laugh, Pagliacci, this is the final tragic hour.

Though Jeanette and Nelson's voices have been silenced, their memory will live on forever.
If the Old Met dies, so will a lot of the culture that has grown around this House!
The great God Tishman moves in mysterious ways.
ADDED
Not to mention devious ones too.
We destroy the "Soul" in order to get money with which to buy back the "Soul."

Mozart refreshes best.
(*Construction fence near Juilliard Music School, New York City.*)

Muzzle Muzak.
(*Button.*)

Oldenburg is a male chauvinist.
(Note: This was written on the side of a sculpture by Claes Oldenburg. The work was a huge tube of toothpaste mounted on a set of plywood tank tracks. The sculpture is located in a square at the Yale Rare Book Library, New Haven, Conn.)

Don Giovanni loves.

Dylan is divine.
 (*Button.*)

The flower generation has a tin ear.

Go, Van Gogh.
 (*Written in chalk on the Van Gogh apartment building, Greenwich Village, New York City.*)

Grandma Moses loves Picasso.

Do you know the John Blow record?
UNDERNEATH
No, how many times?
(Note: John Blow, c. 1648–1708. English composer and organist chiefly remembered for his church music. Teacher of Henry Purcell.)

An artist without ideas is a mendicant,
Barren, he goes begging among the hours.
 (*Florida State Univ., Tallahassee.*)

Artists are misunderstood. Not by people, but by themselves.

On a poster advertising an art school:
At thirty-five Gauguin worked in a bank. It's never too late.
ADDED
At thirty-five Mozart was dead.

John Lennon is the once and future king.
 (*Ladies' room, Bennington College, Vermont.*)

Balls by Cezanne.

 (*From* Graffiti *by Richard Freeman, London, Hutchinson, 1966.*)

Beethoven scares little kids.
 (*Public school wall, Downtown, New York City.*)

Andy Warhol stencils.

Ars Longa, Vita Herring.
(Note: Take-off on the first aphorism of Hippocrates, "*Ars Longa, Vita Brevis*," "Art is long, life is short.")
 (*Lion's Head, Greenwich Village, New York City.*)

Art is Love is God.
>(*Engagé Coffee House, East Village, New York City.*)

Ten seconds from now you will be incased in plaster for George Segal's latest work—"Man in the toilet stall."
>(*Men's room, Museum of Modern Art, New York City, 1970.*)

This decade would be a *total* loss if not for the Beatles.
>(*New York Univ. Hall, Washington Square, New York City, 1969.*)

The Unicorn Tapestry eats paisley pears.

Unicorn Tapestry for President

Walter Keane eats burnt umber.
(Note: Refers to the paintings of big-eyed children.)
>(*Pier 23, a bar in San Francisco.*)

Warhol traces.
>(*Univ. of Florida, Gainesville.*)

When I hear the word gun, I reach for my culture.

A hairspray ad: "Who says that women are fickle?"
UNDERNEATH
Verdi.

A woman's like a piano. If she's not upright, she's grand.
>(*Longdon Hall, De Pauw Univ., Greencastle, Indiana.*)

Yamasaki is strictly Shinto Gothic.
(Found in Yale University, written in Japanese. Refers to a piece of architecture on the campus designed by Yamasaki.)

L'art est mort. Godard n'y pourra rien.
Art is dead. Godard can't do a thing about it.
>(*Paris, Sorbonne, May, 1968.*)

FRENCH GRAFFITI

On n'a [(pas le temps d'écrire!!!)]
We don't have time to write.
>(*Nanterre, May, 1968.*)

Les gaullistes ont-ils un chromosome de trop?
The gaullists, do they have one chromosome too much?
>(*Medical School, Paris, May, 1968.*)

Ouvrons les portes des asiles, des prisons et autres Facultés.
Let us open the doors of asylums, prisons and other faculties.
>(*Music Amphitheatre, Nanterre, May, 1968.*)

Si tu veut être heureux, pends ta propriétaire.
If you want to be happy, hang your landlord.
>(*Odéon, Paris, May, 1968.*)

Déboutonnez votre cerveau aussi souvent que votre braguette.
Unbutton your brains as often as you unbutton your pants.
 (*Odéon, Paris, May, 1968.*)

Il a mis trois semaines pour annoncer en cinq minutes qu'il allait entreprendre dans un mois ce qu'il n'avait pas réussi à faire en dix ans.
He took 3 weeks to announce in 5 minutes that he would undertake in 1 month what he had not been able to accomplish in 10 years.
 (*Grand Palais, Paris, May, 1968.*)

Je suis marxiste, tendance Groucho.
I'm a Marxist, Groucho type.
 (*Nanterre, May, 1968.*)

A bas le réalisme socialiste. Vive le surréalisme.
Down with socialist realism. Long live surrealism.
 (*Condorcet, Paris, May, 1968.*)

Ne me libère pas je m'en charge.
Don't liberate me, I'll handle it.
 Univ. Nanterre, May, 1968.)

La Bourgeoisie n'a pas d'autre plaisir que celui de les dégrader tous.
The bourgeoise has no other pleasure than to downgrade everything.
 (*Sorbonne, Paris, May, 1968.*)

L'émancipation de l'homme sera totale ou ne sera pas.
Emancipation of man will be either total or not at all.
 (Censier, Paris, May, 1968.)

Amnistie: acte par lequel les souverains pardonnent le plus souvent les injustices qu'ils ont commises.
Amnesty is an act by which rulers must often pardon the injustices they have committed.
 (*Sorbonne, Paris, May, 1968.*)

Les jeunes font l'amour.
Les vieux font des gestes obscènes.
Quels sont les porcs qui osent écrire sur les murs?
The young make love.
The old make obscene gestures.
Who are the pigs who dare write on the walls?
 (*Sorbonne, Paris, May, 1968.*)

La révolution est incroyable parce que c'est vraie.
Revolution is unbelievable because it is true.
 Censier, Paris, May, 1968.)

Tous les réactionnaires sont des tigres en papier.
All the reactionaries are paper tigers.
 (*Nanterre, May, 1968.*)

Jeunes femmes rouge toujours plus belles.
Young women who are Reds are always more beautiful.
 (*Gd. Hall. Nouvelle Fac. Médecine, Paris, May, 1968.*)

La culture c'est comme la confiture: moins on l'a plus on l'étale.
Culture is like jam, the less you have the more you spread it out.
 (*Censier, Paris, May, 1968.*)

La perspective de jouir demain ne me consolera jamais de 'ennui d'aujourd'hui.
The prospect of tomorrow's joy will never console me for today's boredom.
(*Univ. Nanterre, May, 1968.*)

Un seul weekend non-révolutionnaire est infiniment plus sanglant qu'un mois de révolution permanente.
A single nonrevolutionary weekend is much bloodier than a month of permanent revolution.
(*Oriental Languages, Sorbonne, Paris, May, 1968.*)

Plus je fais l'amour, plus j'ai envie de faire la Révolution. Plus je fais la révolution, plus j'ai envie de faire l'amour. (Un des enragés.)
The more I make love, the more I want to make revolution. The more I make revolution, the more I want to make love. (One of the outraged.)
(*Sorbonne, Paris, May, 1968.*)

Voyez sur ces murs la répression sexuelle et le refus de soi-même. (A bas l'obscurantisme.)
See on these walls sexual repression and the denial of the self. (Down with obscurantism.)
(*Censier, Paris, May, 1968.*)

Embrasse ton amour san lâcher ton fusil.
Embrace your love without letting go of your gun.
(*Odéon, Paris, May, 1968.*)

Millionaires de tous les pays, unissez-vous; le vent tourne.
Millionaires of all countries, unite; the wind is changing.
(*Censier, Paris, May, 1968.*)

Quand le dernier des sociologues aura été étranglé avec les tripes du dernier bureaucrate, aurions-nous encore des problèmes?
When the last of the sociologists has been strangled with the intestines of the last bureaucrat, will we still have problems?
(*Sorbonne, Paris, May, 1968.*)

Un flic dort en chacun de nous, il faut le tuer.
A cop sleeps within each of us, he must be killed.
(*Censier, Paris, May, 1968.*)

La forét précède l'homme, le désert le suit.
Forest preceded man, desert follows him.
(*Sorbonne, Paris, May, 1968.*)

Oubliez tout ce que vous avez appris. Commencer par rêver.
Forget all you have learned. Start to dream.
(*Sorbonne, Paris, May, 1968.*)

Dieu, je vous soupçonne d'être un intellectual de gauche.
God, I suspect you of being a left-wing intellectual.
(*Condorcet, Paris, May, 1968.*)

FUCK

Phuque ewe.

The only difference between graffiti and philosophy is the word fuck.
> (*Men's room, Limelight restaurant, Greenwich Village, New York City.*)

Whatever happened to virginity?
UNDERNEATH
It got fucked.
> (*Ladies' room, Max's Kansas City restaurant, New York City.*)

Do fairies fuck?
UNDERNEATH
Yes, if you believe in them.
> (*West End Café, New York City.*)

I'd rather fuck the pizza and eat the waitress.
UNDERNEATH
I did. The pizza's better.
> (*Men's room, San Antonio, Texas.*)

Fuck the future and hope that tomorrow will be a miscarriage.
> (*University of Michigan, Ann Arbor.*)

The trouble with my life is that it *isn't* fucked up.
> (*Men's room, Thano's restaurant, New York City, 1969.*)

Fuck scatology.

Dirty is only in the mind, so fuck you.
> (*Men's room at the Newport Jazz Festival, Newport, R.I., 1967.*)

Don't fuck with love.
> (*Ladies' room, Lion's Head, Greenwich Village, New York City.*)

Fuque you.
UNDERNEATH
Class huh!
> (*Wall at 34th St., New York City.*)

Horray, horray. It is the first of May,
Outdoor fucking starts today.
> (*Ladies' room, Lion's Head, Greenwich Village, New York City.*)

Fuck, fuck, fuck and nothing to eat in the house.
> (*Public toilet for workers at Schuckl's Cannery, Sunnyvale, Calif., 1938.*)

I'm a mother fucker—I fuck white mothers.
> (*Wall at Amsterdam Ave., New York City, 1970.*)

Edy likes to fuck with the stars in the night.
(Found on a sidewalk on the East Side, New York City.)

Fuck all Porto [sic] Ricans not that you haven't done it already.

Fuck complacency.
(The Village Gate, Greenwich Village, New York City.)

I don't drink water because fish fuck in it.
(Note: This is really the brain-child of W. C. Fields.)
(Men's room, Gleason's Tavern, New York City, 1969.)

Fuck intercourse.

HOMOSEXUALITY

Let's face it, we're all queer.
(Wall at Christopher St., New York City. Also on a button.)

Male lesbians unite.
(Wall on Christopher St., New York City. Also on a button.)

Master needs slave call 333——.

Slave needs master call 354——.

More deviation, less population.
(Various walls, New York City, and also on a button.)

I'm bisexual.
REPLY
Hey me too—Let's get in touch really.
REPLY
There's no such thing, you're kidding yourselves.
REPLY
Leave her alone—let the kid live.
(Ladies' room, Hunter College, New York City, 1970.)

One man's meat is another man's perversion.

Peter is a fag, he plays potsy, he is 42 years old.
(On a sidewalk on Jane St., Greenwich Village, New York City.)

Practice makes pervert.
(Men's room in homosexual bar in Greenwich Village, New York City.)

All boys who go to Harvard are fags.
UNDERNEATH
Except one and he's a lesbian.
(The Casablanca, Harvard Square, Cambridge, Mass.)

Call 265-6791 for info re The Mattachine Society—if you're inquisitive sweetie. I'll tell you everything!
(Note: The Mattachine Society is an organization which is devoted to male homosexuals to explain their viewpoints and their rights in society.)
(*Lion's Head, Greenwich Village, New York City.*)

Homosexuality is a pain in the ass.
(*Wall at 103rd St., New York City.*)

Dr. Strangelove or how I learned to love the bum.
(Note: Bum is Middle English slang for posteriors.)
(*London rest room, 1968.*)

Equality for homosexuals.
(*Various walls and also on a button.*)

Faggots are maggots.

Better latent than never.
(*Men's room, Boston Univ., Mass.*)

Fellatio is not a felony, fellas, it is a misdemeanor.

Fight heterosexual supremacy.
(*Coed toilet, Alternate U., New York City, 1969.*)

God save the Queens!

Have gums, will travel.
—The Prairie Fairy.

Lesbians read John Updike.

Why is it that graffiti at Harvard is homosexual and that at B.U. anti-Semitic?
UNDERNEATH
Queers prefer circumcised Jews.
UNDERNEATH
So does Christ.
(*Men's room, Harvard University, Cambridge, Mass.*)

Nobody loves you when you're young and gay.
(Note: I've seen this as "Nobody loves you when you're old and gay." This is a parody of the song "There'll be some changes made," in which the line is "Nobody loves you when you're old and gray.")
(*Lion's Head, Greenwich Village, New York City.*)

Now being organized the Greenwich Village Heterosexual Club (underground).
(*Howard Johnson's restaurant, Greenwich Village, New York City, 1965.*)

Young man, well hung, with beautiful body is willing to do anything.
P.S. If you see this Bill don't bother to call, it's only me, Tony.
(*Howard Johnson's restaurant, Greenwich Village, New York City.*)

Stop the homosexual revolution, wear baggy pants.

145

The lesberated woman refuses to betray her body.
(*Ladies' Room, Gay Liberation Front, Greenwich Village, New York City, 1970.*)

Lenny is a stupid faget.
UNDERNEATH
I may be stupid but at least I can spell fagget.
(*IRT subway station, Bronx, N.Y.*)

Wipe out male prostitution—adopt a hustler today. Get murdered tonight.
(*Free Store Theatre, East Village, New York City.*)

Old fairies never die, they merely blow away.

Pederasty is with it.

Daisies of the world unite, you have nothing to lose but your chains.
(*Ladies' room, Vassar College.*)

LITERATURE

What train would come to bear me back across so wide a town?
(Note: The writer was obviously thinking of the line in J. R. R. Tolkien's *The Fellowship of the Ring*: "What ship would bear me ever back across so wide a sea.")
(*Subway graffiti reported in* New Yorker *magazine.*)

Franz Kafka is a kvetch.
(Note: Yiddish word for one who always complains.)
(*Men's room, Brooklyn College, N.Y., and also on a button.*)

Marcel Proust is a yenta.
(Note: Yenta is a Yiddish word meaning gossip or busybody.)
(*Various walls and also on a button.*)

To be or not to be is not the question, it's what was.
(*Old Vic Theatre, London, England.*)

Lucky is he for whom the belle toils.
UNDERNEATH
Lucky is she for whom the balls toil.

Le Petit Prince is a fairy.
(*University of Florida, Gainesville.*)

Renata Adler is smarter than Susan Sontag.

Henry Miller is a virgin.
(*Free Library of Philadelphia, 1968.*)

Hester Pryne was a nymphomaniac.
(Note: The heroine of Nathaniel Hawthorne's *The Scarlet Letter.*)

In the valley of death rode the sex hungry.

Concentrate on Rousseau instead of your trousseau. Sorry I Kant.
> (*Library staff lounge, Fort Belvoir, Va. Reported in* American Library Association Bulletin, *April, 1969.*)

Othello was a bigot.

Support your local poet.
> (*New York City Public Library steps. Also on a button.*)

Better to have failed your Wassermann test than never to have loved at all.
> (*Ladies' room, Limelight restaurant, Greenwich Village, New York City.*)

Clytemnaestra lives in Agamemnon.
> (*Lexington Ave. subway station, New York City.*)

Vote Row A: Allen Ginsberg for Messiah.

Norman Mailer is the master of the single entendre.
> (*Ladies' room, Limelight restaurant, Greenwich Village, New York City.*)

That author is nothing but a Black Mailer.
> (*Arlington County Public Library, Va. Cited in* American Library Association, Bulletin, *April, 1969.*)

Twas brillig and the slithy toads got screwed.

Come to middle earth.
(Note: Mythical location in Tolkien books.)

Gandalf for President.
(Note: Character in the J. R. R. Tolkien Trilogy.)
> (*Wall near voting place, 17th St. West, New York City. Also on a button.*)

Frodo has been busted.
(Note: Character in Tolkien books.)
> (*Men's room, Back Fence Bar, Greenwich Village, New York City.*)

Tolkien spokien here.
> (*Button.*)

Sauron lives!
(Note: Villain in Tolkien books.)

Where are the Snowdens of yesteryear?
(Note: Suggested by François Villon's line in "A Ballade of Dead Ladies": "But where are the snows of yesteryear?")
> (*IRT subway station, New York City.*)

Moby Dick was a honkie.
> (*Library staff lounge, Fort Belvoir, Va. Reported in* American Library Association Bulletin, *April, 1969.*)

T. S. Elliot loves D. H. Lawrence.
UNDERNEATH
Eliot is spelled with one l, you ass.
> (*Old O.P.A. building, Washington, D.C.*)

Thoreau was a hippie.
UNDERNEATH
But at least she could read and write.
>(*Fedora restaurant, Greenwich Village, New York City.*)

Americans haven't read Chaucer—its *Arse.*
>(*Feenjon Coffee House, Greenwich Village, New York City.*)

Brutus is a hostile ingrate.
>(*Lion's Head, Greenwich Village, New York City.*)

Edith Sitwell is a transvestite.
UNDERNEATH
She's dead, you dope!
UNDERNEATH
OK, Edith Sitwell is a dead transvestite.
>(*Chumley's Restaurant, Greenwich Village, New York City.*)

Electra loves daddy.
>(*Ladies' room, Ninth Circle Restaurant, Greenwich Village, New York City.*)

George Orwell was an optimist.
>(*Men's room, East Village Other, New York City, 1969.*)

Henry James must have fucked somebody.
>(*Ladies' room, Lion's Head, Greenwich Village, New York City.*)

Herman Melville eats blubber.
>(*Stuyvesant High School, New York City. Also on a button.*)

Portnoy's mother is a shikse.

Us French counts would rather switch than fight.—Marquis de Sade.
>(Time *magazine's graffiti contest for advertising men.*)

That Marquis De Sade, he sure knew how to hurt a guy.

Who's afraid of Virginia Woolf?
>(*Found by Edward Albee on a toilet wall.*)

Kirkus Lives!
(Note: Virginia Kirkus is a book reviewing service subscribed to by many libraries.)
>(*Free Library of Philadelphia, 1968.*)

Remembrance of things Pabst.
>(*Men's toilet, Greenwich Village, New York City.*)

Truman Capote stays in bed on Father's Day.
>(*Jim Moran column, Chicago* Daily News, *May 27, 1967.*)

Emily Dickinson doesn't have a date for the senior prom.
>(*Jim Moran column, Chicago* Daily News, *May 27, 1967.*)

Henry Thoreau talks to himself.
>(*Jim Moran column, Chicago* Daily News, *May 27, 1967.*)

Mickey Spillane reads the Ladies' Home Journal.
>(*Jim Moran column, Chicago* Daily News, *May 27, 1967.*)

Rona Jaffee can't cook.
>(*Jim Moran column, Chicago* Daily News, *May 27, 1967.*)

LOVE

Why does free love cost so much?
 (*Button.*)

Wrap your loins around me as softly as a kiss on a babies [sic] cheek.
 (*Written on a New York City subway column.*)

Make haste! Make love!
UNDERNEATH
Haste is passe and for amateurs.
 (*Men's room, Harvard University, Lamont Library.*)

Make luv, not catalog cards.
 (*Arlington County Public Library, Va. Cited in* American Library Association Bulletin, *April, 1969. Cited also in* Library Journal, *Jan. 1, 1969.*)

Love is blind
with sex in mind
 but
Don't be resigned
It always takes
two of a kind.
 (*Ladies' room, Limelight restaurant, Greenwich Village, New York City.*)

Even dirty old men need love.
 (*Various walls and on a button.*)

Love is a many gendered thing.
 (*Button.*)

King Kong taught me to love.
 (*Various walls and on a button.*)

If it moves, fondle it.
 (*The Village Gate, Greenwich Village, New York City. Also on a button.*)

Girls, what do you do when you find your cat with another cat?
REPLY
Let the cats be happy together and find a MAN.
 (*Ladies' rooms, Limelight restaurant, Greenwich Village, New York City.*)

I need no sunshine save the light within your eyes,
With all the souls deep knowledge glowing.
I love you Kiwi.
 (*Found written in the dust on a window at W. Houston St., New York City.*)

Put a little love in your sex life.
 (*Button.*)

Artificial insemination: getting a girl you don't really love pregnant.
(*Men's room, Rutgers Univ., Newark Campus, N.J., 1969.*)

I love Steve.
 —Mary
UNDERNEATH
Tough luck, Mary.
 —Steve
(*Univ. of Florida, Gainesville.*)

I love Liam—so does Liam.
(*Ladies' room, Lion's Head, Greenwich Village, New York City.*)

MASTURBATION

Masturbatorium.
(*Coed toilet, Alternate U., New York City.*)

Minorbation is good during a depression.
(*Coed toilet, Alternate U., New York City.*)

One orgasm in the bush is worth two in the hand.

Never pull off tomorrow what you can pull off today.
(*Lion's Head, Greenwich Village, New York City.*)

I come here to get ahold of myself.
(*Men's room, Univ. of Colorado, Boulder.*)

I masterbated here 12/15/69.
UNDERNEATH
Shame on you, a post-graduate student and unable to spell.
UNDERNEATH
I'm a faculty member.
(*Men's room, Post-Graduate Center, New School For Social Research, New York City.*)

MEXICAN GRAFFITI

Al llegar este momento me pongo a considerar
lo caro que está el sustento y en
lo que viene a parar.
In this holy moment I start
to think about how expensive our food is
and how it turns into this.

In reply to a notice which read, "Don't use the toilet when the train
has stopped":

Ma causa risa y sorpresa este aviso
estrafalario pues debe
saber la empresa
que el culo no tiene horario.
Your strange notice gives me a laugh and a surprise, and I want to
tell this company that the sphincter has no time table.

Comen frijoles y eructan a pollo.
They eat beans and they belch chicken.
(Note: Said of those who pretend to be people of high society.)
(*Mexico City.*)

MIDDLE EUROPEAN

Ich hab hier auf das Brett geschissen,
wer sich reinsetzt den lass ich grüssen.
Upon this board I have put my sheetings,
Whoever sits here has my greetings.
(*Men's room, Prussia-Silesia. Reported in* Anthropophyteia. *vol.
7, 1910.*)

Heil dir, Helvetia, heil!
Ein Furz ist kein Pfeil,
Sonst hätten die alten Eidgenossen
Ihre Weiber all im Bett erschossen.
Hail to thee Helvetia, hail!
A fart is no arrow
otherwise the old comrades of the oath
(Helvetians) would have shot their
wives in bed.
(*Toilet, railroad station, Wädenswil on Lake Zurich, 1881.*)

Nur der Jud und Protestant scheisst im Abtritt auf den Rand.
Only the Jew and the Protestant will shit on the rim.
(*Breslau. Reported in Anthropophyteia. vol. 6, 1909.*)

Here is the only place where Jews have shortcomings.
(*Men's room, Germany, 1968.*)

Im Grab und dieser Halle
sind alle Menschen gleich.
Im Grabe faulen alle
und hier stinkt arm und reich.
In the grave and in this big hall
all men are equal.
In the grave all are rotting
and here rich and poor stink.
(*Toilet in a restaurant in Dennheritz i Sa, August, 1906, Bahn-
hofabort.*)

151

Mein lieber Wirt, ich rate dir,
sorge für Klosettpapier!
Denn der Mensch in seinen Nöten
greift sonst oft zu den Tapeten.
My dear innkeeper I advise you,
do provide toilet paper,
for otherwise man in his distress
will grab at the wall paper.
 (Dennheritz i. Sa. 1906. Abort des dortigen Gasthofs.)

Wenn zwei einander küssen,
Und gehn dann pissen,
Und kommen dann nicht wieder—
Sind's warme Brüder.
When two each other kiss,
And then go out for pissies,
And don't come back—
You've got your sissies.
 (Men's room. Reported in Anthropophyteia, *vol. 7, 1910.)*

Ein Bergmann stramm und wohlgenährt,
Der täglich in die Grube fährt,
Und darin wirkt und darin schafft,
Bis er erlahmt, bis er erschlafft:
"Der Bergmann lebe hoch!"
A miner (penis) robust and well nourished.
Who rides daily into the ditch
And therein works and wherein creates,
until he is worn out, until he flags:
 "Long live the miner!"
 (Men's room, Westfalen. Reported in Anthropophyteia. *vol. 7, 1910.)*

Mein Vater ist ein strenger Mann,
lässt mich nicht mal von hinten ran.
My father is a very stern man, he doesn't let me near him, not even
 from behind.
 (Men's room, Prussia-Silesia. Reported in Anthropophyteia, *vol. 7, 1910.)*

Liebes Mädchen, lass dich ficken.
das ist dir ja sehr gesund.
Dann bekommt du dicke Titten
und ein Bauch wie Kugel rund.
Dear girls, let yourself be laid,
it is very healthy.
Then you'll get thick tits
and a belly round like a ball.
 (Binz auf Rügen, 1903.)

Beim Beschneiden: Was das Leben würzt, wird der jetzt verkürzt;
für der Liebe Glück bleibt genug zurück, Schwapp, ab!
During circumcision, what spices life now falls to the knife, for love's
 happiness enough is left however.
 (Breslau. Reported in Anthropophyteia. *vol. 6, 1909.)*

Gar höflich wird gebeten—
Und dies gilt einem Jeden—
Dass für schmiersel'ge Hände
Man nicht die Wand verwende!
Doch drückt ein Witz dich gar zu sehr
Und ist er wert, bewahrt zu werden
So setz ihn, bitte, nicht hierher!
Bedenk', es gibt noch Schreibpapier auf Erden.
Very kindly you are requested—
this goes for everyone of you
smearers—one should not use the wall.
Yet if the joke oppresses you too much
and is worthy of being preserved,
don't put it here. Just think, there
is still writing paper on earth.
 (*Elberfeld, 1907.*)

Arme Köchin, Armer Koch, Euere Kunst geht durch dies Loch.
Poor little cook, your art goes through this hole.
 (*Men's room, coffee house, Vienna, 1910.*)

Hier ist es wie im Himmelreich,
Hier sind sich alle Menschen gleich;
Denn erste, zweite, dritte Klasse,
Alles scheisst in eine Masse.
Here it is just like Heaven
Here all men are equal
1st, 2nd and 3rd class,
Everyone shits into a mass.
 (*Men's room, Reported in* Anthropophyteia, *vol. 5, 1908.*)

Hier sammeln Mann sowohl wie Frau
Liebesgaben für den Ackerbau
Drum dränge und drücke mit ganzer Kraft
Zum Wohle der notleidenden Landwirtschaft!
Here men and women gather gifts of love for agriculture. Therefore
 squeeze and press with all your might for the benefit of suffering
 agriculture.
 (*Toilet in Café, Thorn, 1897.*)

Ein Arschwisch wär jetzt lieber mir als sonst ein wertvolles Papier.
Something to wipe my ass with would now mean more to me than
 any other scholarly paper.
 (*Men's room, Breslau. Reported in* Anthropophyteia, *vol. 6,
 1909.*)

Man onaniert, man schifft und scheisst
Bis dass der Lebensfaden reisst.
One masturbates, one pisses and craps until life's thread is cut.
 (*Men's room, Munich. Reported in* Anthropophyteia, *vol. 5,
 1908.*)

Welche Ahnlichkeit zwischen Abort und Bankgescraft?—Im Abort
 Krachts, dann fallen die Papiere; beim Bankegeschäft ists umge-
 kehrt. (Nimbsch i. Schles)

What similarity is there between a toilet and a bank business? In the toilet you get a crash and then the papers fall; in the bank it is the other way around.

(*Reported in Anthropophyteia, vol. 4, 1907.*)

Ich lasse mich von vorn und von hinten reiten
und von beiden Seiten nach Haus begleiten.
I let myself be ridden front and back
and permit myself to be taken home from both sides.

(*Ladies' room, Essegg, Slavonia, 1900.*)

Viktor von Stein
der macht's recht fein
und steckt ihn (Penem) auch süss hinein.
Victor von Stein
who does it right fine
and puts him quite sweetly in mine.

(*Halle a.S., Klause St. Lukas, 1903.*)

O Mädchen lass mich glühend küssen den schlanken, weichen weissen
Leib, lass mich der Pumpe Duft geneissen, ich bin ja auch wie du
ein Weib!
O girls let me fervently kiss your slender body, let me savor the fragrance of your cunty's dew, for I am a woman just like you.

(*Ladies' room, Breslau, 1909.*)

Junge schöne Dame sucht ein' jungen Mann mit einem ungetähr
starken 30- bis 40 pferdigen Zungenschlag.
Beautiful young lady seeks young man with tongue movement of approximately 30-40 horsepower.

(*Ladies' room, Switzerland. Reported in* Anthropophyteia, vol. 6, 1909.*)

ORAGENITALISM

Cunnilingus spoken here.
(*Button.*)

If Miles Standish had shot a cat instead of a turkey we would all be eating pussy for Thanksgiving.

Cunnilingus is next to godliness.

Cocksuckers of the world unite—bite Birchers.

Observe National Cunnilingus Week, take a clitoris to lunch.

Suck my idd! [sic], kiss my ego!
UNDERNEATH
But don't tell my super duper ego.
(*Construction fence, 14th St., New York City, 1969.*)

Think about him, talk about him, but don't go down for him.
> (*Ladies' room, Ninth Circle restaurant, Greenwich Village, New York City.*)

Up with going down.

The square root of 69 is 8 something.
> (*Men's room, Bernard Baruch College, New York City, 1970.*)

—Lickety split.
> (*Ladies' room, Wheeler Hall. Univ. of Calif., Berkeley.*)

Auto-fellatio is its own reward.

If you're in love, oral copulation can be beautiful.
> (*Ladies' room, Blind Lemon bar, Berkeley, California.*)

PHILOSOPHY

There's more to life than meets the mind.

Today is the first day of the rest of your life—celebrate now.

Turbulence is the end product of all thought.

When in doubt, worry.

Why worry about tomorrow when today is so far off.

Dishonor before death.

Evil spelled backwards is live.
> (*Subway, New York City.*)

Hang on.
> (*Ladies' room, Limelight restaurant, Greenwich Village, New York City.*)

Happiness is a means.
> (*Harvard Univ., Lamont Library, Cambridge, Mass.*)

Have you done enough today to absolve yourself of blame for to-morrow's doom?
> (*Men's toilet, Men's faculty lounge, Hunter College, New York City.*)

I am a non-conformist and I wear a suit.
> (*The Dom, East Village, New York City, 1966.*)

I am an incurable optimist who daily raises my head to the beat of human existence.

In an insane world the only sane men are crucified, shot, jailed or classified as insane themselves.
> (*Le Metro Caffe Espresso, New York City.*)

In today's screwed society you should never ask a three dimensional question like—Why?
> (*Free Store Theatre, East Village, New York City.*)

Me within all,
All within me.
UNDERNEATH
Are you pregnant?
> (*Kettle of Fish bar & restaurant, Greenwich Village, New York City.*)

More things are wrought by laughter,
Than tears about your late disaster.
> (*Lion's Head, Greenwich Village, New York City.*)

I am anonymous, help me.
> (*Button.*)

The wages of Luce living is death.
> (*Men's room, Time & Life building, New York City.*)

What a drag it is getting old.
> (*Antioch College, Yellow Springs, Ohio.*)

The most sincere form of criticism is suicide—do it.
> (*Men's room, Goose and Gherkin Ale House, New York City, 1969.*)

Somewhere a man is catching glimpses of himself and crying.
> (*Univ. of New Hampshire, Durham.*)

For those who think life is a joke, just think of the punchline.
> (*Ladies' room, Bennington College, Bennington, Vermont.*)

To kick the bucket is beyond the pail.
> (*Ladies' room, Bennington College, Bennington, Vermont.*)

I can resist anything but temptation.

I just turned real.
> (*Engagé Coffee House, East Village, New York City. Out of business.*)

I'll cut you in Zen pieces.

We are all one, unite with outer and inner space.
UNDERNEATH
Only on the subway.
> (*Paradox Restaurant, East Village, New York City.*)

Life is a hereditary disease.

All the world's a stage and the people on it are poorly rehearsed.
UNDERNEATH
No, just poorly directed.
UNDERNEATH
No, just poorly cast.
> (*American Academy of Dramatic Arts, New York City, 1969.*)

I think I exist; therefore I exist, I think.
UNDERNEATH
I think, I think: therefore I think.
> (*Cornell Univ., Ithaca, N. Y.*)

Maharishi Freakpuke.

Nietzche is pietzche.

Sockitome, Socrates!
> (*Arlington County Public Library, Va. Cited in* American Library Association Bulletin, *April, 1969.*)

You can't win except thru ignorance.

It's me and you against the world—when do we attack?
> (*Graffiti Restaurant, New York City.*)

Reality is good sometimes for kicks, but don't let it get you down.

Reality is an obstacle to hallucination.
> (*Ladies' room, Top of the Gate, Greenwich Village, New York City.*)

If I have only one life to live,
let me live it as a Greek.
> (*IND subway, New York City.*)

If fate promised you to pass by here you will.
> (*Ellis Island, New York City. Written in Greek on a wall in the main building, 1953.*)

Leibnitz has the answers, baby.
> (*4th-floor men's room, New School for Social Research, New York City.*)

There are no problems to be solved without patience.
> (*Ellis Island, New York City. Written in Greek on a wall in the main building, Oct. 23, 1953.*)

You could be extinct too!
think about that!
> (*Hall in New York Univ., Washington Square, New York City, 1969.*)

Nature never gives up.
TO WHICH WAS ADDED SORROWFULLY
It did on me.

The truth is the safest lie.
> (*IRT subway station, New York City, 1970.*)

Socrates drank no-cal Hemlock.

POLITICS AND POLITICIANS

Dick and Spiro add up to zero.
(*Men's room, Bates College, Lewiston, Maine.*)

How can anyone hate a President with a name like Dick?
(*Men's toilet, Rutgers Univ., Newark Campus, N.J.*)

A pox Agnew.
(*Subway station, New York City.*)

A hillbilly farmer named Hollis
Used 'possums and snakes for his solace
The children had scales and prehensile tales
and voted for Governor Wallace.
(*Men's room, Princeton, 1970.*)

Spiro-Zorba the Beak Geek.
(*Men's room, Harvard Univ., Cambridge, Mass.*)

In your heart you know he is far right.
(Note: Variation on Goldwater slogan, "In your heart you know he is right." Another variation: In your guts you know he's nuts.)

Goldwater in '64. Hot water in '65. Bread and water in '66.
(*Various subway stations, New York City, 1964.*)

Send an assassin to Sacramento.
(*Button.*)

Ronald Reagan for Fuehrer.
(*Button.*)

Reagan can't *act* either.

God bless Galway!
(*Freight elevator, 10th Ave., New York City.*)

LBJ and the CIA did away with JFK.
(*Subway station, New York City.*)

Great Society: a new leech on life.
(*Button.*)

Conspicuous only in its absence—The Great Society.
(*Construction wall, Walnut St., Philadelphia, 1969.*)

Dodd is dead.
(*Men's room, U.S. Senate.*)

Vote for Dick, he's up and coming.
(*Men's room, Electric Circus, East Village, New York City, 1969.*)

Whack HUAC.
 (*Button.*)

Why not make N.Y. State a welfare state?
 reelect Lindsay.
UNDERNEATH
How about making it Racket State for the Whops [sic]?
 (*IRT subway station, New York City, Oct., 1969.*)

John Birch is politically disoriented.

Hump with Humphrey.
 (*Ladies' room, Putney School, Vermont.*)

Unleash Chiang Kai Shek.

I actively unsupport Bobby Kennedy.
 (*Engagé Coffee House, East Village, New York City.*)

Mace the nation.
Beat the press
 (*Men's room, Conrad Hilton Hotel, Chicago. Found week of
 Aug. 28, 1968, during Democratic convention.*)

Lick Dick.
 (*Ladies' room, Bernard Baruch College, New York City, 1969.*)

Senator Dirksen is a leprechaun.

Procaccino for lord high executioner.
 (*Coed toilet, Alternate U., New York City.*)

Stop Keating!
UNDERNEATH
But I never keated.

Long live Nassar.
UNDERNEATH
The only Arab Zionist.
 (*West End Bar & Restaurant, New York City.*)

A plague on both your houses.
 (*Public washroom, U.S. Capitol building.*)

Vote Buddhist.
 (*Button.*)

Vote for Godzilla
 (*The Forum Coffee House, New York City.*)

I am an enemy of the state.
UNDERNEATH
I am an enema of the state.
 (*Wall on the Lower East Side, New York City. The first state-
 ment also appears on a button.*)

Russian circus in town. Don't feed the animals.
 (*Czechoslovakian wall, 1968.*)

They're here. Take off your watches and hide your wives.
> (*Painted on the side of a Russian tank by a Czechoslovakian who took a big chance, 1968.*)

Up the Queen. No Pope here.
(Note: Written by Northerners.)
UNDERNEATH
No Queen here. Up the Pope.
(Note: Written by Catholic Republicans.)
Up Celtic.
(Note: The name of a Catholic Scottish soccer team.)
> (*Belfast wall, Northern Ireland, 1969.*)

Up the Crown!! There will always be an England.
UNDERNEATH
As long as there's a Fort Knox.
> (*Limelight restaurant, Greenwich Village, New York City.*)

Yankee go home!!
UNDERNEATH
and take me with you.

Czechoslovakia has gun control.
> (*IRT subway, Oct., 1968.*)

An American's a person who isn't afraid
to critize the President—
but is always polite to traffic cops.
> (*Midtown New York City construction fence.*)

If you liked Hitler—you'll love Buckley.
UNDERNEATH
There's quite a difference. Hitler was a jailbird and Buckley was a Yalebird.
> (*On wall near New York Univ., Washington Square, New York City.*)

Willy Brandt; don't give Nixon or Agnew political asylum in Germany.
> (*Deli-Plaza, 42nd St. and B'way, New York City, 1970.*)

No liberty without law.
> (*Stockholm official graffiti wall [Kotterplank], Sweden, Nov. 7, 1968.*)

Long live Stalin! Without him the Soviet Union would be an American colony.
> (*Stockholm official graffiti wall [Kotterplank], Sweden, Nov. 7, 1968.*)

Communism; Socialism at its highest potency.
Capitalism: Democracy at its lowest impotence.
> (*Stockholm official graffiti wall [Kotterplank], Sweden, Nov. 7, 1968.*)

Expropiarle al rico no es delito. M.I.R.
To expropriate from the rich is no crime.
> (*Graffito of the M.I.R. [Movement of the Revolutionary Left], Santiago, Chile, 1969.*)

Nixon is XYY.
(Note: XYY is the genetic makeup of a criminal. It indicates an extra chromosome.)
(*Canarsie St. subway stop, New York City, 1970.*)

Eliminate Government waste no matter what it costs.

Beware the Spirochete.
(Note: An order of bacteria including those causing syphilis.)

Free the Panther 21.
UNDERNEATH
Free the 8 million New Yorkers.
(*Construction fence, New York City, 1970.*)

Nixon is the first president to have an ass-hole for a vice president.
UNDERNEATH
No, Eisenhower was.
(*Univ. of Michigan, Ann Arbor, 1970.*)

Spiro Agnew; the human Edsel.
(*Univ. of Michigan, Ann Arbor, 1970.*)

No news is agnews.
(*Univ. of Michigan, Ann Arbor.*)

Rockefeller, he's done a lot, he'll do more.
(Note: Rocky's slogan in the 1970 gubernatorial race, which he won.)
UNDERNEATH
If we're not too careful.

POMPEII, A.D. 79

Here I'd the luck a lovely girl to win.
Folk call her beautiful, she's filth within.
(Note: Written by fellow who got a dose.)

I like a girl with a proper mat, not depilated and shorn. Then you can snug in from the cold, as an overcoat she's worn.

May I always and everywhere be as potent in dealing with women as I was here!
Here I recall I had a girl of late
The intimate details I shall not relate.

Arescusa [sic; probably Arethusa], like a sensible girl, took a firm hold of his best part for her own good.

Here's my advice. Share out the Common Chest for in our coffers piles of money rest.

Serena Isidorum fastidit.
Serena hates Isadore.

Figulus amat Idaiam.
Figulus loves Ida.

Everybody writes here on the walls but me.

I who read am a sucker, he's a sucker who read this.

May you be cheated yourself and then repine.
Landlord, you sell us water, while drinking wine.

Hullo, we're wineskins.

Apollinaris, doctor to the Emperor Titus, had a crap here.
(Public lavatory in Herculaneum.)

Floronius, seconded on special duties, soldier of Legion VII, was
here and the women didn't recognize him, all but a few, that is,
and they succumbed on the spot.

Julius you dirty dog, you sucker-up.
(Note: Written by a student against his teacher.)

Fortunatus futuit Anthusan.
Fortunatus made it with Anthusam.

PRIMIGENIA
(The following graffiti were all dedicated to a young lady named
Primigenia, a resident of Nuceria, a suburb of Pompeii. This girl
apparently was quite generous with her favors.):
How happy we are to have known Primigenia.
Sabinus was here with Primigenia.
By the Roman Gate at Nuceria you may seek out Novella Primigenia,
in Venus Street.
Secondus with Primigenia met here.
Cornelius sends the biggest possible bundle of good wishes to Primi-
genia.
Welcome to Primigenia the sweetest and most darling of all the girls
in the world, our best wishes.
Hermeros wishes all the best to Lady Primigenia. Come to Puteoli
and in the Timian Street at the place of the banker Messius, ask
for Hermeros freedman of Phoebus.
(On the wall of a tavern in Herculaneum.)

Hullo, hullo Mago fare you well, you're obviously castrated.

Lovers, like bees, enjoy a life of honey.
UNDERNEATH
Wishful thinking.

No one's a handsome fellow unless he has loved.

The risen flesh commands, let there be love.

My life, my darling, to play for a while let me beckon, this couch is
our field and you as the horse we'll reckon.

Nothing can endure with an endless motion.
When the sun's beamed his best, he sets in ocean.
The Moon, but lately full, wanes by degrees,
and the storms of Venus fade to a gentle breeze.

Now anger is recent, now is the time to depart.
If tears appear (trust me) love revisits the heart.

What's this, my Eyes? You draw me into Fire.
And it's not Water down your cheeks you pour.
Tears cannot quench my flaring-up desires
They waste my soul and burn my bones the more.
Tiburtinus composed these.

Here I lie properly enjoyed.
(Note: Written by a girl in a brothel.)

It's the Lover who writes, the Sod who read it, it's clear.
The Listener twitches and itches, and he who goes by is a Queer.
And me, I'm a Bear's-dinner I'm the Twerp who stands reading here.

Come lovers all, I want to crack Venus' ribs
and cripple the goddess' lewd loins with clubs
If she's allowed to break my tender heart
why can't I break her head now for a start?

PROTEST AND CAUSE

Independence for Lapland!

Join the teen-age rebellion.
 (*Various walls and on a button.*)

Keep New York green, throw your trash in New Jersey.

Legalize necrophilia.

Let's legalize vandalism.

Protect your local abortionist.
 (*Button.*)

Repeal inhibition.
 (*On gum machine, IRT subway, New York City, and on a
 button.*)

Don't litter, stop the population explosion.
 (*IRT subway station, New York City.*)

Feces on theses.
 (*Fence near New York Univ., Washington Square, New York
 City. Also on a button.*)

Hang Slumlords.
(*Building on Lower East Side, 1969.*)

Help bring F-ck into polite usage.

Help retard children, support public schools.

Help send VW's back to Germany.

Help stamp in sex.

I am a mistake—legalize abortion.

Hooray for the Apollo 11 Eagle! To hell with you degenerated men-
tally sick bathroom scrawlers, negro worshipers, beatniks, misc.
decadent souls. Up America. Up the glorious romantic fire of the
Quest!
UNDERNEATH
Up the ass of the ruling class.
(*Men's room, New York Univ., Washington Square, New York
City, 1969.*)

There's too much water in our chlorine supply.

We want anti-gravity cars, the wheel is obsolete.
(*IND subway station, New York City, 1970.*)

Lake Erie died for your sins.
(*Univ. of Michigan, Ann Arbor, 1970.*)

Piss on the environment; everyone else does.
(*Univ. of Michigan, Ann Arbor, 1970.*)

The pollution you breathe may be your own.
(*Univ. of Michigan, Ann Arbor, 1970.*)

Support New York's finest; bribe a cop today.
(*Button.*)

Help support retarded unicellular animals!
UNDERNEATH
What about multicellular organisms, you idiot you.
(*Men's room, New York Univ., Washington Square, New York
City, 1969.*)

Support carnal knowledge.
(Time *magazine's graffiti contest, May, 1967.*)

Support your local police—help kill.
(*Button.*)

Support your local pornographer.
(*Chalk on sex book store at 42nd St., New York City. Also on
a button.*)

Up with down.

We must silence those who oppose freedom of speech!

If we all work together we can put a woman in the White House.
(*Ladies' room, Bernard Baruch College, New York City, 1970.*)

Repeal the law of gravity.

Save our slums.

Save water, bathe with friends.

The Songs of Watts must be heard.
(*The Forum Coffee House, New York City.*)

Stamp out distemper, but don't step in it.
(*Norton Mockridge's newspaper column.*)

Stamp out mental health.
(*Various walls and also on a button.*)

Stamp out poverty, not people.
UNDERNEATH
Stamp out poverty and people.

Stamp out reality.
(*Various walls and also on a button.*)

Stop air pollution—quit breathing.

Support Black Power—buy coal.

Support free enterprise, leaglize prostitution.
(*Button.*)

Abolish marriage!
(*Wolfie's restaurant, Nostrand Ave. at Flatbush Ave., Brooklyn, N.Y., 1969.*)

Down with macrobiotics!
(Note: Paradox specializes in macrobiotic foods.)
(*Coeducational john, Paradox Restaurant, East Village, New York City.*)

Wives are unpaid labor.

Women of the world wake up! Fight for all you should have had since the beginning of the world. Be second to no man.
(*Ladies' room, Limelight restaurant, Greenwich Village, New York City.*)

Practice birth control—
people are worse than the bomb.

Fewer men—fair admissions.
(*Yale Univ., New Haven, Conn., 1970.*)

Avenge Kent State.
UNDERNEATH
Burn the protesters. Light up a Kent.
(*IRT subway wall, New York City, Mother's Day, 1970.*)

Saxons go home.
(*From Graffiti by Richard Freeman, London, England.*)

PSEUDO-GRAFFITI

(Note: There are some writings on walls that should not be there. They cannot be called graffiti in the best sense. These are the contrived one-line gags or jokes that the writer has heard. They do not reflect the special surrealistic, imaginative qualities of the best wall writing. They tell us nothing about the writer—except that he may be a frustrated comedian.)

Abe Lincoln didn't waste his time watching TV.

Aunt Jemima is an Uncle Tom.

Autopsy is a dying practice.

Benjamin Franklin got a charge out of life.

Betty Crocker is a flour child.

Boris Karloff shies at shadows.

Cape Canaveral is America's soar spot.

Captain Kangaroo tells dirty stories to grandmothers.

Convertibles are topless.

Dean Martin drinks postum.

Help rid the nation of the lunatic fringe! Support your local barber.

If you can believe in Tiny Tim, Santa Claus should be easy.

If you're pushing 50 that's exercise enough.

James Beard burns toast.

John Doe is a nobody.

Julia Childs eats TV dinners.

King Tut had an over-protective mummy.

Lamont Cranston is afraid of his shadow.

Landlord: the roaches around here are getting too cocky.

Lassie kills chickens.

Lawrence Welk travels in square circles.

Newton counts on his fingers.

The only thing you can depend on today is insecurity.

Paul Revere was an alarmist.

Perry Mason bribes judges.

Puberty is for teen-agers.

Rosemary's baby is a little angel.

Snoopy has fleas.

Take a cannibal to lunch.

Think, maybe the Joneses are trying to keep up with *you*.

Unemployment helps stretch your coffee break.

Where there's a will there's an heir.

William Tell wore contact lenses.

Sibling rivalry is for kids.

RACE PREJUDICE

Congo coons rape nuns.
 (*Pete's Tavern, New York City.*)

Fuck your ethnic group.
UNDERNEATH
Yassuh!
 (*Wells Garden Supper Club, New York City.*)

Kill all niggers
Kill all ofays
But leave me alone.
 (*Men's room, Slugs', East Village, New York City.*)

NAACP stands for Negroes Are Always Colored People.
UNDERNEATH
no, it stands for Never Antagonize Adam Clayton Powell.

Stop Zionist aggession [sic].
 (*IRT subway, New York City.*)

Porky Pig is a Jew.

There will be a meeting of all non-Jewish students in the telephone
 booth.
 (*Boston Univ., Boston, Mass.*)

These Nazis never learn.
(Gene and Bunny's Bar, New York City.)

The White Knight is passing.

A Jewish fag = a ju ju fruit.
(Ladies room, Lion's Head, Greenwich Village, New York City.)

All Jews and Niggers are one and the same.
(Men's room, Rutgers Univ., Newark Campus, N.J., 1969.)

Communism is Jewish.
(Union Terminal R.R. Station, two blocks from JFK assassination site, Dallas, Texas.)

Coons read kike N.Y. Post.
(On ad for the New York Times, subway station, New York City.)

Donald Duck is a Jew.
UNDERNEATH
Donald Jew is a duck.

Donald Duck is a Jew.
UNDERNEATH
So what?
UNDERNEATH
So he can't be Porky Pig.
(Men's latrine in South Vietnam, 1967.)

Be kind to Chuck the spade, he's the official Negro.
(Lion's Head, Greenwich Village, New York City.)

Emmett Kelly is a Negro in whiteface.
(Ladies' room, Le Metro Caffe Espresso, New York City, 1967.)

Black girls are better. They're not hung up like Jewish princess virgins.
(Men's room, Brooklyn College, Brooklyn, N.Y., 1970.)

Adam Clayton Powell uses Man-Tan.
(From Art Buchwald column.)

Black go back. Africa needs you.
(From Graffiti by Richard Freeman, London, England.)

Bring back white slavery.

We use to have pity for the white bitches. Today our feelings have left us, so beware, kick ass—black power.
(IND subway E train, New York City. Found two days after the murder of Martin Luther King, which occurred April 4, 1968.)

White people are pink flower bitches. The shaded flower is dead.
(IND subway E train, New York City. Found a day after the murder of Martin Luther King.)

168

Whitey has had it Baby.
Why try to blot it out.
REPLY
Face it, Blacky is not too bright!
 (*Limelight restaurant, Greenwich Village, New York City.*)

White is reliable.
 (*Construction fence, midtown, New York City.*)

LeRoi was here
UNDERNEATH
Le Roi eats white ice cream.
 (*Ladies' room, Le Metro Caffe Espresso, New York City.*)

Negroes just *subtract* from the culture, they *add* nothing and just *divide* the people.
UNDERNEATH
But they sure can *multiply!*
 (*Building on Lower East Side, New York City, 1969.*)

Please flush the toilet, we want the niggers to starve to death.
 (*A Missouri café, 1965.*)

Rap Brown wears blue contacts.

Reprimand White racists but kill Black racists.
 (*Men's toilet, Rutgers Univ., Newark Campus, N.J.*)

Black is beautiful.
CROSSED OUT AND WRITTEN UNDERNEATH
White ain't so bad.
CROSSED OUT AND WRITTEN UNDERNEATH
Black is still beautiful.
 (*Northwestern Univ., Evanston, Ill.*)

Equality for all minorities!
UNDERNEATH
You dunce—by equalizing all minorities, you thereby destroy their identities as minorities, thereby making them no longer minorities.
UNDERNEATH
Semantic bullshit and fourth term fallacy.
UNDERNEATH
You anti-Semantic motherfucker.
UNDERNEATH
Register all puns.
UNDERNEATH
Puns don't kill people, people kill people.
 (*Coed toilet,* East Village Other, *a publication, New York City, 1970.*)

This rest room is reviewed in the 1969 edition of "The Protocols of the Elders of Zion."
UNDERNEATH
Which is why the Jewish Defense League is always on your ass.
 (*Coed toilet,* East Village Other, *New York City, 1970.*)

Roses are reddish
Violets are bluish
If it weren't for Xmas
We'd all be Jewish.

RELIGION

God is a prisoner in the Sandoz factory.
(Note: Sandoz factory is where LSD is made.)

God marks on the curve.
> (*Cornell University, Ithaca, N.Y.*)

God nibbles.
UNDERNEATH
One does what one can.
> (*New York Univ., Washington Square, New York City.*)

God is not dead, he is just very, very sick.

God is not dead; he lives with me.
> (*Ladies' room, Tin Angel restaurant, Greenwich Village, New York City.*)

Walt Disney turned me against God and made me believe in Mickey Mouse.

We didn't invent sin we're just trying to perfect it.

If God is perfect, why did he create discontinuous functions?
UNDERNEATH
He didn't, man did.
UNDERNEATH
Since God is perfect, the theory of discontinuous functions must be wrong.
> (*Univ. of Michigan, Ann Arbor.*)

Sainthood is an Ego trip.
> (*BMT subway station, New York City.*)

Nuns—kick the habit.
> (*Grand Central station billboard, New York City.*)

Evil works.

God is omnivorous; he loves chitlins, bagels, pizza, even enchiladas.
UNDERNEATH
Napalm too?
> (*7th Ave. IRT subway, New York City.*)

God was here.
UNDERNEATH
I sure was.
 —God.
 (*Limelight restaurant, Greenwich Village, New York City.*)

Impeach God and his bright ideas.
 (*Ladies' room, Max's Kansas City restaurant, New York City.*)

What is the difference between God and Santa Claus?
Answer. There is a Santa Claus.

God is silly putty. Can do anything!
UNDERNEATH
I believe in silly putty.
 (*Univ. of Florida, Gainesville.*)

I am an atheist, I don't belive in Zeus.
 (*Construction wall, Walnut St., Philadelphia, Pa., 1969.*)

Hell is empty, for the devils are all here.
 (*Bates College, Lewiston, Maine.*)

I'm in love with a priest and he's a virgin.
UNDERNEATH
How did you ever find a rarity like that?

Vat 69 is the Pope's telephone number.

Revive fertility rites.
 (*The Village Gate, Greenwich Village, New York City. Also on
 a button.*)

Keep the Pope off the moon.
 (*The Rivera, Sheridan Square, New York City.*)

In case of atomic attack,
the federal ruling against prayer in schools
will be temporarily suspended.
 (*Written on a fence; reported in Norton Mockridge's column.*)

Come home Judas—all is forgiven.
 (*Men's toilet. Telephone directory proofreader's office, mid-
 town, N.Y.*)

Judas needed the money for a sick friend.

O God help me I am suffering—
UNDERNEATH
Sweetheart so am I.
UNDERNEATH
From what? Everything.
UNDERNEATH
Who cares.
UNDERNEATH
We care at A. & P.
 (*Ladies' room, Lion's Head, Greenwich Village, New York City.*)

171

God is not dead! He is alive and autographing bibles today at Brentano's.
>(*110th St. subway stop, New York City.*)

Weary, weary is the Lord of hosts. So weary is he in fact that he is dead of it.

Walter Lippmann—God is not dead. He is alive and appearing twice a week in the Washington *Post*.
>(*From Art Buchwald column.*)

Religious faith is merely an excuse for man's moral weaknesses.
>(*Wall at Wagner College, Staten Island, N.Y.*)

On religious poster: "You can lift your life."
WRITTEN ADDITION
With a jock.

Sodom is a summer festival.
UNDERNEATH
Gomorrah the merrier.
>(*Kettle of Fish bar, Greenwich Village, New York City.*)

On a poster put out by The New York Bible Society: "Jesus said, Whoever drinks of the water that I shall give him will never thirst."
ADDED
He should be appointed water commissioner.

God ain't dead, he's just playing possum.

God is a whore and what's more she's black.
>(*Men's room, Slug's, East Village, New York City.*)

God is alive and well in Mexico City.
>(*Various walls and on a button.*)

God is alive—everyone else is dead.

God is alive—he just doesn't want to get involved.
>(*Various walls and on a button.*)

God is alive in Burbank, Calif., if in doubt call (214) 9687.
>(*Ladies' room, Ninth Circle restaurant, Greenwich Village, New York City.*)

God is coming to St. Louis—tickets on sale now.

My God is alive, sorry about yours.
>(*Univ. of Michigan, Ann Arbor.*)

Jesus wore long hair.
>(*Wall at St. Mark's Place, New York City, and on a button.*)

Would Christ carry a draft card?

John Lennon is Jesus in drag.

John Lennon writes his own bibles.
> (*IRT subway, New York City.*)

God is dead
 —Nietzche
Nietzche is dead
 —God

God is dead.
 —Time
Time is dead.
 —God.
God is not dead.
 —Billy Graham.
Who is Billy Graham?
 —God.
> (*Limelight restaurant, Greenwich Village, New York City.*)

God is dead, but don't worry the Virgin Mary is pregnant again.
> (*"Private" men's room, Central Cleveland Police Station, 1968.*)

God is not dead,
he's just trying to avoid the draft.
> (*Park St. subway station, Boston, Mass.*)

God isn't dead—he just couldn't find a parking place.
> (*Ladies' room, Queens College, New York City.*)

Sign reading: "Call on Jesus Now."
ADDED
If no one answers,
leave a message at the candy store.

Jesus was raised in a kosher home.
> (*BMT subway, New York City. Also on a button.*)

Kill a Commie for Christ.
> (*Subway station men's room, New York City; also appears on buttons and was heard on WBAI broadcast as part of a comic routine by Burns and Schriber.*)

Billy Graham is the religious editor of *Time*.
> (*Lion's Head, Greenwich Village, New York City.*)

Jesus Saves.
UNDERNEATH
He couldn't do it on my salary!

Jesus saves; Moses invests; but only Buddha pays dividends.

Jesus saves but the Mongol hordes.

Jesus lives!—Darwin survives!

Jesus was a dropout.
> (*Various walls and on a button.*)

173

Gabriel blows.
> (*Various walls and on a button.*)

Reincarnation is a pleasant surprise.
> (*Men's room,* East Village Other, *New York City, 1969.*)

The world is coming to an end! Repent and return those library books!
> (*Arlington County Public Library, Va. Cited in* American Library Association Bulletin, *April, 1969.*)

Blessed are the meek for they shall inhibit the earth.

The meek shall inherit the earth—they are too weak to refuse.

The Golem will eat your false Gods.
> (*Free Store Theatre, East Village, New York City.*)

Do unto others—and then cut out.

Love thy neighbor but don't get caught.
> (*Men's room, The Riviera, Sheridan Square, New York City.*)

Thou shalt not covet thy neighbor's fag.

Bring back paganism.
> (*Various walls and on a button.*)

REVOLUTION

Anarchism now!
> (*Café Figaro, Greenwich Village, New York City, 1965. No longer in business.*)

Anarchists of the world unite, you have nothing to lose but your decentralized principles.
> (*Paradox Restaurant, East Village, New York City.*)

Anarchy is against the law.
> (*Coed toilet, Alternate U., New York City.*)

Anarchists unite!
> (*Various walls and on a button.*)

We are all under control.
> (*Men's room, Under The Stairs bar and restaurant, New York City.*)

Today East Village, tomorrow the world.
> (*Engagé Coffee House, East Village, New York City. Out of business. Also on a button.*)

If SDS closes down the school you won't be able to get your diploma and graduate.
UNDERNEATH
Too bad! No diploma to Plasticland.
> (*San Francisco State College, Dec., 1968.*)

There will be no irrelevant Greek courses with pacing professors.
> (*New York Univ., Washington Square, New York City, 1969.*)

Vote with your feet.
UNDERNEATH
Do you have prehensile toes?
> (*Columbia Univ., East stairwell, Hamilton Hall, New York City.*)

Read the Redbook.
> (*On the Jefferson Market branch of the New York Public Library, 1970.*)

All the way with Che.
> (*Men's room, Brooklyn College, Brooklyn, N.Y., 1969.*)

Up the people.
UNDERNEATH
Up your ass.
UNDERNEATH
Up the people's ass.
> (*Univ. of Michigan, Ann Arbor, 1970.*)

Better red than black.

Bourgeois elements must go!

Give the guns to the people not the gangsters.
> (*Coed toilet, Alternate U., New York City, 1969.*)

How now brown Mao?
> (*Coed toilet, Alternate U., New York City, 1969.*)

Identify your friends by their enemies.
> (*Coed toilet, Alternate U., New York City, 1969.*)

In the new society, people will ask, "What will the NEW SOCIETY BE LIKE?"
> (*New York Univ., Washington Square, New York City, 1969.*)

The *Journal-American* is a Commie newspaper.
> (*Bronx, N.Y. subway station, 1956.*)

S.D.S. = SS.
> (*Cornell Univ., Ithaca, N.Y.*)

We shall steal the new society from the old one.
> (*New York Univ., Washington Square, New York City, 1969.*)

Revolution allows the revolutionary to sublimate his sado-masochistic, neurotic, anal tendencies into a concern for the working class.
> (*Subway station, Columbia Univ. stop, New York City, 1970.*)

175

The dreams of those who will not act; The reality of those who are not afraid to be free.
UNDERNEATH
What about the fuck-offs who are still afraid to *fight* to be free.
(*New York Univ., Washington Square, New York City, 1969.*)

Fuck Cordier!
UNDERNEATH
Sorry, you can't ruin his reputation, he's impregnable.
UNDERNEATH
Impregnate Cordier!
(*Men's room, Columbia Univ., New York City.*)

Only revolution ends war!
ON OPPOSITE WALL
Only revolution ends poverty!
(*East 11th St., New York City, 1970.*)

You don't need a professor if you can read a book.
(*Wall at Hunter College, New York City, 1970.*)

Fuck the faculty.

Nix on the nun.
(Note: Written by students who submitted demands upon ex-nun Mrs. Jacqueline Wexler neé Grennan who is the head of Hunter College.)
(*Wall of Hunter College, N.Y., 1970.*)

Che lives like a pit in the throat of all capitalists and fascists.
(*Mr. Waffles ice cream parlor, Greenwich Village, New York City.*)

The Alternate U. is run by a Polish Gusano [worm].
(*Coed toilet, Alternate U., New York City.*)

Permanent revolution, "death to the right."
UNDERNEATH
All death is left and right.
(*Men's toilet, New York Univ., Washington Square, New York City, 1969.*)

Lenin won
Fidel won
We will win.
(*Columbia Univ., New York City, April 30, 1968. The day of the student strike.*)

Don't dispare [sic]
Mao's there.
(*The Exit Coffee House, New York City.*)

Join the N.Y.U. 4H club:
—Horns
—Hype
—Hysteria
—Hassling.
(*New York Univ., Washington Square, New York City, 1969.*)

SARCASM AND CYNICISM

All persons involved in the conspiracy report to stockyards 4:30 p.m.
for head bashing—J. Edgar Tumor.
(*Coed toilet,* East Village Other, *a publication, New York City,
1970.*)

The more you cultivate people, the more you turn up clods.
(*Wall at Ann Arbor, Mich., 1970.*)

Ring around a neutron
A pocket full of protons
A fission, a fussion
We all fall down.
(*Construction wall, Walnut St., Philadelphia, Pa., 1969.*)

Pray for obscene mail.

Charles Whitman loves puppies.
(Note: In August, 1966, honor student C. J. Whitman shot and killed
twelve and wounded thirty-three people from the Texas University
Tower.)
(*Button.*)

It often shows a fine command of the English Language to say
nothing.
(*Univ. of Michigan, Ann Arbor.*)

UFO's are for real; the Air Force doesn't exist.
(*Univ. of Michigan, Ann Arbor.*)

The giant Martians landed, thought Los Angeles was a men's room
and left.
(*Column in the* Sacramento Union, *Sacramento, Calif., 1967.*)

A go-getter, in some offices, is the fellow they send for coffee.
(*Midtown New York City construction fence.*)

I am a fetal failure.
(*University of Florida, Gainesville.*)

Honolulu is as American as apple poi.

Machines can never replace human stupidity.

I am an enemy of Graffiti—they killed my mother.

New York's finest; the best that money can buy.

Nostalgia isn't what it used to be.

The Renaissance was a Zionist conspiracy.

Sock it to me with apathy.

This tree is spared but its sex life is ruined forever.
(*Found on a fence near a lone tree.*)

Tomorrow will be cancelled due to lack of interest.

We are the people our parents warned us about.
(*Engagé Coffee House, East Village, New York City. Out of business.*)

We hate all people, regardless of race, creed or color.

Welcome to the Wrinkle Room.
(*The Pilgrim Restaurant, East Village, New York City.*)

I fight poverty: I work.
(*Construction fence, New York City. Also on a button.*)

I just cannot picture you as the end result of millions of years of evolution.

The world is going through a great big menopause.
(*Wolfie's restaurant, Nostrand Ave., Brooklyn, N.Y.*)

You are now shaking your best friend
and he stood up for you on your wedding night.
(*Camp Maxey, Paris, Texas, 1945.*)

You'll never be the man your mother was.
signed A Negro.
(*The Exit Coffee House, New York City.*)

Greenwich Village has moved to Williamsburgh.

America good country, the people no good.
(*Grand Central Station, New York City.*)

Boy hippy: A guy who looks like a Jill and smells like a John.

Count Dracula, your Bloody Mary is ready.

Dallas still lives. God *must* be dead.
(*Men's room, Southern Methodist Univ., Dallas, Texas.*)

Dep't of Slum Maintenance.
(*Written on the door of the Welfare Center, Bronx, N.Y.*)

Do retiring volkswagens go to the "old Volks home"?

Don't shoot, I don't want to be President.

Earthquake predictors are fault finders.

The generation gap is between the ears.

An elephant is a mouse drawn to government specifications.

Familiarity breeds.
(Variation: Familiarity breeds attempt.)

Florists are just petal pushers.

We have an electric eraser. What have you done for automation, lately?
(*Staff lounge of library. Cited in* American Library Association Bulletin, *Jan., 1969.*)

Fixed races nightly at Yonkers.
(*Written on the back of seat on bus that goes to Yonkers Raceway.*)

Remember, even if you win the rat race—you're still a rat.

Marie Montessori taut me to rite at age too.
(*Cover of* The Critic *showing a wall covered with graffiti, Dec., 1966-Jan., 1967.*)

Stop the world, I want to get off.
(*Appeared on several toilet walls long before Anthony Newley used it as the title of his musical.*)

Philadelphia is not dull—it just seems so because it is next to exciting Camden, New Jersey.
(*Construction wall, Walnut St., Philadelphia, Pa., 1969.*)

Motherhood, apple pie, and the American way WILL NO DOUBT LEAD US DOWN THE PRIMROSE PATH TO WORLD WAR III.
(*Florida State Univ., Tallahassee.*)

This must be police headquarters because all the dicks hang out here.
(*Men's room, Under The Stairs bar & restaurant, New York City.*)

Beatnicks are worthless.
UNDERNEATH
Your attitude is worthless.
UNDERNEATH
Beatnicks have been extinct since 1960. Where have you been?
UNDERNEATH
How do you spell beetnick?
(*Forum Coffee House, East Village, New York City.*)

Those who think they know it all upset those of us who do.
(*Univ. of Michigan, Ann Arbor.*)

I was a pseudo Bohemian for the FBI.
(*Café Figaro, Greenwich Village, New York City. Out of business.*)

I was born this way, what's your excuse?
(*Button.*)

I claim this wall for Queen Elizabeth.

I'd give my right arm to be ambidexterous.

You don't buy beer here, you just rent it.
> (*Men's room, The Oasis bar, Palo Alto, Calif.*)

The United States Army;
194 years of proud service,
unhampered by progress.
> (*Men's room, Commcenter Co. C 44th Signal Bn., 1969.*)

I've got what every woman wants.
UNDERNEATH
You must be in the fur coat business.

The Jews are a gas.
> —A. Hitler.
> (*Ladies' room, Limelight restaurant, Greenwich Village, New York City.*)

Landlord, the roaches around here are getting entirely too cocky.

Last sperm in is a rotten egg.

Flower children of the world unite.
UNDERNEATH
Your mothers were all laid by pansies.

Is there any intelligent life on Earth?
UNDERNEATH
Yes, but I'm only visiting.
> (*Wall at Cambridge Univ., Cambridge, Eng., 1969.*)

SEX

Sex before finals.
> (*Wall at Queens College, New York City, and also on a button.*)

Sex is all rumor.
> (*Univ. of Florida, Gainesville.*)

Be creative, invent a sexual perversion.
> (*Ladies' room, Ninth Circle restaurant, Greenwich Village, New York City. Also on a button.*)

Sex is like money—even when it's bad it's good.
> (*Button.*)

She who indulges, bulges.

Virtue can hurt you.
 (*Button.*)

Vote yea on propositions.
 (*Lipstick scrawl in voting booth, 1969.*)

The thing most men learn too late—sex is of interest to both sexes.

To go together is blessed, to come together divine.
 (*Ladies' room, Mother Hubbard restaurant, Greenwich Village, New York City. Also on a button.*)

Girls who use men sexually for power are really abusing themselves.
UNDERNEATH
Groovy abuse.
 (*Ladies' room, New York Univ., Washington Square, New York City.*)

Before Freud sex was a pleasure, now it's a necessity.

Help me! I'm a sex junkie.

Boys marry virgins, men marry women.
 (*Ladies' room, New York Univ., Washington Square, New York City.*)

So let me state in this woeful dirge
That life played a horrible trick
On the man possessed by a giant's urge
And cursed with a pygmy's stick.
 (*Public toilet, San Francisco, 1948.*)

Chaste makes waste.
 (*Various walls. Printed on a button.*)

Women should be obscene and not heard.
 (*Cedar Tavern, Greenwich Village, New York City, 1964. Also on a button.*)

Chastity is its own punishment.
 (*Paradox restaurant, New York City. Also on a button.*)

Copulate for coexistence.
 (*Button.*)

I want to seduce my history teacher.
UNDERNEATH
I did and got an F.
 (*Ladies' room, Hunter College, New York City.*)

I will believe anything if you can answer this question: why are there people.
UNDERNEATH
Sex.
 (*Ladies' room, Ninth Circle restaurant, Greenwich Village, New York City.*)

Genitals prefer blondes.
(Men's room, Cyrano restaurant, New York City.)

The Prudential Center is a Phallic symbol.
(Boston Univ., Boston, Mass.)

Sex is beautiful but unsanitary.
REPLY
So wash.
(Ladies' room, Hunter College, New York City, 1970.)

Call it incest—but I want my mommy.

Use erogenous zone numbers!
(Various walls and also on a button.)

Vagina envy.
(Written in chalk on the sidewalk in front of Brooklyn College, Brooklyn, N.Y., Nov., 1969.)

I'm so horny the crack of dawn better watch out.
(Men's room, Salem State College, Salem, Mass.)

Impotence, where is thy sting.

Incest—a game the whole family can play.

If I am sleeping and you want to wake me, don't shake, take me.
(Ladies room, The Figaro coffee house, Greenwich Village, New York City. Out of business.)

Large cats can be dangerous but a little pussy never hurt anyone.
(IRT subway station, New York City.)

Gilt without sex.
(Engagé Coffee House, East Village, New York City.)

Hail Priapus!
(Univ. of New Mexico, Albuquerque.)

Happiness is a warm puppy.
UNDERNEATH
No! it's a warm pussy.
(Men's room, Boston Univ., Mass. First legend is also printed on a button.)

More congress, less legislation.
(Button.)

Suburbia Today: Bookmobiles are out; wifemobiles are in.
(Arlington County Public Library, Va. Cited in American Library Association Bulletin, April, 1969.)

On a prophylactic machine:
Odorless—Tasteless
Safe to eat
Stainless on teeth
Official Highway Patrolman Uniform
(Viking Lounge, Phoenix, Ariz., 1965.)

Omne Animal Post Coitiem Triste Est.
UNDERNEATH
You're typing people.
> (*The Village Gate, Greenwich Village, New York City.*)

Up with dresses
Down with pants.
> (*The Exit Coffee House, East Village, New York City.*

Van de vetter is hot und sticky
Dat's not de time to dunk de dicky;
Uber ven de frost is on de pumpkin,
Dat's de time to do de dunkin.

Vice is nice, but incest is best.
> (*Ladies' room, Limelight restaurant, Greenwich Village, New York City.*)

Montana—where men are men
and women are sheep.
> (*Bar-Café Service Station, State H'way, Mont.*)

Pubes uber alles.

The name for the pill is absorbine junior.

Never be led astray into the path of virtue.

Have pill—will.
> (*Button.*)

Carry me back to old virginity.
> (*McGraw Tower, Cornell Univ., Ithaca, N.Y.*)

The only recourse is intercourse, of course.
> (*Univ. of Florida, Gainesville.*)

Orgasms for sale, rent or trade.
> (*Button.*)

Orifice—not artifice.

A SOUND MIND IN A SOUND BODY

People are no damned good.
UNDERNEATH
Psychiatrists are worse.
UNDERNEATH
Psychiatrists aren't people.
> (*Scrawled on Park Ave. apt. house, New York City. Reported in Norton Mockridge column in the* Boston Herald, *Dec. 2, 1966.*)

Make your psychosis work for you.

I am a masochist please spindle, fold or mutilate.

Help! The paranoids are after me.
> (*Arlington County Public Library, Va. Cited in* American Library Association Bulletin, *April, 1969.*)

Even paranoids have real enemies.
> (*Back of the seat of bus in New York City. Also on a button.*)

Give your child mental blocks for Christmas.

Alienation can be fun.
> (*Pennsylvania R.R. station, New York City. Also on a button.*)

Hurrah for Korsakov's psychosis.
(Note: The technical description of the DTs.)

Oh to be out of my catatonic trance, now that April's here.

Neurosis is red
Melancholia is blue
I'm schizophrenic
What are you?
> (*Lion's Head, Greenwich Village, New York City.*)

An apple a day keeps the doctor away, but an onion a day keeps everyone away.

Apple pie makes you sterile.
> (*Button.*)

Asian flu for Asians only.

Bagel power!

Birth control pills are habit forming.

Cancer cures smoking.
> (*Various walls and on a button.*)

Cigarette coupons pay for cancer operations.

Caution: breathing may be hazardous to your health.
> (*Various walls and on buttons.*)

Smoke—Choke—Croak.
> (*On subway cigarette ad poster.*)

Of course I smoke—it's safer than breathing.
> (*Button.*)

Dirty train stations cause terminal illness.
> (*Subway station, New York City.*)

It is better to be rich and healthy than to be poor and sick.

Chico has mental health.
(A wall near N.Y. Academy of Medicine, 1957.)

Paranoid—someone is watching you thru the keyhole. Plug it with toilet paper.
(Coed toilet, Alternate U., New York City.)

Think how you look to your pinworms.
(Doctors' bathroom, Bellevue Hospital, New York City.)

Hormones are a big bust.

Masochists: you're only hurting yourselves.

It's banal to be anal, but far worse when
you're polymorphous-perverse.
(Ladies' room, Max's Kansas City restaurant, New York City.)

If you can keep your head when those about you are losing theirs, perhaps you've misunderstood the situation.

SUGGESTION BOX

Help send a girl to Boy's Town.

Stamp out Bert Parks.

Start the day with a smile and get it over with.
(Button.)

Think dirty.
(Various walls and on a button.)

Reporter: Mr. Gandi [sic] what do you think of Western Civilization?
Mr. Gandi [sic]: I think it would be a good idea!
(Coed toilet, Alternate U., New York City.)

Report your loco police.
(The Exit Coffee House, East Village, New York City.)

To save face keep lower-half shut.

Up with minis.

Visit your mother today, maybe she hasn't had any problems lately.
(Button.)

Warning: trespassers will be violated.
(Button.)

Warning—your local police are armed and dangerous.

The world is your oyster, so EAT IT!

If looking down embarasses you, don't look.

Hire a freak today.

Honor thy analyst.

If at first you don't succeed Cheat!!!
 (*Button.*)

Acquit Socrates.

Get the Greeks out of Ilium.

In case of atomic attack
1. Put your hands over your ears.
2. Put your head between your legs.
3. Kiss your ass goodbye. You've had it.

In case of emergency, break glass and pull down Lever.
 (*In chalk on the sidewalk in front of the Lever Building on Park Ave., New York City.*)

Keep the baby.
 —Faith.

Kill a cop.
 (*Mr. Waffles ice cream parlor, Greenwich Village, New York City.*)

Eggheads of the world unite! You have nothing to lose but your yoke.
 (*Yale Univ., New Haven, Conn.*)

Don't pay the unfare.
 (*Various subway stations, New York City. In protest against the fare raise, 1970.*)

Defrock John Birch cops.
 (*Button.*)

Dial-A-Beating 440-1234
(Note: Police Department telephone number.)

Don't hate yourself in the morning—sleep till noon.

Earn, Baby, Earn.
 (*Men's room, Brokerage house, Palm Beach, Fla.*)

Earn cash in your spare time—blackmail your friends.

Easternize the Midwest.

Death to the penis invasion.
(Note: The meaning of this phrase puzzled people for years.)
 (*Julius Restaurant, Greenwich Village, New York City, 1950.*)

Let's take crime out of the streets!—And put it back in the homes where it belongs!
 (*Men's lockers, Sunken Meadow State Park. L.I. Sound, N.Y.*)

Kiss the ass of an Aardvark.
(*Kettle of Fish bar & restaurant, Greenwich Village, New York City.*)

Beware of the Chimera.

A bird in the hand can be messy.

Retain your humanity. Cash it when the price goes up.
(*Bates College, Lewiston, Maine.*)

Lysistrata had a good idea.
(*Ladies' room, Brooklyn College, Brooklyn, N.Y.*)

McDougal St. teeny boppers evaporate! (please)
(*Engagé Coffee House, East Village, New York City.*)

Bring back the Gallo gang, the gang with a soul.

Call again and bring your butterfly net.

Dear T.A.
I can keep it up as long as you can.
(*IND subway station, New York City.*)

Library statistics are reliable if you don't count on them.
(*Staff lounge of public libraries. Cited in* American Library Association Bulletin, *Jan., 1969.*)

Spare the rod and spoil the drag race.
(*Library staff lounge, Fort Belvoir, Va. Reported in* American Library Association Bulletin, *April, 1969.*)

Stop flim-flamming and get down to business—give a damn. End the economic war in Vietnam—Free Huey and the 21.
REPLY
This won't help.
(*Men's room, Brooklyn College, Brooklyn, N.Y.*)

Ride the subways free—fuck the fare.
(*IND subway, New York City, 1970. One of many irate wall messages because of the subway fare raise from 20 to 30 cents.*)

Cast your vote for free subways, put your chewing gum in the token slot.
(*6th Ave. IND subway station, New York City, 1970.*)

Hire the morally handicapped.
(*Various walls and on a button.*)

Arm the vagrants.
IN ANOTHER HAND
Arm the cockroaches.
(*Coed toilet, East Village Other, a publication, New York City, 1970.*)

Children—beat your mother while she is young.
(*Wall in London, England.*)

VIETNAM WAR

Commit LBJ, not the USA.

France has her De Gaulle,
And we have our Neanderthal.
 (*Queens College wall, Queens, N.Y., 1967.*)

Back Mac.
(Note: McNamara.)
 (*Chalk on Wall St. building, New York City.*)
WITH LIPSTICK BELOW
If you liked Hitler—you'll love McNamara.

Barbecue Lyndon.

Stop demonstrations by ending the war in Vietnam.
UNDERNEATH
What kind of idiot thinks that foreign policy can be made by throwing temper tantrums in the streets of big cities?
 (*IRT subway, New York City.*)

Impeach Johnson.
UNDERNEATH
We already tried it stupid, in the late 19th century.
(Note: On Feb. 24, 1868, the House passed a resolution of impeachment against President Andrew Johnson. By a narrow margin, the Senate failed to convict.)

Coitus interruptus in the rape of Vietnam now!!!
 (*Fence at Yale Univ., New Haven, Conn., 1970.*)

L.B.J. for ex-President.
 (*Various walls and on a button.*)

Lyndon Johnson is suffering under the misconception that his mother was a virgin.
 (*Men's room, Colby College, Waterville, Maine.*)

Where is Lee Harvey Oswald now that we really need him?
 (*Various walls and also on a button.*)

Amo—not ammo.
President Johnson is a latent human being.
 (*BMT subway station, New York City, 1968.*)

Great Society, abominable snow job.
 (*Various walls and on a button.*)

Great Society: bombs, bullets, bullshit.
 (*Wall near Tompkins Square Park, New York City, and also on a button.*)

Give us joy, bomb Hanoi.

Bombing can end the war—bomb the Pentagon.

Humphrey is a product of our times—a waste product.
(*Men's room, Bates College, Lewiston, Maine.*)

I'd rather have my country die for me.
(*Men's room, Princeton Univ., N.J.*)

Bring the war home—Oct.8 Chicago
(*Various walls all over New York City, Sept., 1969.*)

Con Ed. is the chemical branch of the Viet Cong.

End the world in Vietnam.

Escalate minds, not war.

Napalm peaceniks!

Resist the army.

ROTC = NAZI.
(*Cornell Univ., Ithaca, N.Y.*)

Send Batman to Vietnam.

Kill for peace, kill for freedom,
 kill Vietnamese, kill! kill!

End the boys in Vietnam; bring the war home.
(*IRT subway station, New York City, 1966.*)

Support peace or I'll kill you.
(*Found on Moratorium Day, Oct. 15, 1969. Blimpie Base,
Greenwich Village, New York City. Also printed on a button.*)

Fighting for peace is like fucking for chastity.
(*Men's room, Rutgers Univ., Newark Campus, N.J.*)

Peace to all and to all a good piece!
(*Men's room, Central Falls, Rhode Island.*)

Vietnam: love it or leave it.

Foreign aid to Ho Chi Minh.
North Vietnam Care Package.
(*Messages painted on bombs in Vietnam, 1967.*)

With more people like me on our side,
we woulda lost the war.
(*IRT subway, New York City.*)

Deface for peace.
(*Ladies' room, Hunter College, New York City, 1969.*)

Don't draft married men, all the fight's out of them.

189

A pax on both your houses.
> (*Ladies' room, "55" Bar, Greenwich Village, New York City, 1969.*)

U.S. vaincra les marines.
> (*Nanterre, May, 1968.*)

Be free, go Canada.
> (*Chalk in front of Canadian Gov't Travel Bureau. Fifth Ave., New York City. Also on a button.*)

You fight and die but can't drink at 18.
> (*IRT subway stop at 42nd St., New York City. Also on a button.*)

Draft the beat.
> (*Various walls and on a button.*)

Supposing they had a war and nobody came.

Hey, hey L.B.J. how many kids did you kill today?
(Note: This was a popular chant around 1966. It later was found on many walls.)

Why should the U.S. Gov't fight for fascism in Vietnam?
REPLY
To fight for the interests of the capitalists.
CONTINUATION
End the war in Vietnam.
REPLY
How?
REPLY
By killing all commies and reactionaries like you.
> (*Bathroom walls at the New School for Social Research, New York City, April, 1965.*)

PEACE BUG

Take my country
Burn my flag
Rape my sister
But please
Leave me alone

(*IND subway, New York City.*)

Effete snob for peace.
> (*Various walls.. Two days after a speech by Vice President Agnew in which he referred to certain peaceniks as effete snobs a button was manufactured with the above legend. Nov., 1969.*)

Richie, Akron, Ohio, 112 days to do in the 'Nam.'
Boot 4 days to go.
Boot 1 day left.
Boot! Only 12 hours left.
Boot! I'm leaving as soon as I finish this shit.
Boot! I haven't got time to take a shit.
Boot! I left last week.
(Note: Boot is Marine Corps slang for recruit, *i.e.*, a novice.)
> (*Men's toilet, Post Exchange, Hill 327, Da-Nang, Vietnam, Feb., 1967.*)

Le May's wet dream—Vietnam.
> (*Boston Univ., Boston, Mass.*)

God is not on our side.
> (*Various walls and on a button.*)

Nixon has pentagonorrhea.
> (*Men's room, Harvard Univ., Cambridge, Mass.*)

Vietnam: The Edsel of foreign policy.

War is good business—invest your sons.
> (*Harvard, Lamont Library. Cambridge, Mass. Also on a button.*)

I can't relate to my environment.
> (*Saigon, roadside shelter.*)

The Marine Corps thanks the USAF.
REPLY
Your welcome, jarhead.
> (*Vietnam, 1966.*)

Girl Scouts wear the green beret.

Take a Viet Cong to lunch this week.
> (*Univ. of Southern California, Los Angeles, 1966.*)

U.S. get out of Vietnam.
UNDERNEATH
U.S. get out of Berkeley.
> (*Univ. of California at Berkeley.*)

Old soldiers never die. Young ones do.
> (*IRT subway, 42nd St., New York City.*)

Join the Marines, intervene in the country of your choice.

Legalize private murder, why should the government have all the fun?
> (*Button.*)

Lock up McNamara and throw away the Ky.

Don't think, follow! Don't talk, shoot! It's the American way.
(*Button.*)

Ho lives!

Make patriotism legal now.

There will be peace in 1978—with or without people.
(*Subway bulletin board.*)

Guns don't kill people, people kill people.
(*Button.*)

WALL GOSSIP

Socrates eats Hemlock.
(*Lion's Head, Greenwich Village, New York City. Also on a button.*)

Spinoza eats bagels.
(*Lion's Head, Greenwich Village, New York City.*)

Little Jack Horner's problem is more serious than he thinks.

Mary Poppins is a junkie.
(*Various IRT subway toilets, New York City, 1965. Also a button message.*)

Superman wears mini-pants.
(*Simple Simon Hamburger Bar, 14th St., New York City.*)

You think Oedipus had a problem. Adam was Eve's mother.
(*Construction wall, Walnut St., Philadelphia, Pa., 1969.*)

Peter Piper picked a peck of pickled peckers.

This is where Napoleon tore his Bonaparte.
(*Ladies' room, Vassar College, Poughkeepsie, N.Y.*)

Tiny Tim is just another pretty face.

Hugh Hefner is a virgin.

Oedipus was the first man to plug the generation gap.
(*Men's room, Princeton Univ., Princeton, N.J., 1970.*)

Wonder Woman takes it in the nose.
UNDERNEATH
No wonder.

Mickey Mouse is a homosexual.
 (*Scholtz's Beer Garden, Austin, Texas.*)

Mao's wife is an Oriyentah.

Mark Rudd is a Virgin.
 (*Columbia Univ., New York City.*)

Marshall McLuhan is print-oriented.

Mary Poppins is grounded.

Graffiti was Mussolini's Secretary of Defense.

Graham Hill was a speed freak.
 (*Free Store Theatre, East Village, New York City.*)

Mayor Lindsay is on welfare.

Long live the Cisco Kid.
 (*Engagé Coffee House, East Village, New York City.*)

Lum Fong was here.
UNDERNEATH
Ah! So!

Leda loves swans.

Leif Ericson is a fink.
 (*Italian section, Boston, Mass.*)

Twiggy is the deflated British pound.

W. C. Fields is alive and drunk in Philadelphia.
 (*The Top of the Gate, Greenwich Village, New York City.*)

Yone [sic] Shimmel put Kennel Rations in his kashe knishes.
 (*Wall in Manhattan's Lower East Side near Katz's Delicatessen.*)

Zeus loves Ganymede.
 (*Lion's Head, Greenwich Village, New York City.*)

Zorro is a homo.
 (*Men's room, The Alibi bar, Bloomington, Ind.*)

Canarsie is a hot bed.
 (*IND subway station, 14th St., New York City.*)

Howard Johnson eats at home.
 (*Howard Johnson restaurant, Greenwich Village, New York City.*)

Senator Dirksen is a leprechaun.

This week I'm going with Bill but I like Jim.
 —Alice.

UNDERNEATH
This week I'm going with Jim but I like Bill.
 —Alice.

UNDERNEATH
This week we are not going with Alice.
 —Bill and Jim.

John Maynard Keynes is a spendthrift.
> (*John Adams luncheonette, Greenwich Village, New York City, 1968. Out of business.*)

Michael Dunn was here.
(Note: Written high on the wall. Mr. Dunn is the highly talented actor who is a midget.)
> (*Fedora restaurant, Greenwich Village, New York City.*)

Oscar eats meat.
> (*Oscar's Salt of the Sea seafood restaurant, New York City.*)

Penelope rejected the suitors—not in stereo but in living high fidelity.
> (*Ladies' room, Bennington College, Vermont.*)

Euclid was square.

FDR, Ike and Rutherford B. Hayes all ate H.O. oatmeal.

George Schleppington washed here.

Gale Storm lives!
UNDERNEATH
It's about time.

General Custer is alive and well and living on a reservation.

General Sarnoff is really a corporal.
> (*From Johnny Carson.*)

George Lincoln Rockwell is a robot.

George Santayana is a dirty old man.

Donald Duck is myopic.

Down with Emperor Ming.

Dracula Sucks.
> (*Various walls and on a button.*)

Immanuel Kant but Kubla Khan.

I never drink wine.
> —Dracula.

John Birch is politically disoriented.

John Wayne for Secretary of Defense.
> (*Various walls and on a button.*)

Jonas Mekas loves Walt Disney.

Lady Godiva wore a fall.

Flash Gordon is low unintentional camp.

Bob Kennedy wears a toupee.
> (*Subway scrawl.*)

Cassius Clay is really Al Jolson.
(From Jim Murray, sports columnist of the Los Angeles Times.)

Norman Vincent Peale takes mood-elevators.
(Jim Moran column in Chicago Daily News, May 27, 1967.)

Cinderella married for money.
(Various walls and on a button.)

Clark Kent is a transvestite.

Dean Rusk is a recorded announcement.

Florence Nightingale was a pan handler.

Zeus gave Prometheus the bird.
(Univ. of Michigan, Ann Arbor.)

Art Linkletter is a pedophile.

Superman gets into Clark Kent's pants every morning.
(Univ. of Michigan, Ann Arbor.)

THE WALL REMEMBERS

Marat lives.
(Note: Jean Paul Marat, 1743–93, French revolutionist.)
(On a button.)

Melvil Dewey played the numbers and lost.
(Staff lounge of a few libraries that had converted to the Library of Congress classification. They had formerly used the Dewey decimal system. Cited in the American Library Association Bulletin, Jan., 1969.)

Rasputin lives! He is in the kitchen.
(Max's Kansas City restaurant, New York City.)

Trotsky will return.
(Café Figaro, Greenwich Village, New York City. Out of business.)

Lenny Bruce spoke the truth and truth died of a heart attack.
(Ladies' room, Max's Kansas City restaurant, New York City.)

Judge Crater—please call your office.

Brian Epstein lives!
(Note: Beatles manager, who died Aug., 1967, age thirty-two.)

Lumumba lives.
(Note: Patrice Lumumba, 1925–61.)

Bakunin was right.
(Note: Mikhail Bakunin, 1814–76, was a Russian anarchist who believed that anarchism, collectivism, and atheism were the answers for man's freedom.)

Bix lives!
(Note: Tribute to famed jazz cornetist Leon "Bix" Beiderbecke, 1903–31.)
> (*Men's room, Eddie Condon's, Greenwich Village, New York City, 1954. Out of business.*)

Dulles lives.
(John Foster Dulles, 1888–1959. U.S. Secretary of State.)

In a series written by different individuals:
Millard Fillmore was the last Pres. born in the 19th century.
(Note: Actually he was the first, being born in Jan., 1800.)
Who was Millard Fillmore?
Millard Fillmore is an Aggie.
Millard Fillmore was a dirty commie rat.
Millard Fillmore is secretly alive and awaiting the call of his country.
> (*Scholtz's Beer Garden, Austin, Texas.*)

Ohsawa lives!
(Note: Founder of the macrobiotic diet.)
UNDERNEATH
but his disciples are dead.
> (*Paradox restaurant, East Village, New York City.*)

Olenka Bohachevsky lives!
UNDERNEATH
And quite obviously in great seclusion.

Unleash Father Coughlin.
(Note: A highly vociferous priest who had his own radio program. He was quite antagonistic toward Franklin Roosevelt. He was finally silenced by his superiors.)
> (*On the cover of a Catholic magazine,* The Critic, *Dec., 1966– Jan., 1967, a wall was depicted covered with graffiti.*)

Viva George Reeves.
(Note: Actor who played Superman. He committed suicide.)

Stranger, stop and wish me well,
Just say a prayer for my soul in Hell.
I was a good fellow, most people said,
Betrayed by a woman all dressed in red.
> (*Chalk on a brick wall a day after John Dillinger was shot by the FBI on July 22, 1934.*)

Jimi (Hendrix) was here but now he's gone,
But left his mind to carry on.
> **—Jimi.**
> (*Men's room, Princeton Univ., Princeton, N.J., 1970.*)

WALL WRITERS ON WALL WRITING

Phone 411-000- Graffiti made up to take out.
 (*Goodale's Restaurant, New York City. In the men's room is a three-foot ruler attached to the wall and men note their measurements. 1969.*)

Do not write on walls!
UNDERNEATH
You want we should type maybe?
 (*Forum Coffee House, East Village, New York City, 1967.*)

Down with graffiti.
UNDERNEATH
Yeah, down with all Italians.
 (*Chumley's restaurant, Greenwich Village, New York City.*)

Do not bend, fold, staple or mutilate in any way these walls.
 (*Florida State Univ., Tallahassee.*)

The graffiti in the men's room is better.
 (*Ladies' room, Lion's Head, Greenwich Village, New York City.*)

Down with protests.
Up with graffiti.
 (*Ladies' room, Graffiti Restaurant, New York City.*)

Why do you wash these walls? Graffiti is a learning experience.
UNDERNEATH
So is washing walls.
 (*Men's room, Univ. of Michigan, Ann Arbor.*)

Take sex, religion and politics out of the john.
 (*Engagé Coffee House, East Village, New York City. Out of business.*)

Stop vandalism—don't scribble on walls.
 (*Found scrawled on a freshly painted wall. In Norton Mockridge column, Boston* Herald, *Dec. 2, 1966.*)

Take the four letter word out of the classroom and restore it to its rightful place. Here.
 (*Men's room, Greyhound bus depot.*)

These are the most interesting, dirtiest walls in town. No shit.
 (*Ladies' room, Lion's Head, Greenwich Village, New York City.*)

Graffiti has changed de face of de nation.

All shithouse poets when they die,
Should have erected in the sky,
A fitting tribute to their wit,
A monument of solid shit.
> (*Public lavatory in Scotland.*)

One should not write in public places.
UNDERNEATH
There are no private places.
> (*Ladies' room, Brooklyn College, Brooklyn, N.Y., 1969.*)

One might think from this flow of wit
That Shakespeare's ghost had come here to shit—
Or Byron with his flaming tongue
Had stopped in here to drop his dung!
> (*Outhouse wall, 1916.*)

A thing that never should be done at all
Is to write your name on the backhouse wall.
(Note: Backhouse: *A privy, an outhouse*)
> (*Kicking Horse Auto Camp, Yoho National Park, British Columbia, Aug. 2, 1928.*)

What happened to all the high class graffiti?
UNDERNEATH
It got read.
UNDERNEATH
Better read than ded [sic].
> (*Lion's Head, Greenwich Village, New York City.; written after the walls were painted.*)

Why do gnomes [affectionate name for custodians] always wash stuff off the walls?
> (*Men's room, Bates College, Lewiston, Maine.*)

Eat your Wheaties and you'll write better graffitis!

Today's graffiti is tomorrow's headline.

Some people are poor
While others are rich
But a shithouse
Poet is a Son of a Bitch.
> (*Men's room, Ogden, Utah, Artesian Park, Aug. 16, 1928.*)

Remember graffiti doesn't grow on walls.

The literature here is what publishers reject—Halleluyah!
> (*The Exit Coffee House, New York City.*)

Join the Graffiti Guild of America.
> (*Coed toilet, Engagé Coffee House, East Village, New York City.*)

This wall is ready for any budding scatologist.
> (*Men's toilet, Rutgers Univ., Newark campus, 1969.*)

Why write on a wall?
UNDERNEATH
Because it's there.

Graffiti is now respectable.
See New York Times et al.
 (*Ladies' room, Lion's Head, Greenwich Village, New York City.*)

You can't whitewash everything.
 (*Max's Kansas City restaurant, New York City.*)

This wall shall be the Rosetta Stone of the next civilization, consider
 your words well.
 (*Men's room, telephone directory proofreader's office, New York
 City, 1969.*)

People probably chipped these things on the walls of Egyptian bath-
 rooms 2000 years ago. So progress is a ball point pen.
 (*The Florentine, a defunct Berkeley coffeehouse.*)

Santini is a book burner.
(Note: This was written when owner Ray Santini had his restaurant's
john walls painted.)
 (*Chumley's Restaurant, Greenwich Village, New York City.*)

A man's a fool, and he should know it
Who makes himself a lavatory poet.
 (*From* Graffiti *by Richard Freeman, England.*)

This wall soon to appear in paperback.
 (*On a wall covered with obscenities.*)

This wall has bad rap.
 (*Univ. of Michigan, Ann Arbor.*)

Happiness is a white wall and a magic marker.

I think that people who write in latrine stalls are immature and
 troubled and need psychological treatment.

WATER CLOSET ETIQUETTE

This urinal will self-destruct in 5 seconds.
 (*Men's room, Under The Stairs bar & restaurant, New York
 City, 1969.*)

Keep the clap out of Max's.
 (*Max's Kansas City restaurant, New York City.*)

Any lady who believes her mother about clap etc. from toilet seats
 should not be in bars.
 (*Ladies' room, "55" Bar, Greenwich Village, New York City.*)

Pointing to toilet paper:
Coarse syllabus—take one.
>(*Men's room, Princeton Univ., Princeton, N.J.*)

Mirror, mirror not on the wall.
>(*Ladies' room, Lion's Head, Greenwich Village, New York City.*)

The Wilt Chamberlain Memorial Wall.
>(*Written on a mirror that was too high up the wall.*)

On notice which said: "Please Pull Handle Up After Flushing" the following was written underneath:
Also Rego Park, Astoria, etc.
>(*Men's room, Astor Place Theater, East Village, New York City, 1970.*)

If you read this you are not aiming in the right direction.

In case of air raid, duck under urinal, it hasn't been hit yet.

Two hands for beginners.

We aim to please, you aim to please. The management. P.S. Our janitor can't swim.
>(*Men's room, Univ. of North Carolina, Jan. 20, 1959.*)

Save paper use both sides.
>(*Midvale Steel Works, Philadelphia, Pa., 1918.*)

Kilroy wouldn't dare come in here.
>(*Univ. of North Carolina, Jan. 20, 1959.*)

Make your deposits in this bank but do not leave any change on the floor.
>(*Over toilet bowl.*)

Here is the place we all must come
To do the work that must be done
Do it quick and do it neat
But please don't do it on the seat.

Anarchists please learn to flush.
>(*Coed toilet, Alternate U., New York City.*)

Be a man, not a fool
Pull the chain, not your tool.

Don't forget to pull the chain for Waterloo needs the water.
>(*Electric Park, Waterloo, Iowa, Sept. 9, 1932.*)

Toilet paper compliments of Acme sand and gravel company.
>(*Men's room, American Academy of Dramatic Arts, New York City, 1969.*)

This door is alarmed.
>(*On a door leading to the ladies' room in Bloomingdale's in New York City.*)

Occupancy by more than 401 persons is dangerous, unlawful and somewhat unsanitary. signed Dr. Equi Excrementi Civilis.

The water closet like the harp is essentially—a solo instrument.
 (*Ladies' room, Blind Lemon pub, Berkeley, Calif.*)

For V.D. cases only!
 (*In a stall in Madison High School, Brooklyn, N.Y., 1953.*)

This is a teepee
For you to peepee
Not a wigwam
To beat your tomtom.

Cuddle up a little closer, it's shorter than you think.

Little drops of water
upon the toilet floor
uses lots of elbow grease
and makes the porter sore.
So now kind friends remember
before the water flows
please adjust the distance
according to your hose.
 (*Madison River Camp, Yellowstone National Park, Aug. 10, 1928.*)

Pilot with short engine mounts—please taxi up close.
 (*Men's room, Alberta, Canada.*)

Puritans with short muskets step up to the firing line.
 (*Men's room, Damariscotta, Maine, c. 1950.*)

Butterfly has wings of gold,
Moths have wings of flame
Toilet crabs have no wings at all,
But they got here just the same.

Is your kitchen as clean as this?
 (*Found in a filthy washroom in a Springfield, Mass., cafeteria.*)

'Taint no use to stand on the seat,
Power house crabs jump 20 feet.

Girls:
 I promise to support your cause for sex and marijuana, etc., if you keep the sink clean and throw papers and such in the waste basket.
 Thank you, Le Metro.
 (*Ladies' room, Le Metro Caffe Espresso, New York City.*)

Ladies be seated.
 (*Ladies' room.*)

YOUNG PEOPLE'S GRAFFITI

Sally is a Humpty-Dumpty with hair.
 (*Little Red School House, Bleecker St., New York City.*)

Jimmy fucked Nancy (almost).
 (*Junior H.S. wall, Brooklyn, N.Y.*)

Fat Mark loves himself.
 (*Wall at 82nd St. and York Ave., New York City.*)

Dorothy wears blue panties.
 (*On wall at 58th St. and 1st Ave., New York City.*)

Steve is a bum teeny-bopper.
 (*IND subway, Greenwich Village stop, New York City.*)

Sue Wilson and nobody as yet.
 (*Among amorous scrawls on a construction fence.*)

Hello to the 119th Street Savage Knight Purple
Killer Warrior Demon Saint Bishop Mystic Unknown
Mother-Hater Carrot Mutilators Sons of the Smiling
Butcher Fathers.
 (*Chalked on pavement around fountain in Washington Square
 Park, New York City, Dec., 1966.*)

From the smiling daughter mongers, and kill, fight,
Drink and sing many happy songs on cold Knights.
 (*Chalked on pavement around fountain in Washington Square
 Park, New York City, Dec., 1966.*)

HOLLAND.
(Note: Stands for, Hoping Our Love Lasts And Never Dies.)
 (*Wall, midtown West Side, New York City, 1970.*)

This desk is dedicated to those who died waiting for the bell to ring.
 (*Traditional desk graffito found in countless schools.*)

Epilogue

The more we examine the phenomenon of graffiti the more we realize that many kinds of people write on walls. There is the large group of second-hand exhibitionists, living in a world of sexual fantasy and getting their jollies from the imagined shock they are causing. There are graffitists who want to get involved with world problems and whose voices cannot be heard except on the mute wall. There are the scrawlers who want to amuse, who want to share their funny thoughts. Many graffiti writers are mavericks, iconoclasts who enjoy nothing better than to violate a taboo. They flaunt their defiance by writing obscene words in public places. There are adults who write dirty words on walls in an unconscious effort to recapture childhood or early youth. The well-known psychoanalyst Sandor Ferenczi writes, "In the fourth or fifth year of life, a period is interpolated between the relinquishing of the infantile modes of gratification and the beginning of the true latency period . . . characterized by the impulse to utter, *write up,* and listen to and read obscene words." The adult graffitist seeks to repair that repressed period during which he channeled all obsenity into socially acceptable activity. We may conclude from this that graffiti, particularly obscene graffiti done by children and youngsters, are normal. Wall writers, many of whom take a dim view of psychiatry, are probably both amused and annoyed by such theory. "Psychiatry the new inquisition" and "Psychiatrist is whore" may have been written by people who recognized their own need for therapy and were angered by the high cost of treatment.

There is no doubt that a great many people equate psychiatric treatment with pressure to conform, and resent strongly any effort

which would represent an attempt to cure them of their "idiosyncrasies." Like the person who wrote "I don't want to be normal" and others who encourage their readers to "Freak freely" or "Have a fit today."

Be all that as it may, much of today's graffiti, especially that found in numerous colleges and universities, is inspiring and heartening evidence of energy and imagination. I quote just a few from a Princeton men's room:

The new cinematic emporium, is not just a super censorium,
But a highly effectual, heterosexual mutual masturbatorium.

Yellow walls of timeless folly,
Frozen scar of melancholy,
Id and ego synthesized.
Testaments before my eyes.
Deck the walls with boughs of holly,
Ivy creeping up your thighs.

All of us are sitting on the toilet but some of us are writing on on the walls. [Note: Variation on the lines of Oscar Wilde: "All of us are lying in the gutter but some of us are looking at the stars."]

Bullshit, bullshit I've known it all,
It just precedes the cosmic fall.

The world is flat.
—Class of 1491.

However, widely practised though it is, and more widely noticed than ever, graffiti remains the twilight means of communication, a dialogue between the anonymous individual and the world.